PHOTO GRAPHY IN ADVER TISING

PEER ERIKSSON

ATTEN
ATION
INTREST
NTIREST
DESIRE
DESTR
ACTION
ACTION
SATISF
SATISFACTION
ACTION

PHOTO
GRAPHY
IN
ADVER
TISING

There is a brief moment in the process of taking a picture when
the photographer has to forget the existence of time, forget that
there is something between him and the subject.

The photographer must also try to see beyond the
assigment that is to be forfilled. During that instant, he stands
in a sense naked, left to see what his inner eye seeks to see.

This disappearence in the moment of creation is
curucial and miraculous. It's in this brief moment of
truth when the thin slice of time becomes communication
and that talking picture is born.

The past reborn becomes present and makes us pause
to listen. The merit of creative photography is that it makes
us pause, makes us notice and allert us by awakening us
to the importance of details.

We seldom pause to notice the differences.
Wait, concentrate and see. Patience with details is,
in one word, precision – the key to communication.

Communication, precision, time, are passwords
to contemporary creative thinking in photography in advertising.

P.E.

CONTENTS:

JOHN HEGARTY

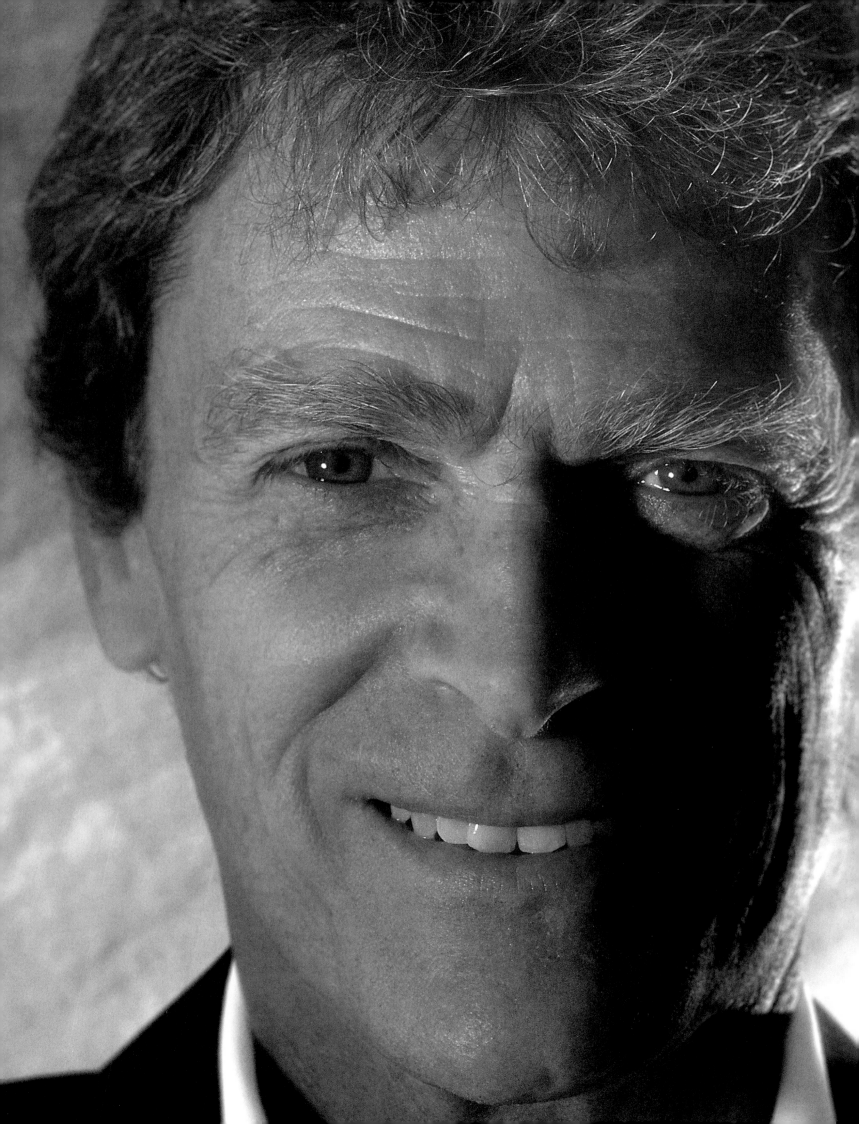

PEER

— Being in the business for 25 years, and you've been there even longer, do you think over the years that the use of photography has changed?

— The holy or unholy marriage between art and advertising, there is a very close connection there anyway. Advertising revolves around what artists and the art world are doing. All art forms have always been in the forefront of society. And it seems like advertising is just one step behind, seeking for inspiration and new ways to sell.

— So maybe that's why photographers, good advertising photographers, not only work in the field of advertising. They also work in the field of art. I think they feed the advertising world with something that the business really needs. Maybe they open doors that might be closed to most people?

JOHN

— The use of photography has changed enormously. But the interesting thing is to go back in time when we went from illustration to photography. That for me was the big change. It was, in a kind of way, the democratization of advertising. Which sounds like a weird thing to say, because ultimately advertising is the most democratic of mediums. It tries to talk to as many people as possible.

But originally it was in the hands of artists and illustrators. Art directors not only did the layout but also drew the picture. What happened in the 50's with the rise of television and the desire to see the real thing, illustration no longer reflected the new photo realism of the age.

I think it was Joseph Beuys who said "We are all artists — it's just that some of us shouldn't exhibit". We saw the democratization of art when Andy Warhol came along and painted the Campbell soup can. It was a celebration of 'the every day'. Pop Art idolized the world around us. This explosion coincided with more magazines printing in colour.

This movement from illustration to photography reflected a new kind of awareness. The audience you were talking to were probably more used to looking at a picture than they were at an illustration.

They wanted a kind of greater sense of reality in the things they were looking at. I think we saw the use of photography explode. People wanted to see the real world; they didn't want to see an illustration. If they wanted to see the pyramids they wanted a photograph of the pyramids, not an illustration.

Advertising in one sense was responding to that, all those things were happening at the same time. Technology was creating the opportunity and the democratization of the business, a driving force. People wanted to see the real thing.

When I came into the business in the mid 60's, I was part of a new generation of creative people who had come from a working class background. We weren't interested in writing novels or painting pictures. We loved Pop Art, rock n'roll and wanted to reflect that in the work we were doing. There was greater economic wealth, people were travelling more, seeing more and it wasn't an artists impression they bought back it was a photograph. The great thing about photography is that anybody can take a picture.

— I think you're absolutely right. Advertising takes these ideas that really are out there and it broadcasts them to an even greater number of people. I think one feeds off the other.
 Similar in the way that Hollywood does; that's why, in the 30's, all those great writers became screenwriters in Hollywood, as it gave them access to a broader audience.

— I've always felt, that it sounds a bit stupid, when people say; "oh, is it original?" It was done by so and so. What advertising does is — it takes these ideas, makes them available to a vast number of people. A much greater number of people therefore see these ideas than if they remained in a gallery or in a book etc. That is the kind of stupid criticism that gets laid at advertisings' door . The same with the movie industry, the pop music, the magazines; it's called pop culture, and we are part of that pop culture. Feeding off each other, inspiring one another. Nothing exists in a vacuum.

— Talking about pop culture, it is also trends that have changed over time. And advertising has definitely changed over time maybe because it follows society, trends and art. If you look on photography and how it has changed in the sense of trends, do you see any major trends in photography?

— Advertising mirrors society and the great themes that drive it. So it is with photography; there aren't so much as trends – but social phenomena that gets reflected in photography. In the 60's we began to see greater reality coming to photography. We started using real people. We started using characters you might see walking down the street or buying a newspaper on a Sunday morning, or in a pub on a Saturday night singing a song or whatever it might be; someone with a funny face, a particular smile. It was about reflecting a broader view of society.

All of a sudden photography began to be more of a social documentary than just an absurd kind of rose tinted view of society. This wasn't just happening in advertising, it was happening in almost every other media.

Along side that, you had the glorification of the ordinary. Warhol glorified a soup can. So, photography in advertising glorified every day products: a packet of cigarettes, a bar of soap, a beer bottle etc.

Burt Stern in the early 50's took some pictures for Smirnoff. I think it's the greatest still life photographs ever taken for advertising and it was a Martini glass with an olive in it and he shot it with the pyramids reflected in the glass. A Martini glass became a work of art.

A glorification of the ordinary. It was part of what photography and advertising were doing; taking very ordinary everyday objects and making them more glamorous. You had a whole number of other themes going on. You also had the idea of nostalgia being used in advertising. Brands were trying to reconnect with their roots as we were living in a fast moving technological society. We suddenly realized that some things that had been around for a long time, had value and that 'new' – wasn't necessarily better. Advertising reflected this. We had wonderful campaigns here from Hovis; "it's as good for you today as it's always been". It was beautiful posters of an old man, sitting in a chair eating his Hovis sandwich. Nostalgia became a very powerful force.

— From there, it went to glamour photography where advertising and photography created a world that maybe wasn't all that real.

— That's true. Advertising has always been about selling a dream. When I talked about real characters, we showed real characters in a slightly glamorized way. Advertising is about optimism.

There were a couple of other things that happened in the 70's, the whole use of the surreal image that came around through cigarette advertising. Certainly that was the case in the U.K. maybe not so in other countries. It came out of legislation, that cigarette companies were not allowed to show images that in any way could be seen as encouraging people to smoke, encouraging them to feel that smoking helped you socially. You couldn't suggest by smoking a cigarette that you were better off or anything like that.

This censorship presumed an airline pilot's sleeve in the picture, would encourage young people to smoke. Of course, what they didn't realize is that no young people thought airline pilots were inspiring anyway. In the stupid legislation they brought in, they helped generate this whole surreal look, which was pioneered by Benson & Hedges. That was then picked up by lots of other advertisers. They made the image a mystery, a puzzle you had to work out. Again it was about accessibility. And of course, this was a wonderful rich vein of creative possibility for photography. An example of why censorship rarely works.

One of the driving themes of the last 10 to 20 years has been sexual liberation. Through music, films and advertising we've seen the body used to provoke a reaction. Kate Moss lying naked face down on a sofa; the recent Gucci ad, with the models pubic hair shaved to reflect their logo. Sexual liberation is still today a powerful force.

— And again photography and advertising becomes surrealistic. In the beginning of the 60's Bert Stern did it and in the mid 80's where a lot of, as you say, very surreal, very artistic advertising photography. Are advertising photography going in circles?

— If you look upon contemporary advertising photography. It's a co-operation between the art director, the agency, the agent, and sometimes even the clients are involved in the process of making images. Maybe that is what contemporary advertising and contemporary photography is revolving around. Advertising and photography at it's best; asking the questions but not giving the answers.

— It's funny you say that because in Sweden they wrote a lot about the Cannes festival and Von Trier, the Danish director, he made a film that is done like a play. It's an empty room, white charts on the floor saying, "Here is a wall, here is a door". And then the actor is moving around it, an environment that is non-fiction but is totally fiction in another way. So that's really real and then again; not real at all. Do you see the next step in advertising photography? Are we going to look back again or will we enter in to a new room where we haven't been before?

— I think in a way, we have almost gone back to illustration because of the ability to manipulate pictures. The ability to take a stock picture and create out of it – a different kind of image. It gets back to being an illustration – in a sense the photographer is much more of an artist. The art director and the photographer work much more together, to create and do something different and very distinctive. It's not really a circle but it's almost gone back to the beginning.

— That's right. Questions are in the box but the answers are outside the box. It's quite interesting, I think that people are so used to looking at manipulated images. What is real anymore? Powerful photography's real power was that it reflected the real world, even though it was glamorised in some way or another.

Whilst now you can manipulate anything. You can make anything happen. In a way I'm not quite sure where it's going to go. Will we go back to an organic photography? One which hasn't been manipulated.

It's like in food, we talk about no chemicals, no additives. Will the photographer go back to that or will we go into a much more illustrative era in advertising and photography, it's going to be interesting to see. I don't think anybody knows yet.

We are now in a world where, for instance, you go to the movies and you know that when you see 'Gladiator' you know that they didn't rebuild the Coliseum. It was all done with computer-generated technology. You accept all of that. You are looking at this computer-generated world that we are living in and ask, "How far will we go?", "Do I relate to it?", "Will there be a movement against it?". Or will it go back to "Now I want to see a real person, standing in an empty room with a cup of coffee in his hand". And you know it's all for real.

You might almost put captions on photographs saying, "Nothing in this picture has been manipulated".

— I don't know what the answer is, I'll tell you when I get there. Nobody knows what's going to happen tomorrow and that's what's so exciting about it.

My quote is "Do interesting things and interesting things will happen to you".

ALBERT WATSON

PHOTOGRAPHER

PEER

— I have always wondered as time goes by – different trends of photography have revolved around what's happening in our society. If you look back, say 10-20 years, do you see any big changes in photography and advertising?

— I guess it's hard to keep your integrity intact?

ALBERT

— I think it's a lot harder today to find the right campaigns to shoot in advertising, when there is this question of integrity. In the sense of holding on to your own image and at the same time making your ad a functional piece. There is a great difficulty in that. People come to you because of your style or your work and the art director would see you in a particular way, and see the quality of your work and say "Ok this person is right for this job". In that way, sometimes you got to make sure that you're protecting not only your own image when you go into a project like that but you're protecting the image of the company ultimately who you are working for.

— If for example, you are doing something for IBM it's very important that you protect your own name, and of course protect the name of IBM. What I mean by that is that you have IBM, immediately you have all the names from IBM, the vice President or the President in charge of marketing and advertising for IBM. Then you would have the creative director of the agency in charge of the IBM account. Then you would have the art director working on the account. So basically, you can sometimes have to go through three or four people before you reach the company itself. Speaking of the company in an abstract way. So consequently the art director, he has a vision too. The art director has to answer to the creative director and the creative director has to answer to the client and so on.

My big complaint, a lot of time the head of marketing for the corporation never comes to the shooting, which is one of the mysteries of advertising. If you do a national campaign, they spend millions of dollars. Why would the head marketing not come to the shoot? Because then you have a long string of pearls there that can break at any point.

Consequently it's very important that you in the end are doing what feels right for the company. Not disappointing the art director who has come to you because of possible editorial work that he has seen of yours that is a lot more free. But in the end one always has to remember that this is advertising. You're trying to inject yourself into it and sometimes what I feel today is that young photographers they're almost oversellers in their protection of their own selves. When they enter into it, they're very concerned about their own image. But the bottom line is that somebody is paying you. They are paying you to be yourself. "We want you, we want your work but it's for us".

A good analogy is if you're an interior decorator and you feel the current fashion and the current thing to do is to paint the room green but you are doing it for a client that is just allergic to green. How do you solve that problem, how do you make that connection? Looking back I think 20 years ago it was easier to find more ideas. If you go back 35-40 years, there were campaigns coming out of America during the 60's period, that had very freeflowing ideas. A lot of that has disappeared.

When you look through a stack of magazines, it's very difficult to find a great, great campaign. People more often refer to fashion campaigns. Because fashion is one of the things that are sells through images. In a weird way it is advertising – because it has someone's name on it and they are trying to sell you something.

The fashion people were very clever, people like Calvin Klein. Because they actually reversed the role of advertising and editorial. They did this brilliantly. What they proceeded to do was that their advertising became more and more so called editorial, like contents out of a magazine. They insisted on editorial feeling. They would send you the dress, with the bracelet, with the Calvin Klein stockings, CK shoes, with the CK belt. With a note that they would prefer it standing. Basically, they didn't have control over the shoot, but they would indicate very strongly. They would then let the magazine know if they were happy with the shoot or not. The magazine time and time again would have to listen to CK.

The reason they had to listen was because those people were spending millions of dollars in advertising in the magazine. So the roles were reversed. CK began using advertising as image and the editorial part of the magazine was used more like advertising. In other words, they use the editorial part as advertising. It's a very clever thing.

— What about your advertising work today?

— Advertising today has changed; it's getting tougher and tougher. I actually find that one of the things that I do in advertising, that I get the most out of right now, that it's not only lucrative but you can do something with it. Is the portraiture you would do for movie posters. So consequently you use your skills as a portrait photographer to do it and, you light it the way you think is the correct way to light it. You know that it has power, strength, clearness, integrity and so on. You at least get on a piece of film something that is a true portrait of the individual. And you have a little bit of freedom with the little bit of maneuver ability, as I said before, it's lucrative that also quite good. It's shot under a great deal of pressure. Because you have a very little time to do strong images. So portraitures is one of the main areas you can, at least, have some integrity.

— I think this is pretty interesting, the thing about integrity because as you say, what the client or the agency is buying is the integrity and the artistic knowledge of the photographer. But in the end they won't buy that anyway. They maybe interfere too much in the creative process. How do you keep the artbuyer or the client or the agency out of your studio or do you want to have them in the studio?

— First of all there are good art directors, so therefore, if you think a little bit along to the photographer, more than in line of being film work, that it is a team effort. Directors can't make films alone. So if you think along those lines, where you need good people around you, if you have a bad art director then you have a bad art director, if you have a nervous art director that is almost worse.

— Because they actually don't know what they want?

— Yes, and also you have to understand that sometimes an art director may work on something for tree to four months before he gets to that point of shooting. It can represent four days of selling to a client. Therefore it's a danger sometimes at what you have to watch if there is someone that comes to you, it's an image of somebody's finger in an ear. You basically started ten o'clock in the morning shooting a person with a finger in the ear. You shoot from every conceivable angel and you shoot until quarter to five, finishing at five, and the art director, after you done that says to you, "go wild, be creative" quarter to five. And the art director says, "Is there anything you like to do now?"

I'll give you one very good learning experience that I had 12-15 years ago. And it was at a time when I was stronger with art directors and tougher with art directors. I was doing a shot in the beginning of the day when I did this photograph. I peel a 4x5 Polaroid so you could really see the shot; because it's quite a big piece of film. The art director looked at it and said he was very enthusiastic about working with me and so on. And he looked at the Polaroid and he said "That's good. Now, this is what I think is wrong. Then he began to say, "Can we change this, and can we change that". In my head I thought this is pretty good looking, this shot. I begin to change things because I agree to change them. Then there is the question of integrity. What happened to integrity?

The integrity was that I did it the way I thought was the correct way and I laid it on a plate for him in a shape of a large, clear-cut Polaroid. What happened was that, bit-by-bit, we drifted away from that shot rapidly and then spent the rest of the day shooting other things. And at six o'clock he picked up the original Polaroid that was just laying there and he turned to me and he said, "Did we shoot this?"

When you tell the story, the surface of the story is obviously against the art director. But the person that was 100% in fault was myself. And the reason for that is that if you are waiting for a Polaroid to be done. If I feel that that shot was right for that company,

forgetting about the art director, that during those three minutes I knew the shot was correct and good, that it should have been put on film by me, that's integrity. But I mistakenly didn't do that.

I did have the integrity at first and then the art director bit by bit pulled it apart. What I should have done at that point is to shoot it, put it on film, and hand the contacts to the art director on the day the film comes back. At that point, that's integrity. If he dumps it? Fine, he dumps it, not me.

— But the client is buying that integrity. But they mess around with it anyway. Why is that?

— I think that there are difficult times now; I don't only mean economically. I think there is more freedom when the economy is very good. When you are not making millions and the company is failing, then you go, " Let me see this, oh wait a minute, that shot is too sexy for us or too this or too that". They challenge the shot more. They put it under the magnify glass. Sometimes, they are right and sometimes they are wrong. Things become more and more conservative, more straightforward and not so challenging.

— And people become more scared.

— Some of the English magazines that are doing glossy magazines that are kind of fashion art driven magazines. Superficially, you look at it once and you go "Oh that's interesting. You look at it a second time it looks a bit thinner, third time and you realize it's not quite so good quality – that it doesn't have quite so much weight in it as it should have. I think there is a difficult time across the board; I think it's a difficult at the creative end of things in editorial and advertising. And I think it's difficult at the non-creative end as well. I think this is very, very tough days.

One thing that is very important no matter what you do, you have to hold on to the quality of the photographic image. You can never let that slip, no matter what. At that point, you unfortunately have to resign the job in the middle of it. If the quality is not there, the quality is in danger; the craft aspect of it is in danger. At that point you shouldn't be doing it. That's the bottom line, the quality. If it goes below that line then the ship is going down.

— As you say, these times are pretty hard, the company people become scared and they are concerned "Can we do this or can we do that".The bravery is not there anymore. You don't see anything new, you don't see any groundbreaking things in advertising. But maybe that's why advertising is turning into art because you have a lot of projects that are art based and they are your own projects.

— Well, it's the only solution that you have. Like the Las Vegas project, if you don't see what I'm doing, which is fine, if these images are not correct or not good or don't hold up and you don't see what I'm trying to do, and then the failure is 100% mine. There is no one else to blame in the way the images are being presented, if you don't like the imagery and you don't think the image is strong. I have seen other images I have done in the past where there is no art director, creative director, marketing director, vice President in charge of marketing, there is no one to blame. So consequently, you truly become the master of your own destiny. You become the master of yourself.

— And maybe becorse of your own project, is the reason for art directors or clients to choose you.

— They can but there is difficulties with somebody like me. You know in the 70's, I was doing a lot of hand-held 35-millimeter work that was easy, snappy and fun. At that point I was very much in demand because the work was relatively strong but it had a sense of humour and lightness to it. What happened was that when I got older the work got stronger. And when I say the word "got stronger", I don't necessary mean the work got better, I just mean the work naturally became more powerful. Powerful doesn't necessary mean better. A snapshot can have all the integrity of a very heavy portrait or a heavy landscape. But for some reason, and it could be that my initially founding was in graphic design. And if you look at the work to this day it's graphic design written all over everything. I was trained as a graphic designer. And after that I was at film school for four years in London. If you look at the work, film is written over everything.

Consequently what happened was, I realized, if I was light and a bit fluffier and not so strong, I was able to be very commercial and make more money. But what happened was, the ghost of my past, being in art collage for and seven years or spending so much time in an intellectual environment, because I did a regular degree, a masters degree and a PHD

and then to be involved in a intellectual background for that. Once I got through that initially thrust of being fun and easy and snappy and so on, I returned more to the roots. I got stronger and stronger. And once again I would like to emphasise that it doesn't mean better and better. It just means stronger. I'm using the term of the graphic power, the integrity of the shoot, and the way of the shot. The shot got heavier.

— What do you mean by heavier?

The work I am doing now, it's not exactly lightweight. Even if it's a snapshot. The picture back there, that was done in a male strip club. That stripper walked by me, a girl looked over the shoulder, and she's a striper. I snaped that picture. I didn't set it up. It cannot be any more snapshot like that. But even that picture has some weight to it. I think that's what I mean by weight.

I went to Vegas after Morocco. I was looking for something else since Morocco is a very classic country, a very religious country, a very Islamic country, a very rich country, and that's how I presented it. At that point, dropping myself into the middle of Las Vegas, it was like going to the other side of the galaxy, to a place that has a visual decadence. It's another extreme and it was more interesting for me. But I actually had problems with that project. It has taken longer time than any other project I have done. I did an enormous amount of work there in the beginning, that was totally misplaced. Here is where the photographer has to watch out. Advertising, doing too much advertising, contaminated my initial work. It had an effect on me. Watch out for the virus that works that way. Watch out for the contamination. Watch out for the integrity. My initial work in Las Vegas was quite simply "too well" done. It was too polished, too high end, it was too over constructed and it was too heavy.

The work became too claustrophobic. Bit by bit I began to lighten up a little and I began to see if I could do things with a little bit less perfection.

— So basically you use all kinds of technical possibilities that are around?

The biggest project was done from disposable camera, 35-mm camera to a quarter camera, to a quarter panoramic camera, 4 x 5 camera and 8 x 10. And everything intermixed. The information is loaded into computers. Then I work on the images in the computer, very carefully. The computer puts something into your work and you have to be very careful about that. I remember very early on when I was at school, using a Xerox machine. You take a rather boring photograph and put it in the machine and out comes a high contrast black and white image that looks pretty good. It made my boring picture look stronger. Then you do a whole portfolio of Xeroxes and suddenly you put it all together and you go; Wow it looks great!

Suddenly you relies that it has become a Xerox portfolio, something new.

— If you look ahead at the project you're working on now, the Las Vegas project, is this the kind of fun you like to do, your own projects? Sort of a bigger project, a more heavier project?

I don't know if fun is the right word? But if you like doing it, you like doing it. And you enjoy it and you look forward to it. And at some point me being British, I say "Oh it's five o'clock and I like a cup of tea". So I look forward to that cup of tea. And if it's seven o'clock and it's too late, you think "Oh, I haven't got my tea today." I think when you are working on a project its little like five o'clock tea, in a way. You're looking to do this, you're looking to make images because you're an image-maker.

AERNOUT OVERBEEKE

CLIENT: NISSAN
AGENCY: TBWA
ART DIRECTOR: ROBERT JANSSON
COPYWRITER: K. VAN NOORDWEAK
DATE: MARCH 2001
GENERAL USAGE: POSTERS ETC.
EUROPE

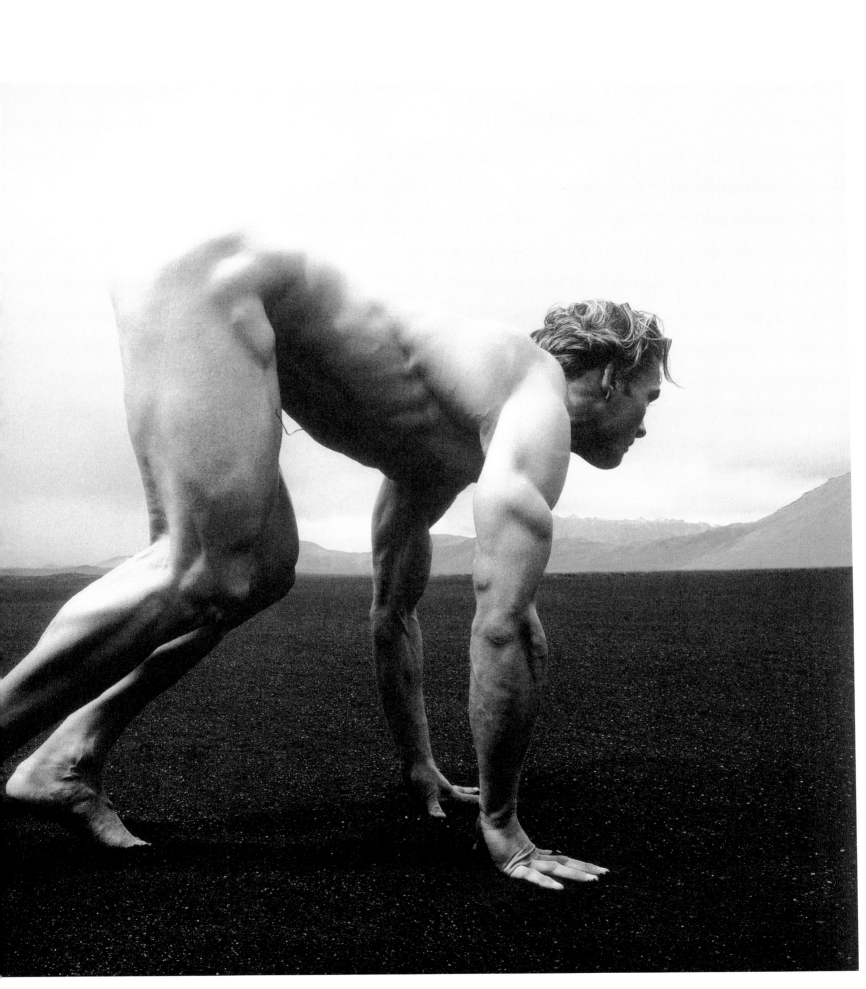

ALBERT WATSON

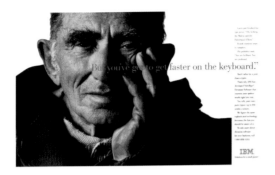

CLIENT: IBM COMPUTERS
AGENCY: OGILVY & MATHER
ART DIRECTOR: DAVID JENKINS
DATE: JUNE 1995
GENERAL USAGE: PRINT CAMPAIGN, USA

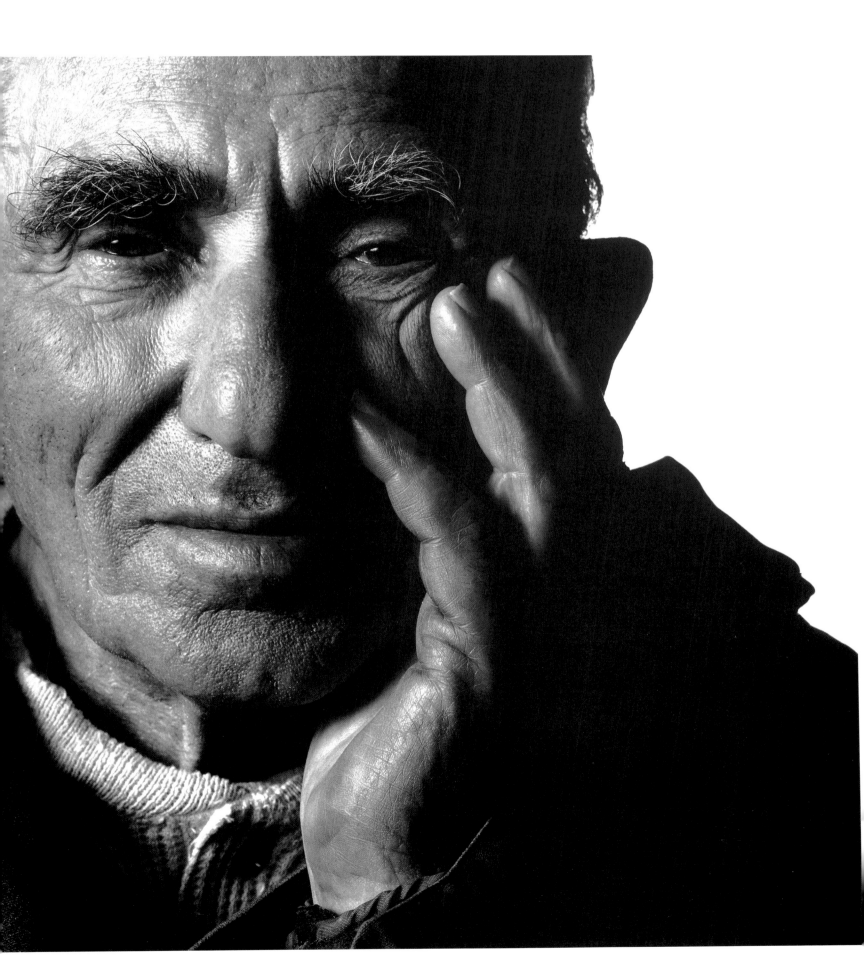

ANDREAS HEUMANN

 Second Nature

CLIENT: SADOLIN "SECOND NATURE"
CAMPAIGN
AGENCY: CONNECT POINT,
MANCHESTER, UK
ART DIRECTOR: SIMON BROADBENT
DATE: FEB/MARCH 2003
GENERAL USAGE: PRESS & POSTERS, UK

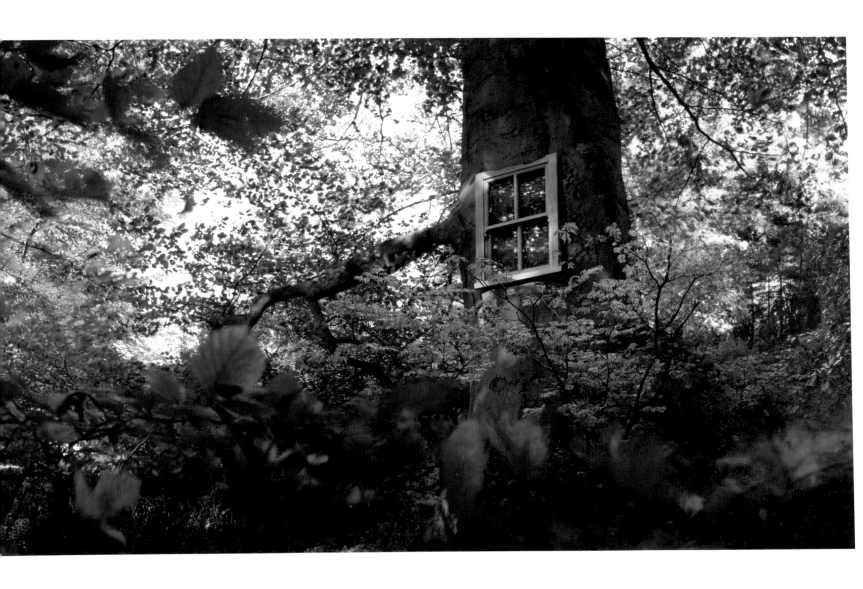

JENNY & TOM

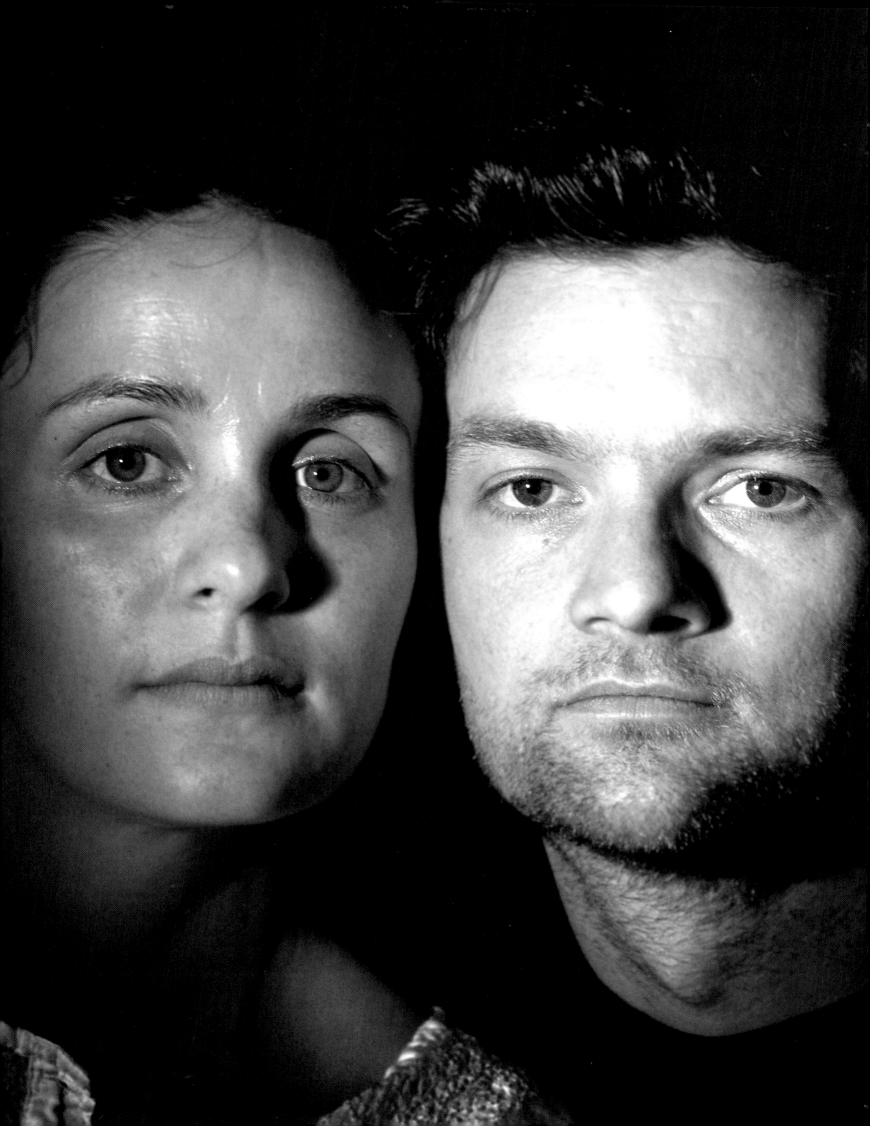

PEER

JENNY & TOM

— It seems like the people that work with publishing today don't care that much about photography as a technique. Most of the photographers are more interested in imaging, rather than being "handcraft" photographers. They are more "image-makers". How do you look upon that, are you photographers or image makers, or is it impossible to label you?

— J: I think that I came from a more traditional background in photography. I went to college and then I went to graduate school for photography. Correct, I should have more formal training in photography, but Tom came from a more film making background. Definitely more interested in image making – that the images had to be beautiful, but they did not have to be done so serious with big cameras and lights. He was much more interested in replicating sort of the feeling of cinema and stuff without using all the lights and big things that they use. So we are sort of a combination.

— T: The cinematic aspects is also important. I studied painting when Jennie and I started first working together. One of the first times that we really started discussing were aspects of photography were when we were painting together.

I think Jenny was a really great technician, when it comes to making really beautiful images of whom which she was shooting with. Because of the painting I was always pushing her to bring the abstract element into the photograph. She was making these gorgeous images and I was more like, the color has not to be exactly right, the "glance" can blow out and there can be big places where it's out of focus. And she taught me how to be like a technician and my sort of thing was always like abstraction.

— When you do commission work, how do you start out?

— T: It kind of works in the same way. For the not commissioning work, it is usually Jenny who has an idea, like a lot of what we do that is not commissioning comes out, as like an autobiographical thing that comes out, of Jennie's past in some way. We just talk, and talk and talk and go over it. And we do it in terms like the narratives, a structure, there is a character. It is always about a person, about a woman and she has a story, a background. We build the character in a cinematic way as a filmmaker builds a character.

— So there is a lot of story telling in your images?

— J: Both in the art work and the commercial work. It is special in the editorial work – there is a little more freedom there.

It is always a story. And then the girl and the clothes become incorporated into the story. Like Tom is saying, it is not a huge difference to how we approach it, but actually how we end up making the work, there is a difference, because of the stylist, the hair, the make-up. And as we continue to do more of the editorial stuff, we start to learn how to fine-tune all that as well. Because if your are making an art work, it is Tom and me, and usually our main subject is women, one girl, two girls at the most. And a trunk of clothes.

It is more making the transition to all the other support people that are with us, trying to make that a good thing and not like overbearing.

— When you look at your pictures, it is not only the story that you see? Is there something in-between?

— T: That's what I mean when I say that we talk and talk about it. We come to recognize who the character is, what she has done in the past before the moment that the photograph is taken, and is just a part of entire continual of who that character is, where she is and what she is wearing, what she happens to be doing at the moment. It is all a product of us knowing that character so well that she couldn't be doing anything else. It is like that she is caught there at that moment because she is sort of who she is. And we know well enough who she is and why she is there. Even if it is not at all evident in the photograph, it is evident to us. That is the thing that gives the photograph a "depth".

— Storytelling in religion has always been an important. It seems like magazines and MTV are taking over.

— T: It is like our religion, like what we do in life that is important to us, some people believe in things that are like church stuff, neither of us really believe that, so we believe in what we do.

J: I do not know if we feel that narrative photography and storytelling is extremely strong way of working, people do seem to relate. When you were saying the work is a story, but then there is a story outside of the picture frame, I mean I think that it brings if you are in and not something that people can really connect to. It is not just the girl story in the photograph but sort of what you are projecting on to her story, what you are adding to her travel.

T: That is the difference to what we are trying to do and what a lot of people who do what is called narrative photography and what you will find in a church. That stuff is completely dramatic and it is meant to embody a large chunk of time. And it shows you that somebody has been put up on a cross, or something like that. Whereas I think, art thing relies much more on ability to give people that moment that is full of potential within the photograph, that single moment, that is completely full of potential, but also sort of like that connect with them in a way that like we trust them to come up with the rest of the story. Like the opposite of being dramatic. It actually asks a lot from the viewer, in a way. To formulate all those things themselves. We rely on the fact that we are in emotional tune with something, that will allow them to have that reaction.

— Is there a lot of documentary in your photography?

J: We want it to feel real, because we believe it. It is very real for us, the obsessions, the stories, whether they come from past experiences or if they are complete fantasy, there is a part of our life. There is an element of fantasy, but I think they way that the work looks to the documentary and more reportage that helps people fall into the story and really believe it, and also goes back to what you were talking about, where it is not overly glossy image making. You do feel like somebody was capturing a piece of this girl's life.

T: It is also interesting when we look at different projects that we have done. To go from the whole group of work, some stuff is very much like documentary, like a hitch-hike girl, she is like a run-away, we met here and it is that shot. And then, on the other hand you have a very similar picture, getting a very similar feel in a story in a fashion magazine that we completely constructed on some level. And they all fit together in a way. All those photographs kind of fit together, because for us it is all one story. So it is like, there are certain times when it is very much like we are using art to create things, and there are times when it is completely sort of like honest, what would be called honest situation. To us it doesn't matter so much, because it is all part of that story. It all comes from the obsessions that we have with making those images. It is not dishonest to do that either.

— What about clients and art directors. How do they get involved in your work?

J: Well, it is not always created after a situation, like Tom were saying we are talking and going over things, we will do things that are very planned. Like a story that looks unplanned, we will have the location scouted and the props and all those things ready, but it depends. We have had jobs where they had the layout for us and it is much harder to do what we want to do with that, and then we have had some great jobs with big clients. We did something for IBM and they really just came to us and said; "We love the way you use light and isolation of the character" and really let us do our thing. I think because they had so many accounts, it wasn't so scary and the art director definitely took a chance.

— The art directors do they give you that freedom?

J: For the most part.

T: I think, the people who will come to us, have come to us recognizing what we are good at. So we have had a good experience with art directors, because I think they are not coming to us to do something that we would not.

J: We don't work a ton in advertising, but we do advertising job, and it seems like the people that have had hired us have always had a real understanding and appreciation of art and really come to us feeling that they can. Like they don't to have to make it up, do something completely different from what we do.

— You come from the art world, you work like an independent artist. Does it give you more freedom?

J: I think so. The art directors who have hired us, they have been very confident, do you know what I mean? Like not feeling: "Oh my god, I'm so nervous about the client". Everyone is alike, not taking a risk, but just a little bit. We are hiring these people who aren't just doing catalogues. Because we have had really good experiences. Definitely, every once in a while we have had to make work that is not ideal, but definitely doesn't feel like digging ditches.

— But do you have to do that, if you have a strong integrity? Like "If you want to hire us as photographers – Fine, but we will keep our own way of doing our thing". Is it like that?

J: Exactly. And then the persons who hires us seems to have their own integrity, because they are confident enough to hire somebody like us. We know that they have a client to make happy.

T: When Jenny had her show in 2000, Joe McKenna, the stylist, called and asked if we could do something for W Magazine. That was really the first time that we did something like that. But the thing is, I think that one reason why we work as artists. We were always looking at, whether it was film or fashion or advertising. Because the idea is everything, all is one big story. Like we have one big story and it is all part of the other big story, which is sort of a whole, it is all the images that you see. Maybe that is what you were talking about, when you were saying that there were places like the church. It is a collective memory or collective vision out there, of all the images that you see. It is not just the art images. We are making these pictures and they are going to exist as pieces of art and stuff. We were seeing great images that were appearing on movie posters and we were really excited about certain advertising and fashion stories, and been excited just as much of a beautiful picture by an artist that we were studying. I think that was one of the things that allowed us to enter into it and not see it as different. We never really saw those images that hang in galleries as different from the ones appeared in magazines. If they were good they were good. If they hit you, they were good.

I think that is part of the reason. That is interesting too, because at the time when we were drifting in to people that were telling us, "you can't do that, you will get slapped out". And people have got slapped – came from the art world and began to do magazine or advertising work.

Partly because of people like us who are doing it, partly because there is not the same black and white, one world another world, which obviously you recognized too.

T: Which is interesting.

— Everything is floating together.

T: That is kind of interesting. Definitely like the idea that there is especially sort of like optimism that so much of what we look at now as like creative work from the past, was obviously like commissions and paid for by somebody who had an agenda but the artist tried to do what the artists always try to do, to make great work, and some of it really stuck around. So maybe we should put our pictures up in the church?

J: When I was young I put my pictures up in the post office, but they took them down.

— I guess nobody cares about photography, nobody cares about whether it is fashion, editorial or art. Everything sort of blurs together, becomes one. It seems like the artists are more interested in communication, trying to say something. Either being a storyteller like yourself or doing single pictures, strong images.

J: Yes, definitely. I remember one of the most memorable advertising campaigns that I saw recently, maybe six-seven years ago, was a product campaign, I don't know the brand. I think Glenn Mushford shot it. She was floating out in a boat, a fire behind her. I created a whole story behind that. I think it was a one year campaign that he did. That is the hard thing about advertising, when they cut if off and then they hire some other story teller to do it. Like wait a second, I really liked that person. There is some great advertising out there that really does that. That kind of communication that brings you in.

T: We are seriously studying art, like figuring it out, and you see those photographs that is like wow those are just amazing.

J: And it did not matter whether if it was advertising or what.

— We live in the age of storytelling. We read stories to our children, we read stories in books. We see soap-operas on TV. I find that advertising, when at it's best, can be real good storytelling.

— J: Definitely I think it is the other way around. The commission work is fuelled by the art work. Because the art work is all about this obsession with the woman, whoever that woman is at the time. That woman usually is not a model, she is beautiful but in a different way, much edgier way, a little bit more real.

For advertising we want the people in the photograph to feel real, not the kind of photographers that are going to do big studio lights and tons of hair make-up. It is going to feel much more like the woman is all made up. There is a definite edge to it.

— What about your art projects. Are they driven by the commission work or is it the other way around?

— J: It is hard to say. The stories change.

— T: A lot of the things that we are doing now is actually going back to the roots. Like taking that traditional technique, trying to put that into the story that is going on now. I think that changes it a little bit. We just made a shot for the W Magazine. We made a story that was really influenced by the same idea of the characters. The women that we have these obsessions about and then we did it like a large format camera and sort of like an inspiration for us, large format like the American photographers of the 60's who had that sort of light, American backyard gossip, kind of saying who the people that we were studying ten years ago and start to feel that coming back in.

The story continues, it seems like you go along with it.

— If you look a couple of years ahead, how would you change your story telling?

— J: We have sort of started this a little bit new phase in our work, with the big format camera, not running around quite as much. It is like a little bit more careful, it takes longer to breed. The runaway girl that we have created, now it is like that girl has grown up a little bit, she is settling down....

— Getting married, having kids?

— J: Exactly, just like me.

ANTON CORBIJN

CLIENT: MUTE RECORDS
ART DIRECTOR: ANTON CORBIJN
DATE: 2001
GENERAL USAGE: WORLDWIDE
CD-COVER/ADVERTISING

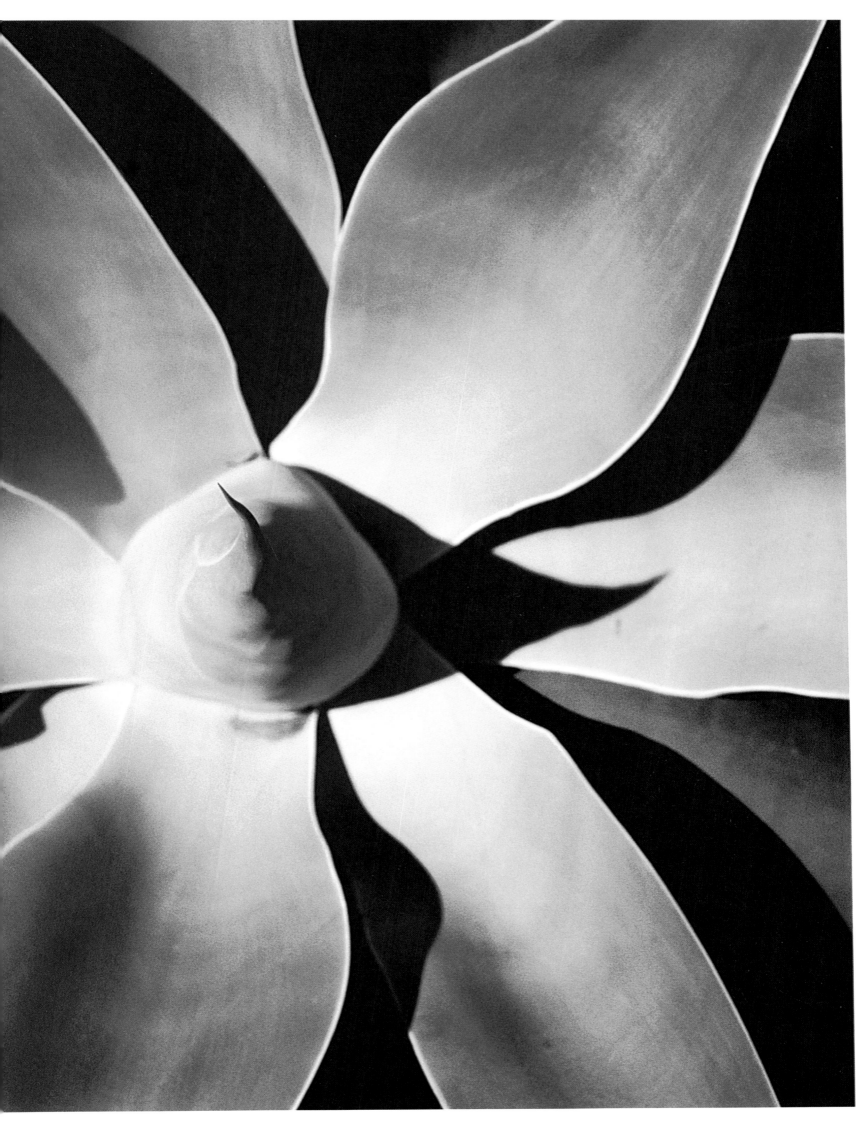

BLAISE REUTERSWÄRD

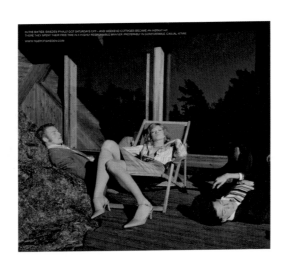

CLIENT: TIGER/FRITIDSHUSET
AGENCY: LOWE BRINDFORS ANNONSBYRÅ
ART DIRECTOR: MAGNUS LÖWENHIELM,
PATRICK WATERS
COPYWRITER: STAFFAN RYBERG
DATE: 2002
GENERAL USAGE: BILLBOARDS

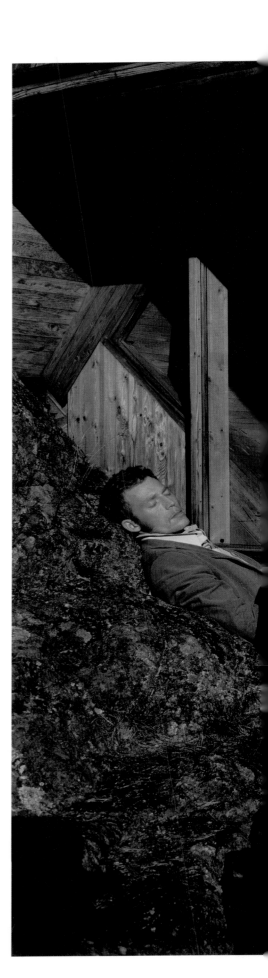

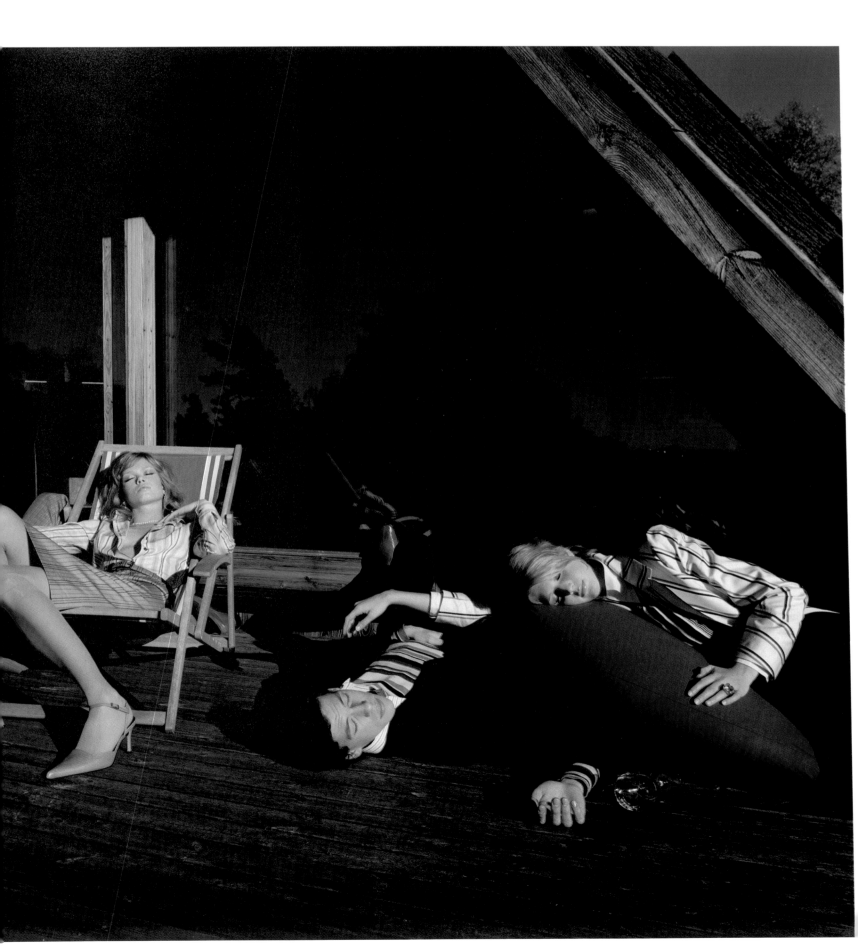

BOB CARLOS CLARKE

CLIENT: URBAN STONE
AGENCY: EXPOSURE
DATE: 2001
GENERAL USAGE: PRESS

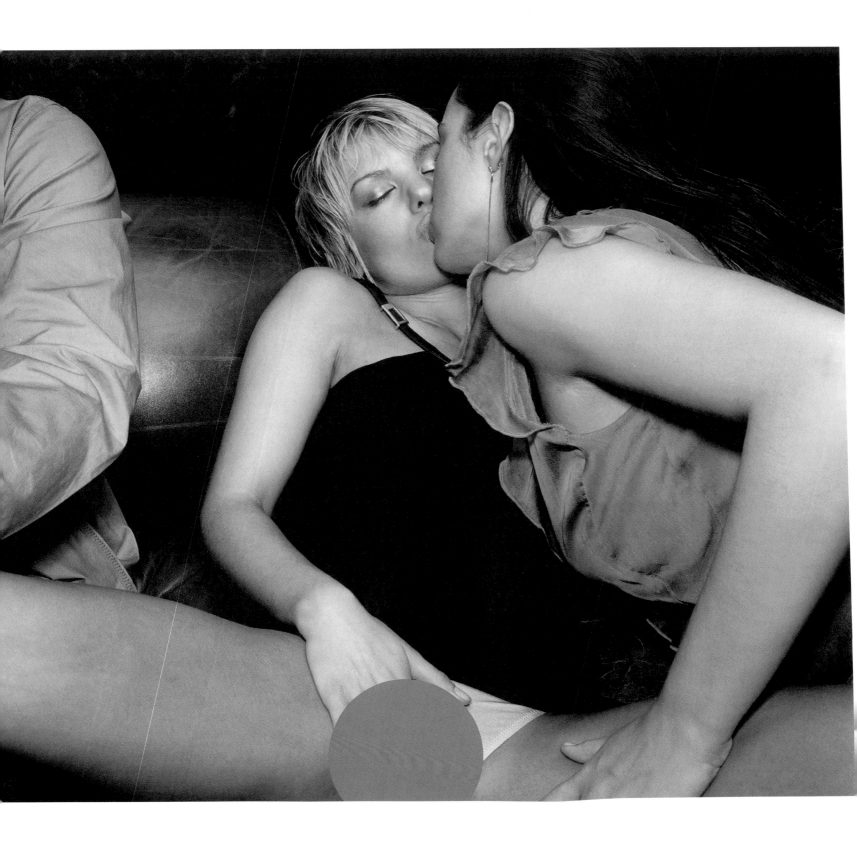

PEER

JOSETTA

— How did you end up in New York?

— I worked as a journalist for a while but I didn't like it so I took a master in anthropology and didn't like that either. I took an advertising class in college. I finished my master in anthropology and got out of journalism and I went to work for an ad agency in Maryland, and it was a really good one, O'Palmer Brown. That started me up working with ad agencies and I've always wanted to live in New York. I came here about ten years ago and I've been here ever since. Hopefully leaving in the next ten years. I don't want to grow old here.

— Is it possible to define your job as an art buyer?

— I think art buyer is a strange word and I don't know why they still use it. But a lot of people choose to read or title themselves art producer or in-house producer or photo producer or just buyer because the job is less about buying art and more about a production. Especially, in smaller agencies we started out very small, and a lot of my functions overlap with an outside production company, because some of our budget can't accommodate hiring a producer and a production company. So I end up doing a lot of the things myself, like location scouting and casting, I do all the casting for Levis.

Of course, I find all the photographers and the illustrators. Just acting like a production company but in-house for BBH at no charge to our client, and it is only to facilitate getting work done. So the term art buyer is not so relevant any more, it's more like producer, art producer, in-house producer or whatever.

— It seems to be a really important part of the creative process.

— Yes, it is interesting. It's fun for me to work with different creative types because with each team that comes in you have to get to know what they are like and what they don't like. So when a book comes in here, I pretty much know who to give it to, who is going to like and who isn't going to like it, because I've gotten to know them over the weeks or months. I'm pretty good at judging characters, because I've been doing it for so long and not to say that all art directors and copywriters you can stereotype them or put them into a category but esthetically it is easy for me to see who is going to like what. You can almost tell by what they wear and how they talk and the music they listen to.

I always introduce myself when they first arriv and try to get a feel for them so it is easier for me to do my job. It is a good function because it doesn't waste their time. They don't have to answer the phone calls from the rep. I'm kind of a streamline gateway to work on the outside world. It's interesting because a lot of times people over the years have come to interview me from other agencies, for example, in Canada they don't have art buyers either, the art directors do the art buying themselves. That's great but sometimes it can be troublesome, because certain art directors that I've worked with, when they really want a photographer to do a project they'll do almost anything to work with them. And sometimes the fees are too outrages to be allowed for the production to happen. An art director might push it just because they've always wanted to work with this one photographer and they'll get the project in at the right cost, but then they find that it is not producible. They can't afford the hotels in that area, they can't afford models, things like that. So my job is to make sure that stuff like that doesn't happen, make sure that there is enough money in the production to actually give them a good production. A lot of times, especially lately we are out to give budgets when we present photographers books. And this is definitely the preliminary stage of the layout process that hasn't gone through the client bullshit and changing stuff a million times.

So it is hard to estimate it at that point, but you have to do it and then they hold you to those numbers. So it is really critical in my function that I keep all the money under control. Make sure that no one goes over the budget, and make sure that if the client makes new changes that I'm flagging it with the account persons "Hey, this is beyond what we were talking about. We need more money."

It is a thing I just don't think the art directors should have to worry about. Some of them don't have the time to get to know all the people that are out there. I've been doing this for a while and people from the outside world know that they can call me and I see a young guy or someone that they are thinking of taking on. So I have met so many different people

— It seems to be a really close relationship with the art director's. Can you understand what he wants without he is saying it. How do you create that intimacy between yourself and the art directors?

— Which is very strange because it seems to be such an important part of the creative process. What do you look for when you look for a photographer besides their style?

— That must be hell to have that kind of a situation?

— I can understand that. Sometimes you have the art director on one side and the photographer on the other side and you are right in the middle and the creative director is putting pressure on the art director and again you are in the middle.

— Maybe it has always been like that. You have those that you know what they are doing. It seems like advertising is always looking for a new art director, young photographer or both. Is there any specific at this moment that you feel that you are looking for?

— What is that?

at different levels of their careers. I mean everybody comes to me with projects. They say " Oh I need pictures of a guy in a hospital. I've probably met someone a long the line a guy doing a book on hospitals in Cambodia". And I just call the person to get the book, so it's a good resource for them.

— It doesn't happen with all of them. It usually does but there is a handful like I usually have problems with writers. Art directors I understand where they are coming from because they think visually. I have more problems establishing relationships with copywriters who are put in creative director position. That's why I get into trouble because a lot of them don't think visually, they think verbally. And they have a hard time discussing what they are seeing in their heads because they are so used to verbalizing everything that they don't know how to verbalize the visual thing in their heads.

With art directors I usually don't have any problems because I could almost be an art director. I'm like a secret weapon for them. I never put my ego in the way of their progress and they know if they partner with me I'm going to make their work better because I'm going to get whatever photographer they want. Even if it means I have to do more work like doing all the casting, all the location scouting myself so that they can afford this photo-grapher, I'll do it. To me it is more important that they get something good for their books and I get the credit. Because you don't get any credit as an art buyer.

— They have to come in here and talk to me or at least one phone conversation before I hire them. I have never hired anyone with at least talking to him or her once. I think there is so many egos in this business, so many insecure people especially at a higher level that I can't afford to have an extra ego on set. And I'm not saying that some of these photographers' egos among us aren't huge, but I can't have a conflicting ego. So there are certain people when they come in to meet you, you know they are going to be a nightmare to work with, and I just won't do it. There has been two or three times where I had to really be an insane asshole on set because the photographer was totally out of control! That was like in the past and I won't let that happen any more. There is too much pressure on me and I'll be the one they'll come screaming to.

— I just got off a shoot with Nadal that was kind of tricky. He can be difficult. We're good friends so that's fine, but I'm the one that everyone comes to because I have known these photographers over the years and worked with them so much. I'm friendly with a lot of them and sometimes people are intimidated by them and use me to get their dirtywork done. Sometimes the photographers are cool about it; it is just depends on how you approach them.

— Oh yes, there is so much pressure and everyone is putting pressure on me. It's ok. The reason why I enjoy it is I like helping young photographers. I like finding someone's work who is new and exciting and helping them get somewhere. Even if they don't get anywhere and they're working on a project and they need money, like I'll give them "Do headshot work here; " Do this for me". Just help them so that they can afford to do what they really want to do.

— Probably, I mean the economy is so bad. I'm getting a lot of photographers in every day. I have at least three appointments a day. I know what not to look for because right now there is an abundance of the same kind of photography out there.

— It seems like everybody goes to the Whitney and has whatever bandwagon is there for the moment that lasts for about two years. Four years ago it was the man golden thing. A year before that it was the Terry Richardson thing even though he wasn't at the Whitney but that was fashion. I'm sure maybe a piece or two of his were there as a fashion iconography. Now it is "the Gumsky thing", huge pictures of factories and Monday in offices or pictures

of inanimate objects, white trash America in fashion is just so boring. Fashion is really boring right now. So it is so easy for somebody to stand out right now. I think that the people that are really good right now are still working now because they are in the upper line. There is so much crap out there. I have taught at SBA a few times and I'm overwhelmed in a class of 40 people, how only one student is actually talented and they are never photographers it is always the weird painter or the sculpture. It is something different that captures my eye because these kids are growing up looking at magazines. I can't look at magazines any more. It is so easy for things to stand out. There are so many other people doing the same thing that all you have to do is to do something different.

— Everyone is looking for things that stand out. When you see work like that what do you do?

— If I need somebody and they come in, I'll take their book and show it around and then when ever somebody has a project I'll call it in for that and hire the person. They usually go with my top 3 pick.

— So, they do listen to you a lot?

— Yes. And it is so obvious that the top three that I have chosen are perfect for the job because there is a photographer for everything. We did a color poster and I had wanted to work with Charley White for the longest time, he is with the Andrea Rosen Gallery. We had this opportunity and there was no money and it was a really quick turn around. I got him to do it for us. And it was because I wanted to work with him. I sold him through and we got to work with him. It was fabulous in the end. When I have the heart set on someone I just push them so much that eventually it catches on.

— You are listening to your heart. You look for something special, something personal that stands out. So again you seem to be a very important person for the art director and the photographer. What about the agents, do you get along with them?

— Yes. I have gotten burned by few of them. I have to make sure that....I usually like to recommend the production company because I have gotten in to a lot of trouble in a few shoots going over budget because the production company wasn't buttoned up. I do so much of the production myself but the client never signs the estimate. So by the time they finally sign the estimate, I have done the casting. I have found the location. I practically gotten all the props. It's almost impossible to go over budget so I make sure that I give them two or three production companies that I have worked with. And that I really like working with. It kind of leaves the rep of any undo pressure to keep things under budget. And it kind of seems to keep our relationship a lot cleaner. Because they can't complain to me about the producer because I recommended them. If it goes over budget it is my problem because I'm the one that pushed for it but it never does because I always use good production companies.

— Talking about budget and negotiation, is that an important part of your job?

— Yes. Sometimes the client don't give out the budget so I get to come up with the budget and they never listen to my budget. So I always try to go a little high, knowing that never in a million years I'm going to get that. So I usually try to approach photographers with the budget and do it as a "take it or leave it" kind of thing. This is your budget make the numbers work and from that your fee will come. So they work pretty hard for you because they want their fee to be higher. It shouldn't always be like that but lately the economy has been really crazy.

— So you mean how you negotiate today it's more like "take it or leave it"?

— Sometimes, like with Levi's, it's tuff negotiating because they have such high levels of model expectations. So a lot of times, when I say this is the budget then I have to back and say "Oh the budget is 300.000 dollars less", because they want to use supermodels and that supermodel is going to eat the budget.

Levi's is a lot of negotiating. They never have enough money to do anything so like every ten minutes you are arguing with a rep trying to get the numbers down. And it is hard for them to understand. Like I did this shoot with Nadar for Johnny Walker and it's hard for people from the outside world understand why Johnny Walker doesn't have big budgets and that's just the way it is nowadays. New York is in a huge recession now; clients are very intimidated about spending money on advertising. We are still shooting a lot. BBH is very fortune in fact they are really busy but the budgets are very small.

— Yes, the budgets are very small and their is a recession going on a the time.Does it also happen that the client take more part in the process?

— I think that's where Europe and America differs a lot because we are used to it here wherest in Europe clients respect the agencies more. Especially BBH in London that will never happen. That you have a client who is dictating what will or will not happen.

Here in N.Y., to combat that, I'm pretty insisting on having at least two pre production meetings with the client, even though it is a pain in everybody's ass. I do very complete pre-production books with pictures of everything, everything worked out to the teeth so by the time you get on set, there is little left to the imagination.

— It sounds like a very good idea.

— It is to protect the photographers. Some of the bigger photographers find it to be very boring, because its staple their creative process and it locks them into locations a.s.o. But it really doesn't as long as we cover what the client is expecting. If they want to do something extra that's fine you just have to streamline it that way. So that you won't have those issues on the set because part of my job is to protect the photographer. And my other part of the job is to make sure that the client's interest is represented. And another part of my job is to the art director to get the photos that they want for their book so they get a better job someday. You have to juggle all these things.

I wouldn't ask them to do something they wouldn't do but there are certain words you can't have the photographer saying in front of the client like airy, gloomy, fat etc.

— What about models and model agencies, do you also buy them?

— Yes, that's annoying. I think now I've gotten to know because of Levi's that I have established pretty god relationships with most of the agencies.

— What is a good agent in your opinion?

— If I put someone on hold, that if I have a first or second option, first or second option is the same as we get closer to the shoot. I try to put everything on writing with them so that there is no mystery. It can be very challenging.

I have established a good relationship with some of them. If I have to work with a certain agency and I don't like my specific rep. I just change reps. I'll call them and tell them that I really don't like this person and I want to change the rep.

— Do you also take care of the models at the shoot?

— Yes, I make sure that they know where they are going, I make sure that they are not cold, I make sure that they don't go overtime.

— It seems like being an art buyer is actually a wrong title because you are more like the spider in the middle of the web. You are trying to keep everything together and keep everybody happy.

— I don't think all art buyers are like that though. I heard that some are different. And I have noticed when I've hired people in the past that they are different than me. There are some similar to me but there are some art buyers that are older that comes from very traditional backgrounds and they are more like paper pushers. I'm not criticizing them but there are people that are more traditional when it comes to their job. But I just can't do that.

— What's a good art buyer and what's a bad art buyer?

— It depends on the agency. At some agencies it is fine to just be a paper pusher. We are three art buyers here including myself.

— Do you work together as well?

— I oversee them both. One is my assistant and I oversee everything she does and the other one helps me out with Levi's. I do the advertising for Levi's and she does the instore. And I do all the casting for her because it is so big and it is hard for her to handle it by herself because it is so overwhelming. The instore stuff is like a 10-day shoot, 28 shots. It is just crazy stuff so she needs help. So we work together.

— If you look ahead how would you like your profession to change?

— I think about this all the time. A lot of times the creative directors are so busy and they put so much pressure on the art directors that I would love for the creative director to use art buying more as their creative trustee on a shoot. I could make the art director feel much better about what they are doing. Here I have established a good relationship with everybody so they trust me.

I mean they show me polaroids. I'm just one of them. I stand next to them, we talk to the photographer together, and I'm with them all the way. But I can't make them feel better about their decision, I can say "I like that" and they appreciate that. That is flattering for me, but I like more of a combination of efforts from the creative director so that there was less pressure on these guys to triple think what is going to be said when they bring their

contact sheets back. That is the hard part for them. Because people are saying, "Why did you do it that way?" The creative directors question things a lot when they can't be on the set. So look, if you are not going to be there then at least trust somebody to do what you want.

I like to see more of a communion between all creative directors and me. Certain ones I have that with but other ones that are new and I haven't established relationships with because they are so busy. John would send me in his place to do the shoot and I'm not saying that I'm capable of being an art director or creative director but it was nice to have the trust or they knew that I knew their vision and I can execute it properly. And I just like a little bit more of that in the future for all art buyers because it is a nice thing. We can represent the photographer and usually the photographer knows what shot is best but not always because they don't know the client's concerns. But if the photographer is going to know what shot is going to look the best for the layout and as an art buyer you can take that into consideration more than a creative director can, because they don't sometimes, especially the writers don't know photography as much.

So I think it represents all art buyers. I think they all like to get more trust from upper levels and work more in conjunctions so that there was more autonomy on the set to let things go a little further. Make people feel less insecure about what they are doing as long as the client is happy about it. If the client is insecure when they are on the set and they say "I don't want to do that" then that's another story. As long as you have covered their pictures and you want to experiment doing other things that's fine. It is not necessary all the time but sometimes it is really. Just to see if you can come up with something better. If you are doing one shot every day why the hell not.

CARL JOHAN RÖNN

CLIENT: LEXINGTON COMPANY
AGENCY: APPEL & FALK
ART DIRECTOR: LENA RÖNN
DATE: JULY 2000
GENERAL USAGE: LEXINGTON COMPANY

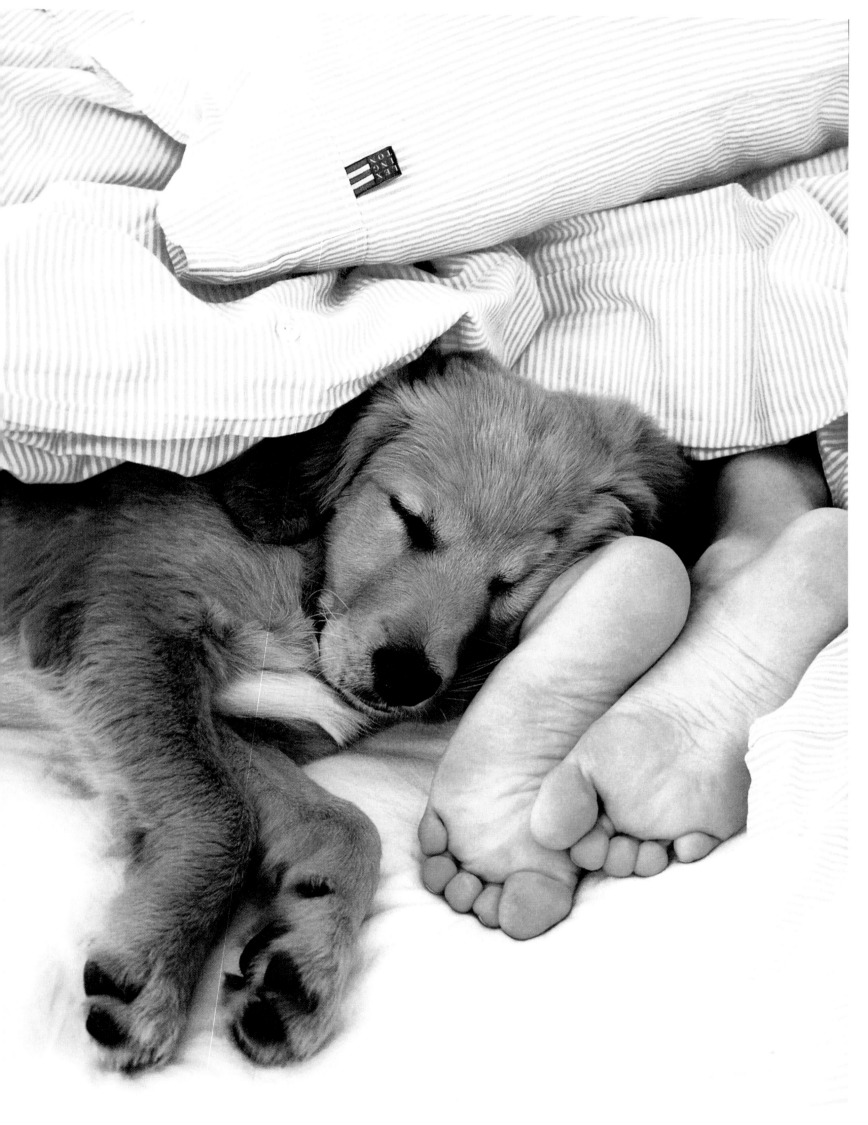

DAVID STEWART

CLIENT: GERICAPS/PHARMADASS
AGENCY: FANTASTIC BRILLIANT
ART DIRECTOR: TONY VEAZEY
COPYWRITER: MIKE KEANE
DATE: 2001
GENERAL USAGE: PRESS, UK

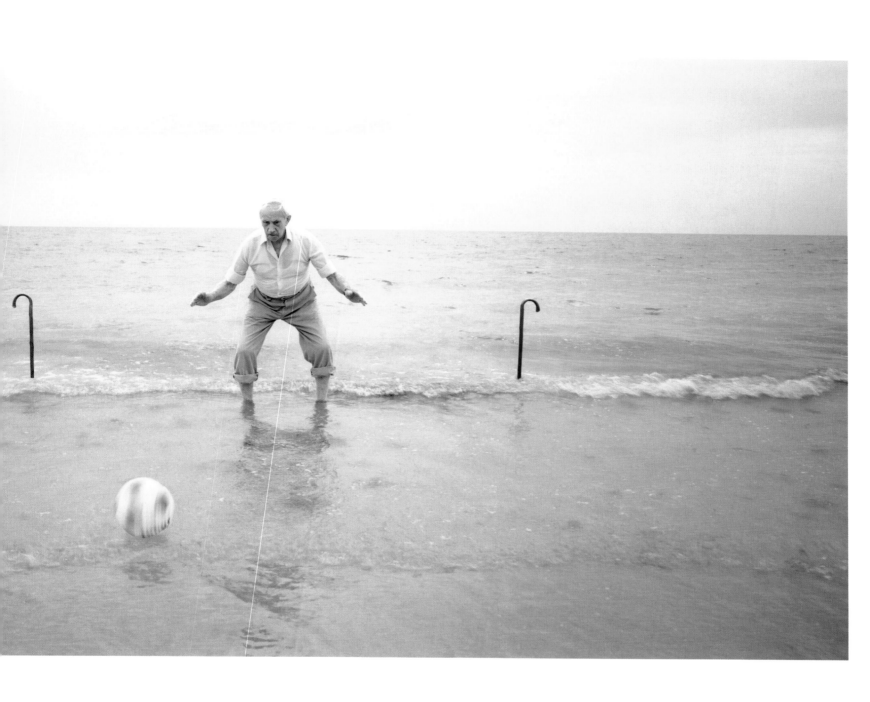

DAWID

CLIENT: OLYMPUS CAMERAS
AGENCY: LOWE HOWARD-SPINK
ART DIRECTOR: BRIAN CAMPBELL
COPYWRITER: BEN PRIEST
DATE: 1995
GENERAL USAGE: SPREADS

KATHY
KNER

PHOTOGRAPHERS AGENT

PEER

KATHY

— How did you decide to come into the business as an agent?

— I was doing a degree in photography and realized that I was actually more interested in everyone else's work than my own. When I was at college we were very much encouraged to specialize and I didn't particularly enjoy these restrictions. I loved the diversity of photography and knew I wanted to stay in the industry, just not as a photographer. I did some research and discovered that many photographers had agents. After looking in industry source books I approached a few agents for work experience, based on the photographers they represented. David Burnham was one of those agents, we got on well and just before I finished my degree he offered me a job, that was 10 years ago and he is now retired.

— A good agent, you have really good photographers. What do you look for when you meet new photographers?

— I think it's a combination of things. The most important is that I have a gut reaction to their work, an instinctive passion for it. Second is their attitude. As a photographer you are never going to have the definitive portfolio. You are never going to say, "That's it! This represents how I see the world". I think you can tell if photography is in their blood and, as long as they have that passion, you know that they will always keep pushing their work. I believe for someone to be really successful, and to maintain that success, photography is a drug to which they are addicted.

I always aim to have long-term relationships with my photographers, hence I do not take on new photographers that often. I am not interested in chopping and changing. In any relationship it takes time to get to know each other and the longer you work with someone the better you can represent them. Seeing their work develop and change over the years and being a part of that process is the best bit.

— How do you help your photographers to get ahead?

— I keep my agency relatively small. We represent eight photographers and that is about the number I like to work with. This enables us to have contact with all the photographers on a daily basis, so we can work with them on such a level that we know exactly where we are with all aspects of their careers. We work together with the photographers on their portfolios; it is a combination of creating a book that best represents them, but also understands the requirements of the portfolio as a selling tool.

— How do you "sell" your photographers to a client or to an agency?

— My main area of business is from advertising agencies, but we also work with design groups, the music industry and the editorial world. I don't do hard sell, it is that old cliché that the photographs should speak for themselves. I am very careful when taking on a photographer that their portfolio is understood as its own entity. The nature of this industry means that much of the time people are viewing photograhers' portfolios when neither they nor the agent is present.

However, promoting our photographers is a multi-faceted role; we regularly do portfolio presentations, target specific people with specific work, send out mailers and, most importantly, make sure the portfolios and our website are as up to date as possible. It has definitely helped coming from a photographic background myself, I hope I can understand the photographers' creative needs as well as managing the business side of their careers.

— So it's business and emotional instincts at the same time?

— Absolutely. The money side of things is only part of what being an agent is about. Working with a Creative in any field has to have an emotional side. Creatives open themselves up to the world in a way that not many of us do, exposing their very personal view. But we do have to make sure that the work is put together in a way that can translate to the commercial arena. I think that the industry has changed a lot in the last 10 years, some of those changes have been a great advantage to photographers working in the advertising industry. When I first started the photographers' portfolios were very different in terms of how

they were set up and presented. The emphasis was much more on the commissioned work. It is great that over the last six years this has completely switched. The emphasis is now on the photographer's personal work. Art directors are much more interested in seeing what the photographer is all about; what they, with their individual view, are going to bring to their idea/campaign. Also, photographers are not under the same pressure to specalize, (car photographer, beauty photographer etc.) It is much more about their style or way of seeing and that can translate into any area of the industry.

— To find a niche?

— When I first started, Nadav was probably the only photographer whose work really translated right across all areas of photography. As I said before, I don't like the idea of photographers being put in boxes and I think that comes across when you look at who I represent.

— So you have a wide range of photographers. Is there a competition between them or are they not pitching for the same jobs?

— I am very careful, when taking on a photographer, that their style is very individual and particular to them. So absolutely, two or three of my photographer's portfolios might get called in for the same project, but in the end it is very clear what style the creatives were looking for when they commission someone and you can then understand why the others were not right for that particular campaign.

Nowadays, agencies are calling in 30-40 portfolios per project, so if I'm doing my job properly, hopefully they are calling in several of mine.

— But isn't that strange that they call in so many portfolios?

— To do anything really innovative and fantastic there has to be an element of risk, but some clients are too insecure at the moment to take those risks, hence why so many photographers are considered.

— But do you think there is a way to make the client less insecure and more broadminded?

— Not at the moment. I think once things start to stabilize, which hopefully they will soon, people will be prepared to push things creatively again. There are still clients that are brave enough to do that, but unfortunately they are in the minority. You definitely have to fight harder to make sure that the creative aspect of a commission is not lost under the pressure of tight budgets and deadlines. I also wish that work was not put into "research", when I hear those words I always know it is the kiss of death to anything really creative.

— Most people, when they are asked to comment, they have a negative comment.

— If you are paid to comment on something, you are going to feel pressure to make an impact.

— If you look ahead, will the business change its rules. Will there be bigger agencies with more photographers or will it be kept on this intimate level of today?

— I only have my office in London and I have chosen not to expand into other countries because I like to have that one-on-one contact. I also want to be able to have a life outside of work! So for me, I don't see things changing that drastically. The industry is becoming far more contractual due to American influence, which I can understand, but because of that I think the role of agents will become even more essential to the photographer. I have much more paperwork to do than I did just two or three years ago and I am sure that will get worse. Photographers want to be able to concentrate on the creative side of taking pictures, not the business side.

— Your passion is photography but it is becoming more administration and legal work?

— The balance has not tipped too far that way, yet. When and if it does then it will definitely be time to consider what this role is about. I can understand it to a certain degree, people are trying to protect themselves, but as an agent, you now spend a lot more time in facilitating the shoot. That's why there are three of us in my company. Together we can make sure the promotion and support side of being an agent is not left behind, ensure that our clients potential/existing are seeing all our photographers' new work, as well as dealing with all the production side of the business.

— What about the negotiating side of
the whole thing? Is that getting more
complicated?

— I don't think the actual negotiating is becoming more complicated. Campaigns have
become much more Global and therefore that has encouraged the increase in the
contractual side of things. I do find that clients are putting much firmer and, unfortunately,
lower ceilings on their budgets, so often art buyers are put in the position of saying," This
is the client, these are the layouts and this is the budget", full stop. It is a take it or leave
it situation.

— Do you think that the clients are getting
too involved in the creative part of a job?

— It has got to a point where, in some situations, they want to see how the finished ad will
look before the shoot has even started. Some of the best work comes from spontaneous
ideas between the photographer and creatives on the shoot.

Some clients are not giving the agencies the freedom to come up with the best ideas
to sell their product. They are putting restrictions on them and that restriction is being
translated across to the photographer.

The client chooses a specific advertising agency for a reason, the art director will choose
a specific photographer for a reason. Of course the client has to be involved, it is their
product and their money, but why hire an agency at all if you are not going to listen to their
creative expertise?

DBOX

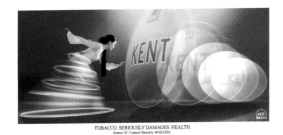

TOBACCO SERIOUSLY DAMAGES HEALTH
Source: EC Council Directive 89/622/EEC

CLIENT: BRITISH AMERICAN TOBACCO/ KENT
AGENCY: G2, LONDON
ART DIRECTOR: PETER NASH
COPYWRITER: ADRIAN KEMSLEY
DATE: 2002
GENERAL USAGE: 5 YEARS WORLD WIDE MULTI USE

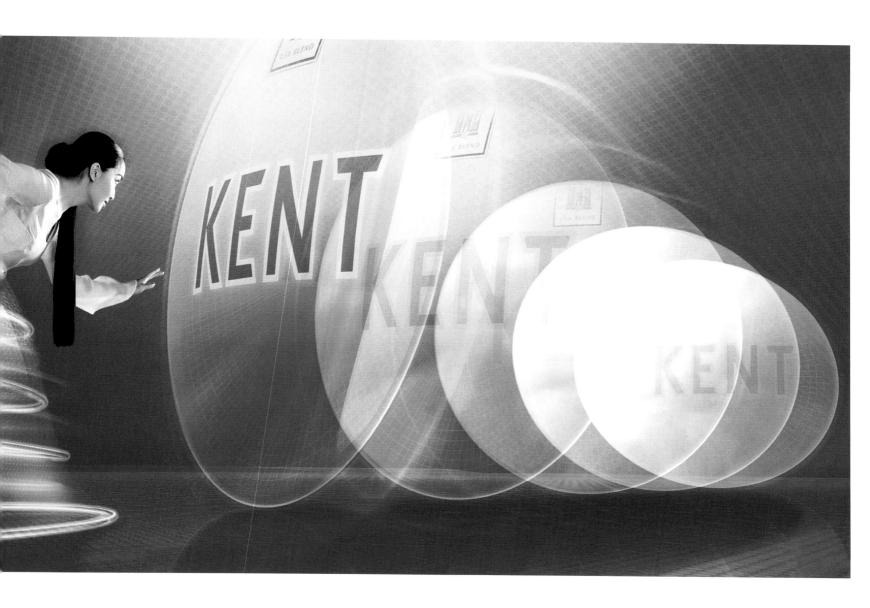

EWA-MARI JOHANSSON

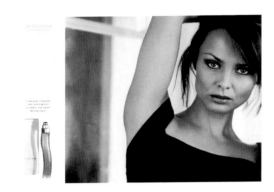

CLIENT: ORIFLAME COSMETICS AB
AGENCY: IN HOUSE
ART DIRECTOR: CHRISTEL BERGMANIS
COPYWRITER: ORIFLAME IN HOUSE
DATE: 2003
GENERAL USAGE: WORLDWIDE ADVERTISING,
FOCUS IN EASTERN EUROPE

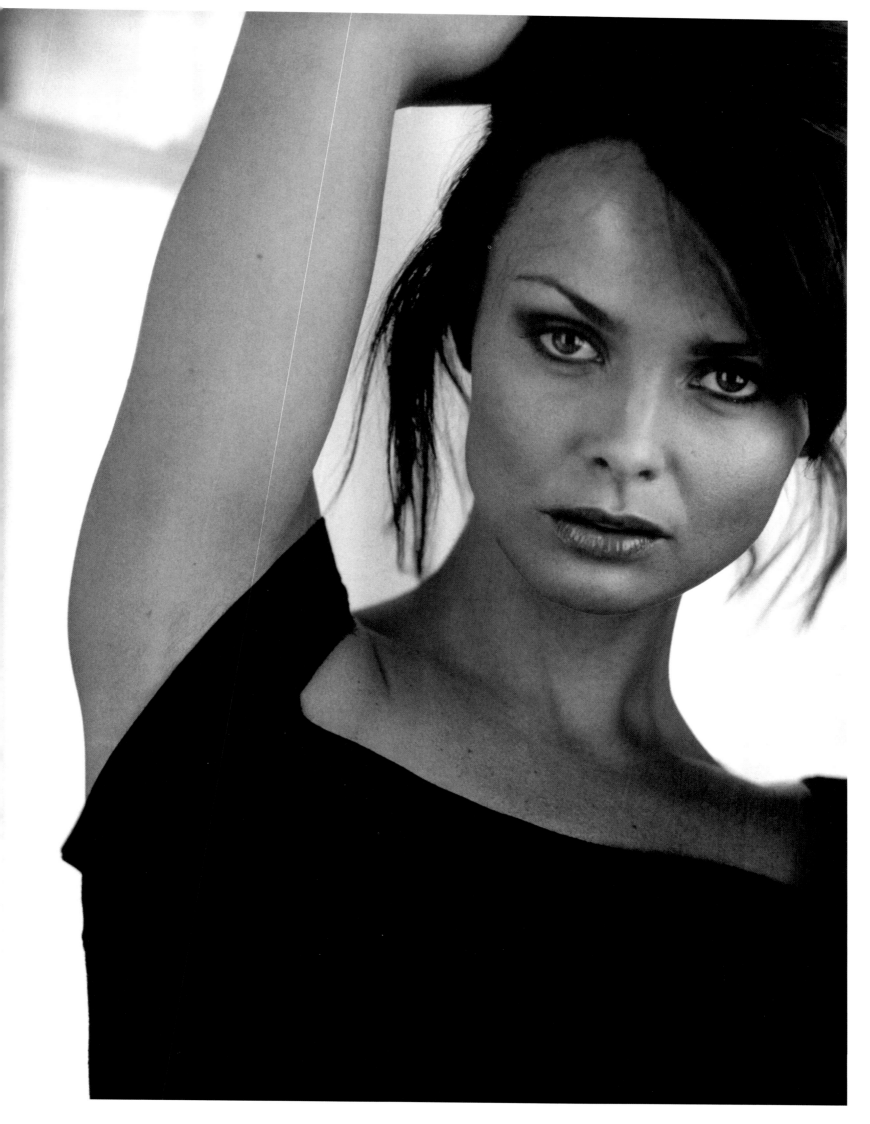

FRANCOIS GILLET

7mg TAR 0·7mg NICOTINE
SMOKING KILLS
Health Department Chief Medical Officers

CLIENT: GALLAHER SILK CUT
AGENCY: SAATCHI&SAATCHI-LONDON
ART DIRECTOR: CARLOS
COPYWRITER: KEITH BICKEL
DATE: 2002
GENERAL USAGE: PRESS/POSTER UK

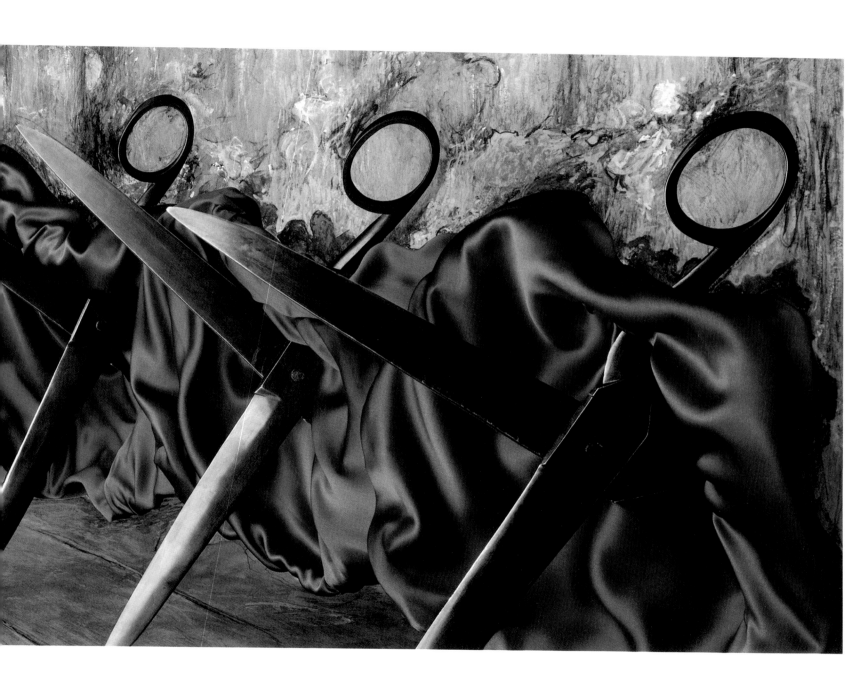

ART BUYER AT MCCANN-ERICKSSON

PEER

ANDREA

— How many art buyers does McCann-Ericksson have?

— How would you define the title art buyer today?

— As I can understand an art producer has to get involved at a very early stage of the project. An art producer can be the art director's best friend but also his worst enemy.

— But that must be hard trying to please everyone?

— Being in that position, being in the middle of everything and keeping everybody happy and making sure that the things that needs to be done gets done and keeping the budget etc. How do you go about that?

— How long have you been an art producer?

— What to you love about it?

— How many art directors do you work with?

— I guess a total of 10 people in the department. Not all of us are art buyers, two stock photo buyers and then it will be 8 art buyers, senior and junior art buyers.

— Three years ago, we changed the title from art buyer to art producer here at McCann. If I explain the reason why we switched it then maybe it will explain why it was the way it was before. I think why most of us are switching the title is because we feel that we are producers. We are not buying existing artwork. We are helping to create new artwork. And producing, working with the art director and working with photographer and with the photographer's producer. To produce something that doesn't exist already. We like to compare ourselves to broadcast producers here at the agency. I feel that we do the same sort of thing except that instead of working with art directors and production companies, we are working with photographers, illustrators, models and production companies that are producing prints. So we get involved in the very beginning when an idea or a concept has been approved by the client. We take a look at the layouts or the brief and then work with the art directors to think about whom will be the best photographer for the project. We talk about the project obviously, just a lot of dialog about how it should feel like, what it should look like and what the story should be or not be.

— You've got a lot of people you want to please. You have the art director who wants to have something and you have the client who maybe wants something else. Sometimes the two of them don't always match. And most of the times you have the photographer who wants to get something which again might not necessarily be what the other two wants. I think our position is challenging, I think the art producers want to get something for everybody, want to try to make and keep everybody happy. Whereas the art producer himself never thinks about what he or she wants. But I like to try to get something for everybody. But the first thing is to try to get what the client wants because the client is paying the bill in the end. We can't walk away from a shoot without accomplishing that. And then you want to get what the art director wants because he is going to put it in his portfolio and the photographer. And ultimately hope that what you are getting is all wonderful stuff.

— I think you have to work with really good people. If you work with a really great professional photographer most of the time you can accomplish it. Unless the client is really unreasonable. Things come up at the shoot, that were not really necessary. A lot of times we are able to do it. I think everybody needs to be flexible.

— I think that's when your experience comes in, having gone on photo shoots, which we do, which I think is very important.

— About 22 years. I sort of fell into it and I really loved it.

— I love working with all the people that I work with. I don't know if I could work with art directors full time, I don't think I would love it as much. Also I don't know if I would be happy working with the account manager all the time or the client all the time. It's never the same and that's what I love about it. And that you work with so many different people who have, not just different personalitie but a lot of people bringing different aspects of the job. It keeps it fresh. Every job is different, every client is different and that is all very challenging. It keeps it interesting.

— It's probably over 200 art directors that work here. I probably know most of them and I have had some sort of contact with them.

— How do you team up with them?

— Art directors are assigned to certain businesses so they create advertising for those businesses. What we do here in this department, we divide the businesses among the art buyers. We try to hook the art buyers up with the art producers to an account where we maximize their particular strength. We try to link up the accounts. Not so much the people working on the account but the account itself with the individual art producers and then whichever art director that is working on that business at the time because that changes.

— You don't work with the same clients then?

— I think it's best not to work with the same people over and over again. I mean you are involved in a production if location is involved and casting is involved. You spend up to two months working with the same people and it is pretty intense. By the time it is all over you are happy to move on to something else which could be completely different. It keeps you fresh.

— Is it possible to pinpoint what is the essence of your work?

— I think I like most of it. I definitely enjoy working with a variety of people. Not working with any one group of people constantly. I like working with the people in the agency but I also enjoy working with the rest. I enjoy working with photographers; I enjoy working with illustrators. It's great because it is constantly interesting, challenging and new and fresh. I get bored very easily so for me this is perfect.

I don't like some of the restrictions the client place on us. Some of them are financial restrictions. Clients are people that don't necessarily see the world visually or in a two dimensional way. When we are involved producing and creating, they bring their ideas to the table. Well, sometimes that can be very frustrating. They see it very differently and they think about it very differently. You want to do the very, very best, you want to do such wonderful work and it is not that they don't appreciate it's just a difference between someone going to work in a suit and one coming to work in jeans and a baseball cap. It is very different worlds and these two worlds are meeting and you try to accomplish something. So of course there is compromising involved. The result is not always the way you had wanted to see it.

— You get to see a lot of portfolios. Does it often happen that you see new, fresh things that you haven't seen before?

— It happens all the time. When I started working you didn't see that at all. We weren't global. We were working in New York there were no fax machines and there were no computers. There were no European agents here in New York and even if you were to have met somebody from Europe it would be very difficult to work with a photographer from Europe or even a photographer from Los Angeles if you were in a New York advertising agency because in order to get the layout to that photographer you had to put it in the mail. It took three days to get the layout out there and then you had a conversation and then it took another three or four days to get the estimate back so you didn't do it. We worked with a handful photographers. We were familiar with all the New York photographers. Today of course we are working with photographers from all over the world and seeing work from photographers from all over the world. It is not a limitation anymore. Geography is no longer something that is a problem.

— Everything today is global but if you look a bit ahead how do you think your position will change?

— I don't think it will never go back being local. I think it's going to be very global. I don't know what kind of restrictions it will be besides finanical restrictions. People will always like to work with new people a.s.o. I think it is wonderful that you can work with so many different kinds of people. And really try to find the right person for the right job. If we are doing our jobs properly, we are matching people. We are like a dating service.

FREDRIK LIEBERATH

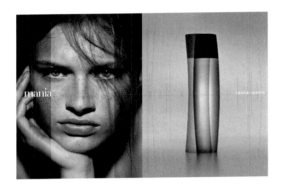

CLIENT:ARMANI
AGENCY: BARON&BARON
ART DIRECTOR: MALIN ERICSON
CREATIVE DIRECTOR: FABIAN BARON
DATE: 1999
GENERAL USAGE: WORLDWIDE

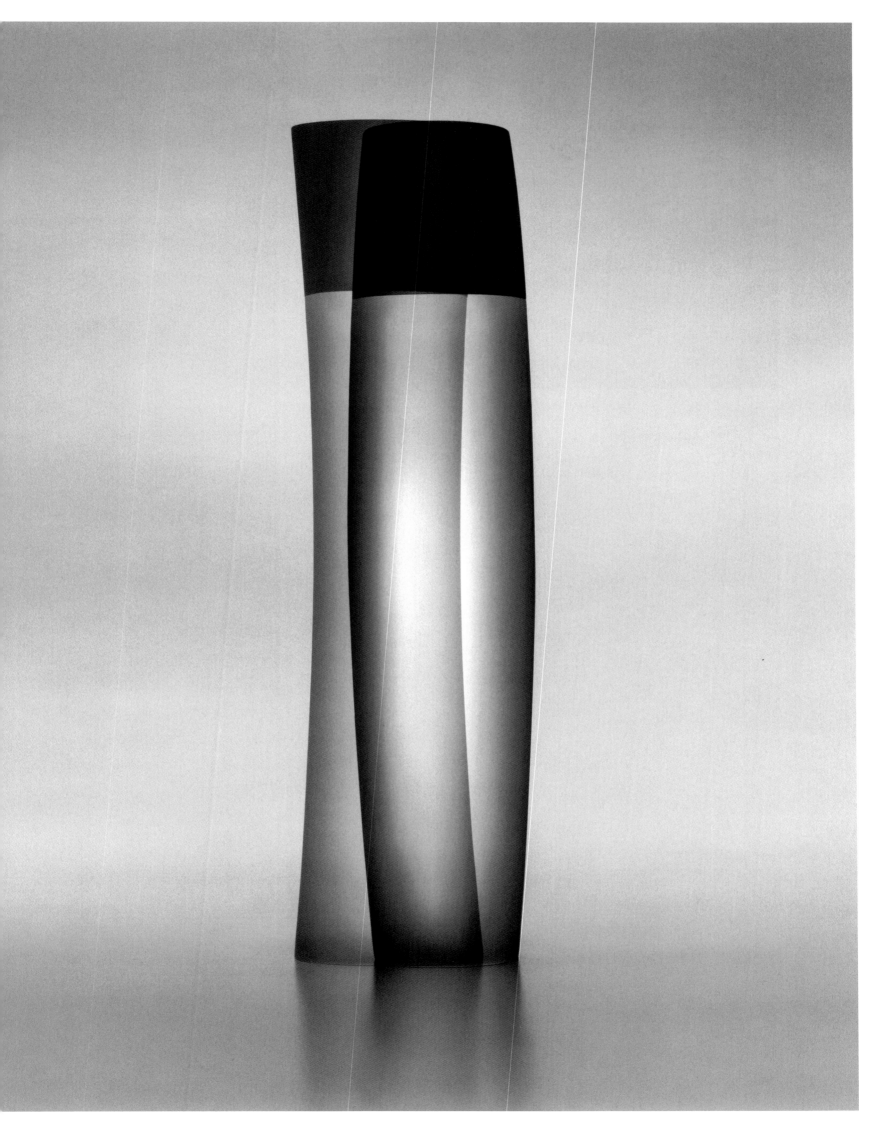

GERED MANKOWITZ

CLIENT: TELFAST MOBILE PHONE
AGENCY: M-LONDON LIMITED
ART DIRECTOR: MARK ROBINSON
DATE: 2002

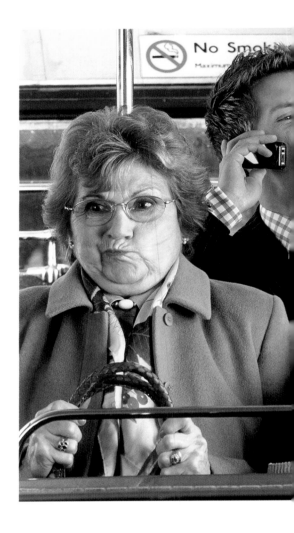

GILES REVELL

CLIENT: SONY CD WALKMAN
AGENCY: BMP DDB LONDON
ART DIRECTOR: NICK ALLSOP
MARK REDDY (HEAD OF ART)
DATE: NOVEMBER 1999
GENERAL USAGE: PRESS & POSTER,
ONE YEAR, UK

NIKK
KON
AMANDON
ICO

ART DIRECTOR

PEER

NIKKO

— Pictures have always been commissioned. If you look at the Sixtine Chapel or Rembrandt's 'The Night Watcher', they were also commissioned. Although at the time, the commissioners were mainly the Church or wealthy sponsors. When you commission pictures, what drives you?

— As an art director, you get a commission and create an idea from the customer's brief. You create a visual communication. How have you changed during the yeas since you started working?

— How do you know when what you see is right? Do you go by the book or does it require more intuition?

— You say you work in teams and every part is equally important. Is it difficult to be so many in the team and not have a leader?

— Sometimes I have experienced a problem: you shouldn't have a picture as guideline as a model, but an idea or a feeling you want to communicate: Which means you don't have anything to show the customer. But they nonetheless demand that you show something in advance of the photo shoot.

— So you mean you need a lot of artistic freedom? But is that enough?

— So you mean you need lots of trust?

— If you look back over twenty or thirty years in fashion, is it with trust and integrity that photographers build client confidence? Has anything changed in recent years, do you think?

— Do you mean that the customer hires you because you have a good track record? And because you have been able to interpret fashions many changes, you are regarded as trustworthy? When you choose a photographer, what are the most important thing?

— The trickiest part of my job is the choice of photographer. When you look through a photographer's portfolio you really do not know who's behind the pictures. The client? The stylist? Or the creative director??? You really need to look in the photographer's hidden drawers to know... Hm...
I wonder how many paintings and sculptures the Holy Church confiscated and destroyed forever. What we see today is a tiny part of our history.

— I haven't. I have always wanted to do sexy pictures. I'm a sexomaniac! And I adore pictures shot by Jürgen Teller, Terry Richardson, Ellen von Unwert in the early 90's. I think these guys are more than just photographers, they are great communicators. Fashion is all about sex.

— It's when the mood is high, the boom box plays heavy metal, the girls are gorgeous, the boys bombastic. And the photographer is happy as a bird. The client is smiling... that's my intuition.

— The leader is me... he, he...! I choose the photographer and the girls (it is always a fight between me and the photographer). I choose the location, ideas and then the show starts...

— We normally create an inspiration board to explain the feeling. That's all. This gives us a lot of space and freedom.

— Of course, you must as a creative director know the product, the target group, the brand values etc, etc.

— Without trust you are fucked up!

— It is all about the clients "DNA". When I worked for a Swedish client, which had a lot of "gullegull" (sweetness) we tried to do it more edgy and that was really hard v-e-r-y hard. Because you can't change the attitude of the owner, and when you can't, well, you just have to give up. We did some gorgeous campaigns with a young Mikael Jansson that we had to hide because it was too much for the client. It wasn't about sexy pics, but the photography was a kind of young Avedon look but with lots of humour and attitude... so at your question if anything has changed my answer is NO!

— That's the word " trustworthy"... You know what the most important thing is? Money, money, money! I would just die to work together with Meisel, Teller, Testino, Weber... but my God, they cost a fortune... and I would die to work with my favourite girl... Kate Moss. I love her; she is the greatest of them all. You see it is all about money. Apart from that, when I choose a photographer I already know what I want because the idea and the way I want the image is there in my head!

— So what you mean is that the picture is more interesting than the photography?

— A strong picture remains in you brain for a long time. You know the terrible picture shot by Robert Kappa, that's a God damn snap shot. You won't forget that. Talking about fashion I had my brain orgy when I saw a picture for Katherine Hamnet 10 years ago. A guy sitting in a sofa with a girl on his lap, her legs spread, showing her underwear and her pussy hair! Jesus, what a client! Because the first thing you do is to retouch away all that sexy stuff. That picture was in its total innocence so erotic; it was like being hit by Mohammed Ali. And, you know what, that was my future love story... Terry Richardson.

— So what you're saying is that each job, each customer and each product needs its own type of photographer since each has a different way of working. How do you choose them? By track record or do you go after a certain feeling? How do you find the right photographer?

— Looking in magazines, that's for me the only way of choosing photographer. I have done that with David Sim's for Levi's. Carter Smith for Levi's and Sisley... Terry Richardson, Alexei Hay, Matthias Vriens...

You know what I hate? Smart advertising agencies who choose edgy fashion photographers to show their clients how hype they are. I've seen famous photographers, which I admire suddenly pop out in an unrecognisable advertising campaign. When I choose a photographer I respect his personal style and that style should also be recognized in a future fashion campaign for my client.

— For Sisley you worked with different photographers didn't you?

— Yeah I did... You know that! I will take the opportunity to thank the most brilliant guy I have ever met and worked together with and that is Magnus Skogsberg. A great friend (he loves to talk about sex exactly like me) a brilliant director, a stylist and a devoted working machine. Let me think. We did a great job on the island of Capri with Guido Hildebrand, which was in 1989. I remember that because my daughter was 1 year old. It was a great Italian story. We had our base in the countryside staying with an Italian family. They helped us with everything including cooking. Fresh buffalo mozzarellas, braised lamb, fresh pizzas from their own wood oven, it was paradise. In our group we had a good looking American male model, one day when we were all having lunch the male model had one of the Italian sisters on his right (she was in her late 70ies and in love with our young male model). Suddenly the model declares... there is somebody on my dick. The old lady just smiled her tooth less smile and her eyes twinkled. Sweet.

Another amazing story was New York shot by Micke Jansson. We did several campaigns together with Magnus Reed; Cuba, Berlin etc. We did a sexy campaign in Venice shot with a straight guy and a gay guy dressed like a woman the entire shoot. At the end the two models fell in love (for real). That job was shot by an extremely talented woman; Ewa-Marie Rundquist. Carter Smith shot two campaigns and then I met this strange guy Terry who looked like a Yugoslavian plumber.

We started up with two great campaigns for Levi's Europe. I liked him a lot and I remember that my art director Jonas Hjelte for Levi's was completely shocked when he saw his equipment, two small cameras. Nothing more. I was so impressed by the way he worked and the way he was talking with the kids (models) I just said to myself, he is the guy for the next Sisley shoot. And the success story started for him and my client.

— So suddenly, the photographer is not even a supplier. It sounds as if the photographer is an important part of the whole process, not only the shoot but also the rest of the communication process.

— Terry supplies us with much more that just photography. He is a media phenomenon. There is no other fashion brand that has had as much press and TV time as Sisley. We have been contacted by TV channels from all the European countries that want to participate and do a story of the next Sisley shoot. Journalists from the most prestigious news papers like New York Times, The Times, Le Figaro and so on.

ID, Arena, The Face, Elle; France, Italy, Spain, Germany, Vogue etc etc. Jesus Christ, this brand is not Gucci or Dolce Gabbana. With our strategy we have succeeded to put the brand Sisley in the media. When the media talks about sexy fashion ads they mention Gucci, YSL and Sisley. And that's my satisfaction.

Terry is the rock star of the new trashy, glamo, snappy shooters. The journalists love him. He is "shy"... and when a female journalist asked him what is the secret behind his pictures, he answered with a timid voice "i fuck them all before we start to shoot"...
(big smile)

— I can see a parallel between what you say and when we talked about the artist and the commissioned pictures. Art has always been a way of breaking of new ground and generated debate about sex and violence, etc. Has advertising started to play this role in the information society? To be a kind of groundbreaker?

— I really do not believe that, in general advertising it is all about flirting with your public. An artist does not flirt with his public! He wants them to be upset, to react, etc etc. An artist has no client so it is much easier for him to generate reactions. You do not get an emotional reaction or debate with a Volvo ad or a mobile phone ad, do you?

In my opinion the only two brands that have had a global reaction in terms of violence and sex is Oliviero Toscani's campaigns for Benetton and Terry's pictures for Sisley. And both of these brands are owned by Mr. Luciano Benetton and he is the real genius. You know what Mies van Rohe said – "There are no great designers, only great clients". This is damn right true.

— I think it is quite remarkable the way that commissioned pictures have been published in newspapers, but many of them can also be in exhibition. You are yourself going to have an exhibition with Terry Richardson's pictures.

— Of course! The massive reaction we have had with Terry's pics need a great exhibition. This also gives us the possibility to show pictures shot during the campaign shoots but never published before. The first one we had was in Florence. A huge space in an old abandoned railway station. We showed about 100 pictures. The largest print was 400x500 cm. Fantastic. Then we had one in Berlin at Kunst Werke (Museum for Modern Art). A great Opening. We had six TV stations that did stories with Terry. Cool!

— Do you think you can draw a line between traditional art and media art?

— Today NO! There are no more boarders between art and media art.

— Modern media communication as it looks today and the art market seems to be merging into one. The role that religious art (like the Sistine chapel) played when it was painted was a kind of communication or the society, just the way that Sisley and Terry Richardson communicate to the world and the fashion market of today. Maybe what's happening is that they play the same role but just in a different way and in a different era.

— Of course! Man has always wanted to communicate. From the Flintstone era until today. Drawings, paintings, buildings, war, the way people dress, films, books, religion, music. And you know that the way people dress is an important part of us, it tells who we really are (or who we want to be). Naked we are all more or less the same. What is the difference between Leonardo's painting and Aeon's pictures of Andy Warhol and the members of The Factory? I think they are both masterpieces of an era. Can you explain why Leonardo was painting out of focus? Who is the innocent girl sitting on Jesus' right side in the last supper? Why does Mona Lisa smile? Still today we do not know. This is the secret of good communication.

— If you look at religious pictures which were painted over because they were too violent or sexy, don't you think it's because the paintings that were in churches awoke the same outrage as many advertising pictures do today?

— Yeah... and don't forget that the old masters had another "secret weapon", and that is the symbols they were playing around with in the paintings. I love that.

— If we draw some parallels, trendsetters of today play a very important role in young peoples' lives. Fashion magazines are more important to them than churches, and that's why pictures and the way the fashion world tells stories have even greater importance than religious art.

— MTV has taken over, that's for sure. They do not follow the trends in fashion magazines. Kids are glued to the TV screen and they know exactly how to be and dress to be cool. And they get new stories every day; it's not easy to be a kid today...

— How do you develop a concept like Sisley's?

— The first pictures we did in LA with Terry were a kind of guideline, a kind of fashion documentary snap shots. I knew this was not a Levi's shoot so I pushed him to go further. We had our first kissing girls and it was really hot. Our client was amazed because the three-day shoot was so erotic... Love you, Paola.

— I think Sisley dares to show something genuine. Reality isn't always so politically correct. They are documentary, but at the same time playful. The problem I think is that as soon as you want to show reality, people look at it as a caricature of reality. Lots of things in advertising appear cynical or ironic. How do you safeguard and develop a brand's personality and inner values?

— Another component that you see clearly in religious paintings and even in modern advertising is story telling. When you look at an altar painting for example, a story is always being told. How have you developed story telling with Sisley.

— You are right! Sisley is one of the few brands that dare to show a kind of reality and transmit the real feeling of the three days of shooting. I personally hate the stereotype female and male models in the high fashion label ads including all make-up ads, brrr, horrible stuff.

People are so used to see unreal images, glamorous dead eyed women looking at you saying absolutely nothing. My communication is far away from all that rubbish. I love the documentary style and the response from the consumers confirms that they like it too. I know thought that people in the fashion business just hate this kind of pictures. Sisley pictures are like Satan creeping into people's fantasies, waking them up. Wake up! React! Do something! Naughty pics! Whooa! Reaction is what I love most!

— We do not stand in a studio, that's for sure and there is always a theme I want to do. A story I want to tell. The next trip is to Las Vegas, with big pastel coloured poodles, Elvis look-a-likes, gorgeous girls, lot's of glitter, lot's of tits and fun... Viva Las Vegas!

GRAHAM WESTMORELAND

CLIENT: CHRYSLER CARS/PT CRUISER
AGENCY: PENTMARK, DETROIT
ART DIRECTOR: JOHN SCULLY
DATE: JUNE 2001
GENERAL USAGE: MAGAZINES, NORTH
AMERICA

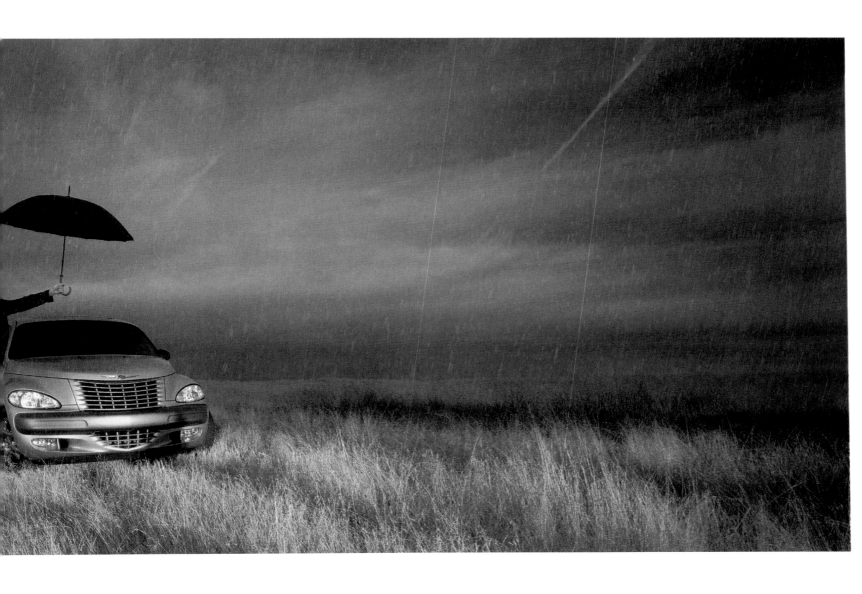

HENRIK KNUDSEN

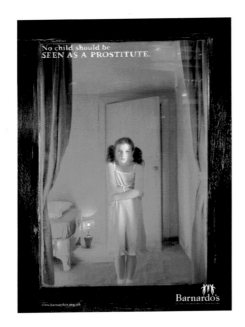

CLIENT: BARNADOS
AGENCY: BBH
ART DIRECTOR: ADRIAN ROSSI
COPYWRITER: ALEX GRIEVE
DATE: AUGUST 2002.
CAMPAIGN: END 2002
GENERAL USAGE: UK POSTER
(SPECIFICALLY LIFE SIZE)

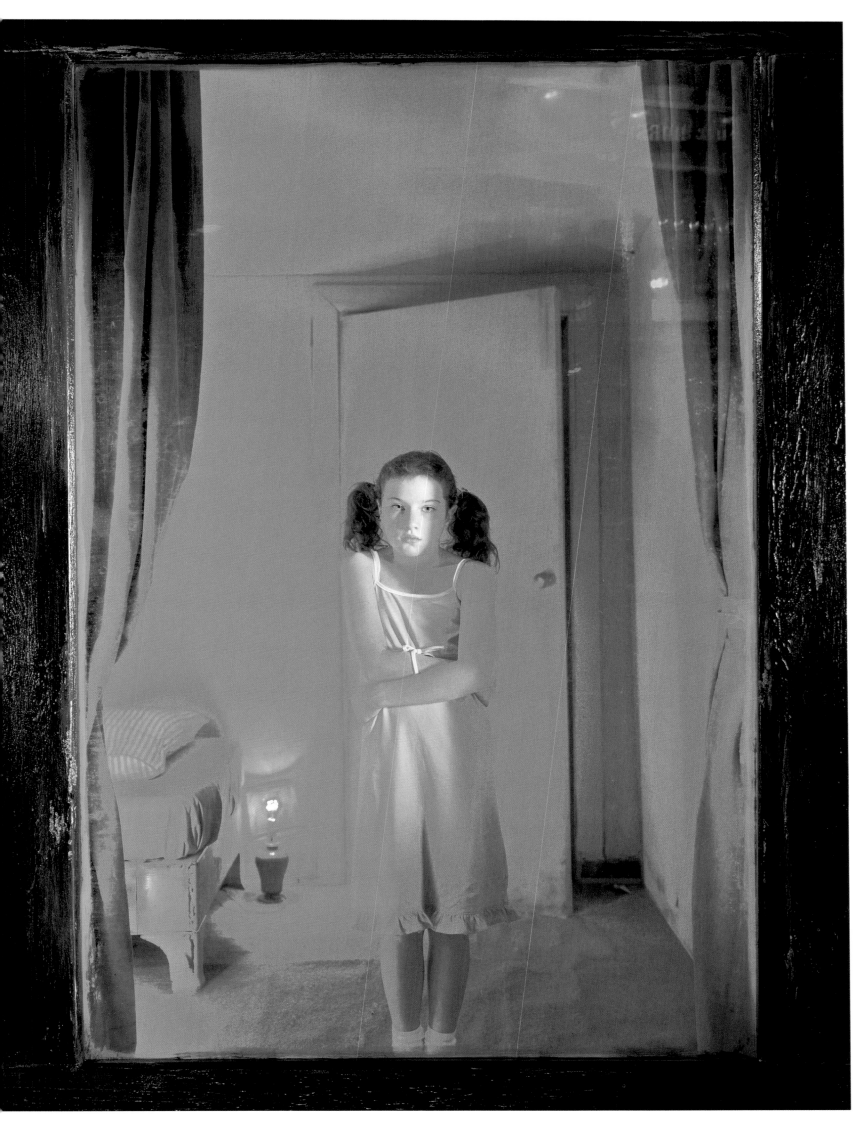

JAN BENGTSSON

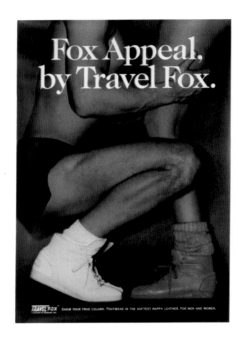

CLIENT: TRAVEL FOX
AGENCY: HALL&CEDERQVIST/NY
ART DIRECTOR: LARS HALL
COPYWRITER: HANS VON SYDOW
DATE: 1989
GENERAL USAGE: U.S.

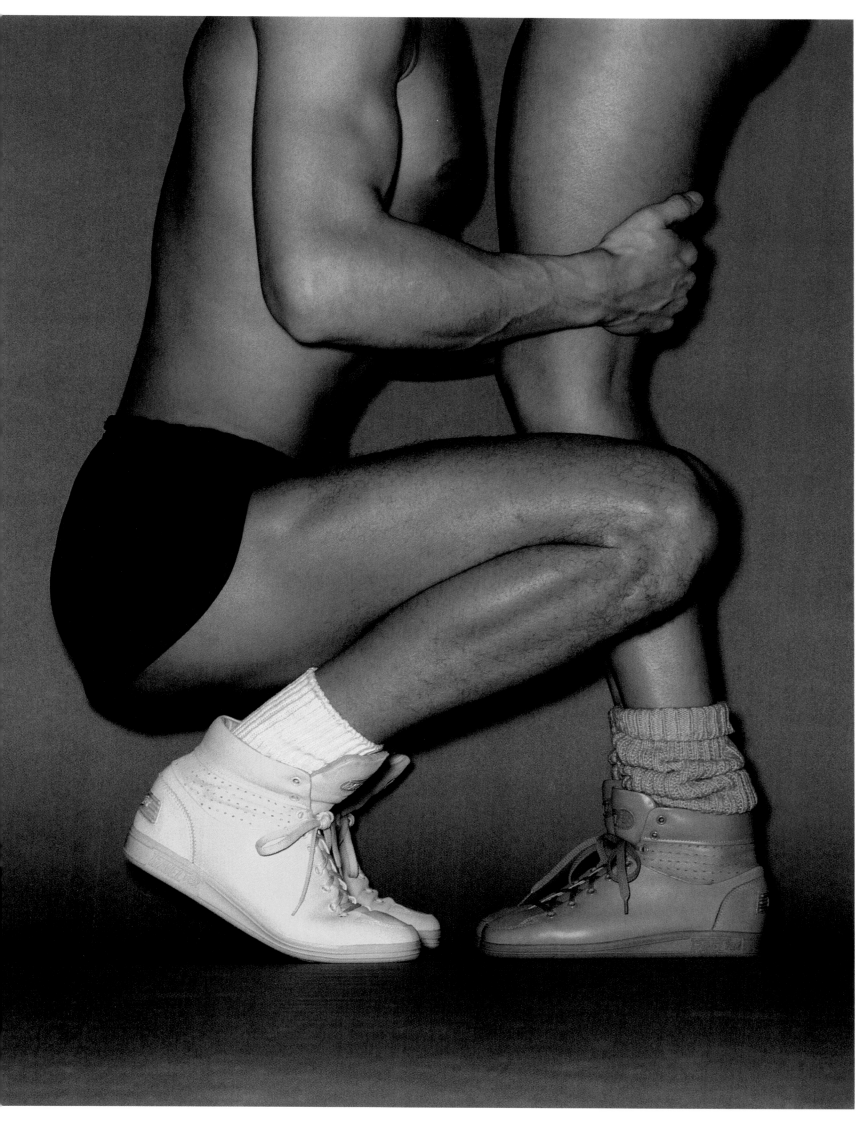

JEANLOUP SIEFF

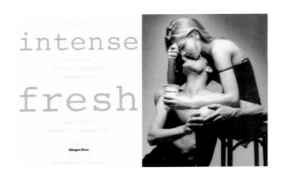

CLIENT: HAAGAN DAZS
AGENCY: BBH, LONDON
ART DIRECTOR: RONNIE CURUTHERS
COPYWRITER: LARRY BARKER
DATE: EARLY 90'S
GENERAL USAGE: PRESS, POSTER, POS,
BILLBOARD, ALL PRESS MEDIA (UK),
FURTHER EUROPEAN USAGE.

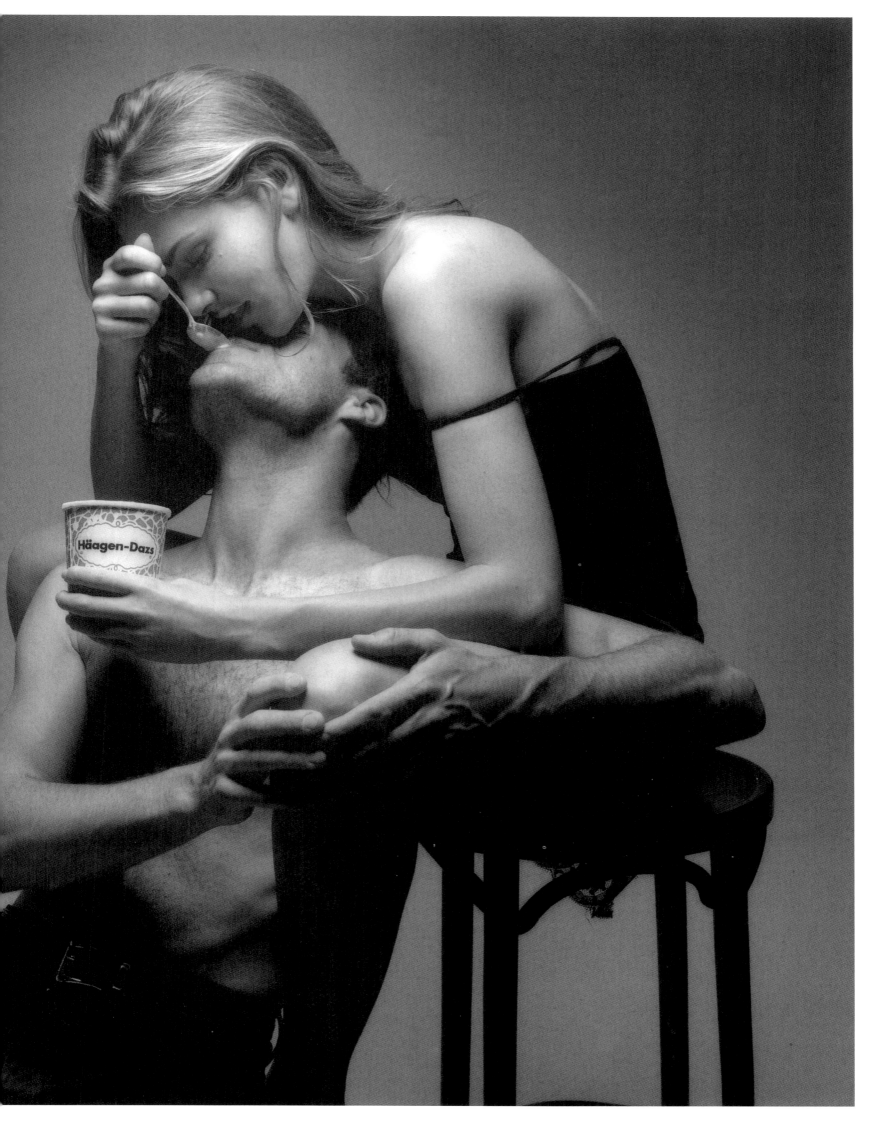

JIM FISCUS

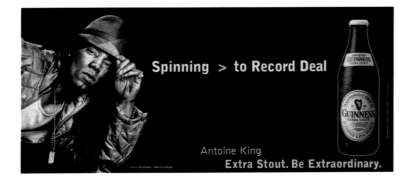

CLIENT: GUINESS
AGENCY: MANHATTAN MARKETING
ENSAMBLE (USA)
ART DIRECTOR: BRETT WINGATE
DATE: MARCH 2004
GENERAL USAGE: BILLBOARD

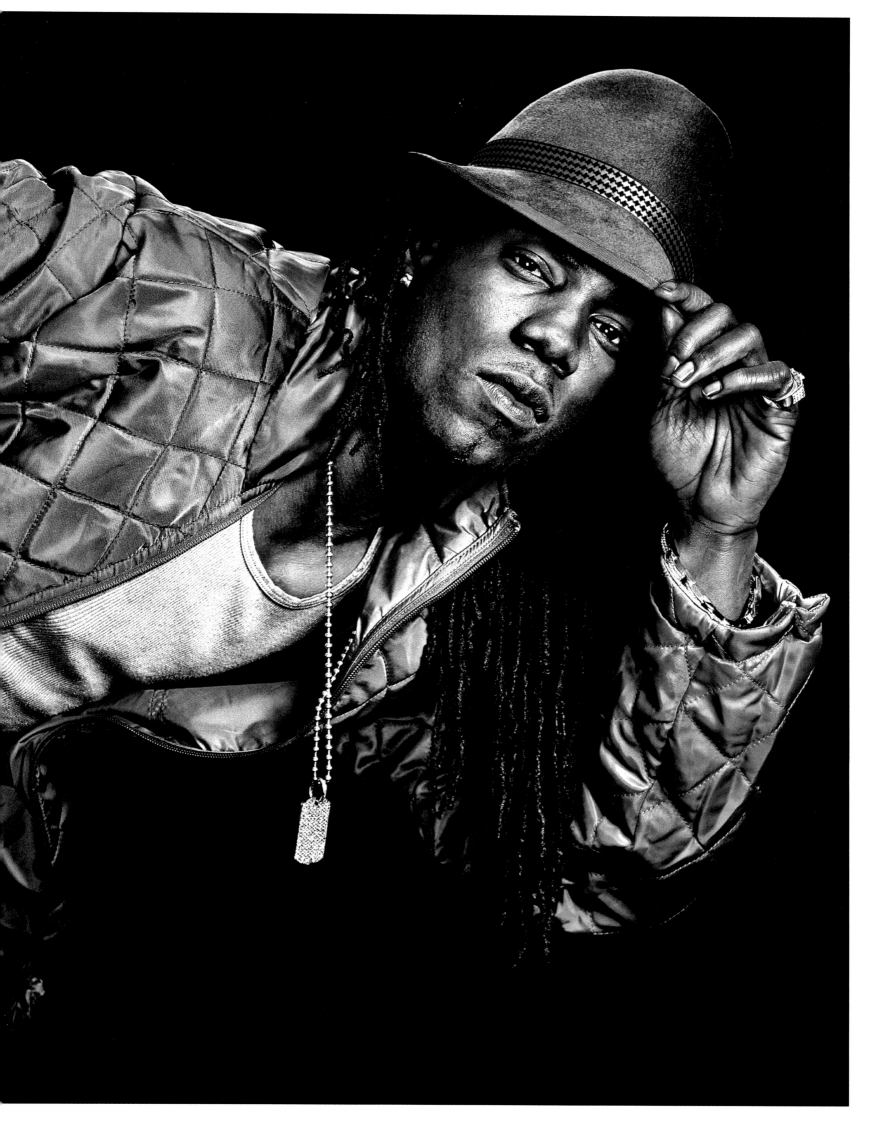

JEN NY VAN SO MM ERS

PHOTOGRAPHER

PEER

— How did you first decide you wanted to become a photographer?

— To get into a business whether it's photography or advertising, to find good collaborators – how did you find yours?

— Collaboration has to do with chemistry I guess. Is there something specific you look for?

— Art directors, agencies or clients when they approach you, what are they looking for?

— So the technical part with cameras and lighting it's not that important after all?

— Do you use the computer as well?

JENNY

— I have always loved art and been technically inclined.

— I remember having a conversation with a photographer friend of mine years ago at art school. And he said that his philosophy was no job too big, no job too small. I said that my philosophy was only to shoot jobs that I found interesting. Getting into photography you just have to choose between those two ways of doing it. The first way you move along much faster in the beginning, but the second way you have a much more interesting career. People are saying, is not what you know, is whom you know but I think that's nonsense because when I arrived in London I didn't know anyone. I had one friend of a friend to call on.

— I think you can fight with somebody and still come up with something really great. It depends whether your creativity fits together. Generally, I never had to fight with anyone. I find most art directors very agreeable. People come to you with a project, knowing what you do. That's a big help because they already want to work in your style.

— My look, if you like, is very plain, very minimalist, very simple. It was a reaction to advertising that was, very slick, very technical, involved hundreds of lights.

Seven years ago when I arrived in London, there was a feeling that everything should be torn down and reduced. Advertising had this reputation that we have to get a thousand of the most perfect flowers and photograph only one of them. Finding the absolute perfect specimen of every single thing in the photograph. I was much more interested of getting the plainest, most boring specimen of anything that had to be in the photograph and putting it in there. The photograph would be the sum of the total of all these boring things. I suppose I'm still pretty into that.

— Well, apart from having to light the background separately, and maybe a car takes a couple of light sources. Most things I shoot would be with one or maybe two lights. I've been in one of those big studio complexes and I have looked in and I have seen they have had 20 lights around the subject, and they have had little pieces of mirrors and all kinds of stuff. I've always thought "Oh my God, what am I doing? I must be doing something horribly wrong", because I've got only one light.

I actually had one client last year, after we did the shoot and he liked the polaroid. We shot it. And then he said, "Can we have some more light?" And I said, "Yes, of course". So we put every light in the studio onto the object and then we did a polaroid. We laughed a lot.

— Yes, I do but really just to touch things up. I don't use it massively to do really big things. I find it a tiny bit unreliable because you don't know how good your operator is going to be. Some of them are absolutely brilliant and someone's not. It depends on what your client can afford in terms of operators as well. I tend to prefer to be prepared on the other end. I'm a very big fan of model making. If it's ever a choice between doing something with computer afterwards or building it, then I always go for model making it. Because it's

an extraordinarily process, it's incredible what they can achieve. I am always much more amazed by that, then I am of what a computer can do. The only time I find it really useful is when it's kind of pretty much impossible to make it in a model making process. For example, in one of the pictures we did a glass table. We could only afford one glass table. So we shot that perfectly. We got 20 pieces of glasses that were identical and smashed them all and put it in position and shot it again and then we just put it in the computer. It was a very, very simple thing to do in a computer and I find that the simpler the computer things are, the better.

— Again the most important thing is the communication, what you say with the picture, than the technique itself?

— Yes, I think it's important not to patronize the viewer. If you are creating something real then they can see that. When you create too much of it in the computer, people can tell that almost immediately. It's not just professionals who can tell, every single person on the planet can tell.

— Today everything is possible. If you take a movie like the Matrix for example, you see that everything is "possible". When people see it they probably think it's fixed in one or other way.

— Yes. There is two things happening in the Matrix, one is CGI, which I personally hate because it's got a long way to go in my opinion. CGI is when they produce the creatures and the cities completely in the computer. They used a lot in the last Star Wars. The only part of Star Wars, which look real, is when they are in Chinesiro. They are using the old buildings built out from mud. Then you actually feel like you are there. It's the same with Matrix, the only interesting effect where you really go "Wow", is the one, which is created with the bank of cameras. You know this effect, when they have a hundred cameras in a circle all taking the photograph in the center. That's a mechanical process that they are going through and it has a big wow-effect. When they have 20 people made on the computer, its completely banal and I think the same thing goes for photography. The more work you put into it, to making something real at the front-end, you are going to get a much more wow-result. You know the hours I've spent with people sitting with a computer, trying to coax something realistic of it, it can be very frustrating.

— I think there are no boundaries technique-wise, I mean today you can do almost everything in a computer. But your own work, does it have boundaries because you work in different projects on the commercial side, but you also work on your own projects. What are your own projects?

— That's what I've been calling my artproject. Basically, I produced it twice. The first lot, I produced and I had sitting in my studio until I decided that I didn't like it. It was not interesting. And now I have produced a second project. Basically, it's a little bit like a technical lighting, series of exercises, if you like, played out on a series of very, very simple sculptures. They are not even sculptures, they are paper sets.

I started off using a setbuilder but recently I just have been building it myself. It is basically just planes and shapes put together. I also have shot architectural models. Generally, when you get an architectural model, you get the main building that they are building in full detail with the glass and everything. Around it you get these blocks and they are very abstract. It is very interesting. It looks like a cross between minimum sculptor and lighting exercises.

— Are those images also in your portfolio?

— No.

— There has always been a cooperation between art and advertising.

— I personally think it's dangerous to take something that an artist has done as a video installation and use it directly to sell products. I think that we are running into fairly murky territory with that kind of activity. But I do think that if you are looking for an idea for a campaign and you got a piece of blank paper in front of you, walking around a gallery for an hour, it's probably just a process of getting your brain moving. Being stimulated and inspired. I do think there is a difference between taking somebody's work, direct copying it and walking around having your own ideas.

— Could that happened with your own work. If you nave it in your portfolio and an agency will see it. Would you say that if somebody wanted to use it? Would you do that?

— Yes, of course.

— You see something that somebody else doesn't see or understand or have come up themselves. And when you show that it's like a kick-off for that person.

— The most important thing for a commercial photographer is to keep exploring their own creativity, completely outside of the commercial scene it's like flexing a muscle, it gives you strength. And I think that's an important creative process. When someone presents you with a project, you can apply those ideas or those experiments that you've been doing to their project.

— That's maybe the collaboration we started off talking about?

— I produced that work to essentially feed my own creativity; so you have something to offer. If you just produce ads, then you're essentially just selling the same thing over and over again. And eventually, I felt when I was doing that, I was kind of slowly selling off all the ideas that I'd had. It's very important for my own work that I'll keep moving in new directions.

JENNY VAN SOMMERS

CLIENT: STELLA ARTOIS
AGENCY: LOWE
CREATIVE TEAM: ANDY AMATO & MICK MAHONEY
DATE: 2000
GENERAL USAGE: PRESS U.K.

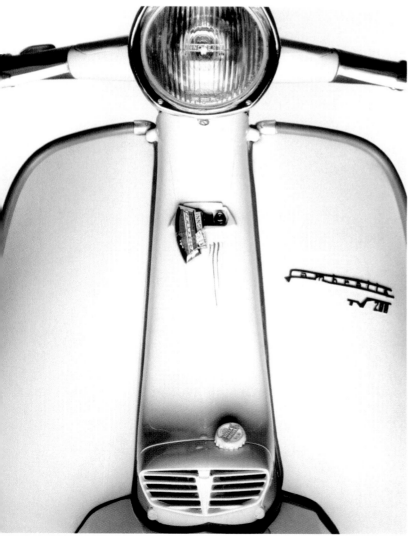

JO CROWTHER

REUTERS

CLIENT: RENTERS WORLDWIDE
AGENCY: BMP DDB LTD, LONDON
ART DIRECTOR: MARK REDDY
DATE: 1998
GENERAL USAGE: PRESS + POSTERS
WORLDWIDE

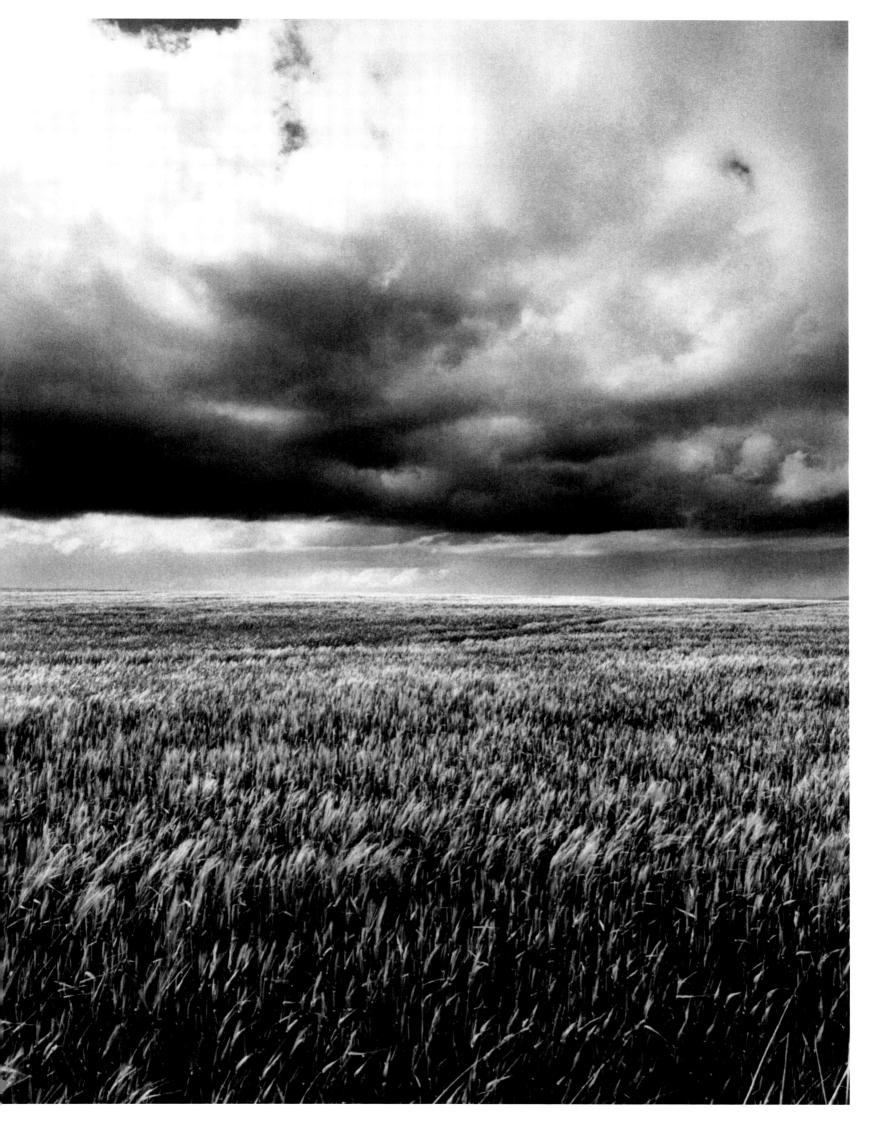

JOHN SCARISBRICK

CLIENT: UNITED BAMBOO – (AMERICAN/
JAPANESE CLOTHMARK)
ART DIRECTOR: THUI THAN
DATE: MAY 2002
GENERAL USAGE: ADVERTISING WORLD-
WIDE

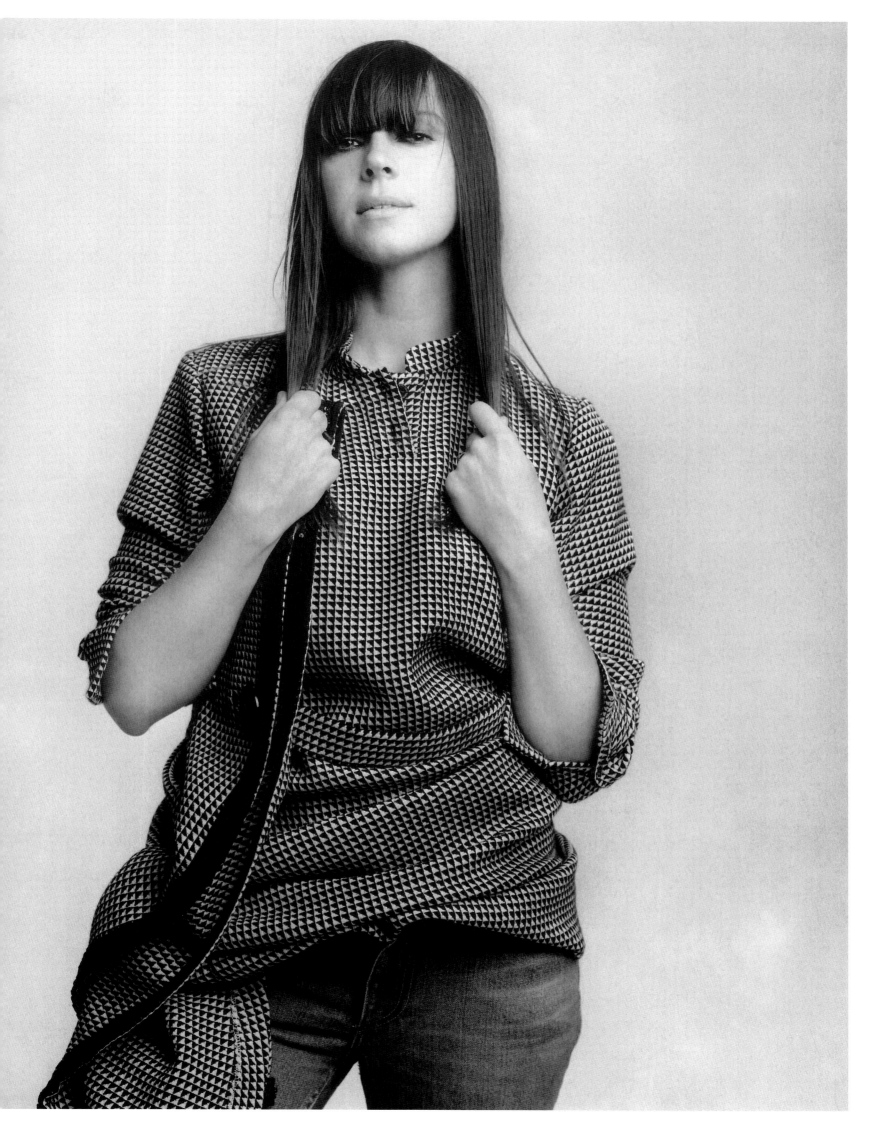

JOHNS WANE ALE

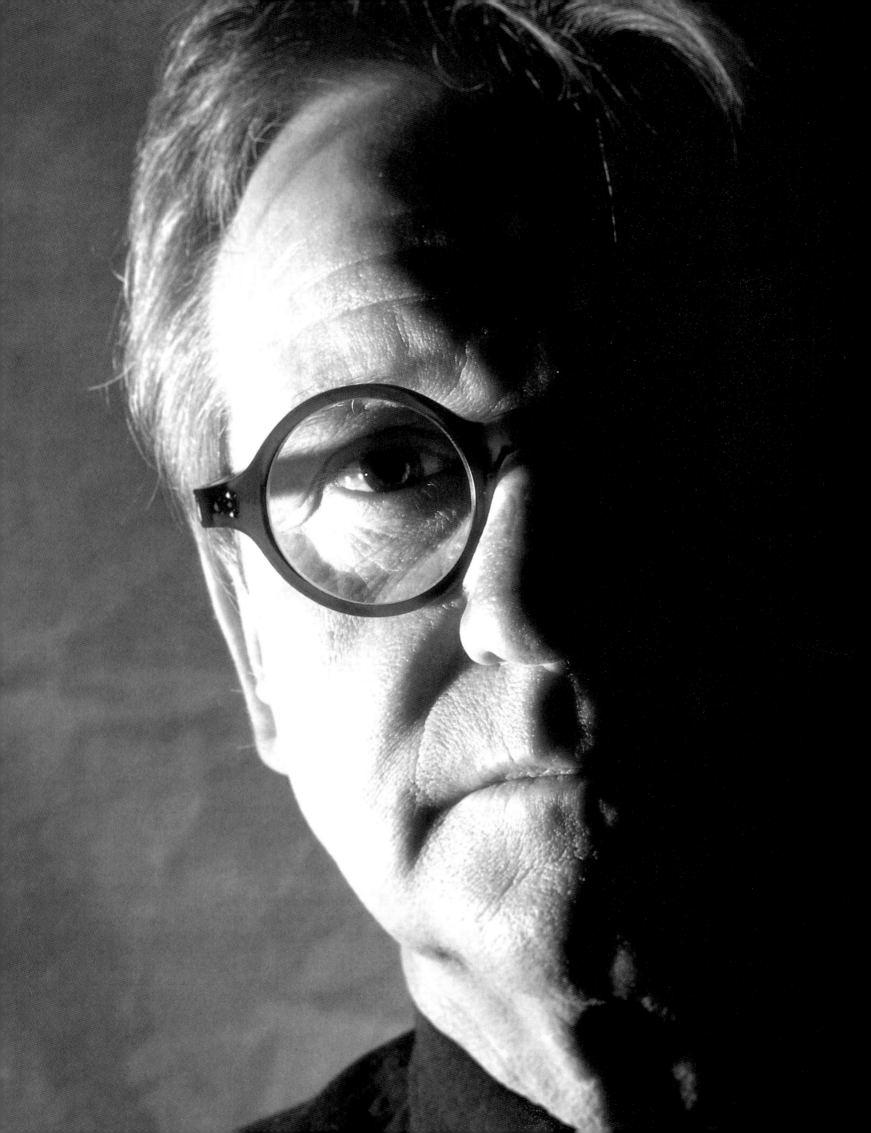

PEER

JOHN

— I'm around 50 years old and I've been in the business for 25 years and I have seen photography come and go, I've seen the trends changing Have you also experienced that?

— Sure, it changes all the time, that's what's good about the business. It keeps everyone on their toes. Irving Penn can probably get away with doing the same pictures for 50 years because they are so good and they have been copied so much.

— I saw a wonderful exhibition by Penn. There was a book called Dancers, it was a fat lady who was completely nude.

— I think that is the way you do books. You take pictures you like, and then you do a few more and suddenly you think, "I've almost got a book here". Then you concentrate on finishing off that book for another year and when that one is finished you look around and find that you have another book of landscapes or a book of nudes.

— Do you feel that your photography has changed over the years?

— Not much, certain things have changed, but I don't think it's drastic. I feel the same things that I felt when I started out. I think the quality is the same.

— How did you start off in photography?

— I worked with Bailey for 4 years, so I just drifted into fashion after that. I worked with a couple of photographers before Bailey at Vogue studios for two years, in the black and white darkrooms and colour processing. I don't think about that time too much, although it was important of course, but I don't look back thinking that that was a special time in my life. It was all pretty boring, but it was a learning process.

— Sometimes it is good to move on and sometimes it is not. Do you feel that you have been forced into doing things that you didin't like?

— Yes sometimes, especially with fashion. There was a trend about eight years ago when Nick Night and other photographers started to use flash up against the wall. All the youngsters thought it looked fantastic, which it did, the way he shot them looked great. But everyone forgot that Helmut Newton was doing that in the 60's and Guy Bourdain did a lot of it too, but some of those kids had never heard of those two photographers. They just thought that Nick Night was inspirational.

For those of us who have been in the business for so long it takes a really good photographer to inspire us, especially now that everything has been done. It is going to be quite difficult to knock me off my feet, because I've seen everything.

— Is there a way out of doing the same thing all over again. Like going in circles? What area would you like to explore?

— If there were I would be exploring them. The only way things will change is if a new piece of equipment comes out. In the 60's it was electronic flash, then people were able to go outside with the handflash, on a beach for example, that was pretty trendy. Ringflash was another one. So it is when a new product comes out on the market, some will be there first, get a contract and get the first fashion spread and everyone will go "Wow that's great!". It's only a new piece of equipment, but that's what changes things.

— Do you think now when a lot of digital photography is being used and in fashion and they are being computer generated images, that that will change the trends?

— Yes, of course, that is what's happening. If you look at all the magazines 20 years ago compared to now, for example the editorial in Vogue 20 years ago was sensational. The photographers were doing great things and the advertising was rubbish. Now the advertising is as good as the editorial. Revlon, Valentino, Karl Lagerfelt etc, they all have the best photographers plus they put it in on the system. They spend £50.000 on system work, but you cannot afford to do that on editorial work. The advertisers can afford to spend any amount they want. I'm thinking about some of the big names like Gucci, they spend a fortune, but then their advertising budget maybe £2 million, so £50.000 for retouching their ads is not very much. But the ads do look great; they get the top models and the best photographers.

— Do you also work digitally?

— Yes, sometimes.

— Is that something you wanted to do or were you inspired by it?

— No. I just drifted into it. You look at your picture and then you look at somebody else's and you think, "Oh, that girl's skin looks wonderful" and you look at your picture and wonder "What's wrong here?" Then you realize they have put it on the system and worked on the skin. Some people do go too far and get carried away with it all.

— Do you think that the demands on the photographer have changed? I mean if the client or the agency or the art director expect more out of the photographer now than before?

— I don't think so. If you have an idea for an image and there is a great way of shooting that image it's about doing the best that you can. I don't think the art directors are pushing any harder, they have always pushed hard.

— The photographer has come to be part of the creative process much more now than before. Do you feel that as well?

— Yes, I think so.

— I feel that I can come with the idea and then the photographer and I team up together. And then you develop the idea together rather than you go to the photographer and say, "I want something like this".

— Yes, if someone comes to me with an idea, I think about it and see how they have visualized it and I can suggest, "Let's go down this avenue. I'll show you a couple of images that I took a few years ago for references". And you show them and they say "That's great but lets push it in this direction". I work like that all the time.

If they have already sold the idea to the client and then they come back to you and ask, "How can we push it?", hopefully you have got the time to do what the client has approved and your own ideas.

— Do you feel that the client is more involved in the job now than before?

— Not particularly. Some clients are very involved and others are happy to have the minutes from the meeting taken down so that everything is recorded and everybody knows what is expected of the shoot.

— Could it be the other way around, that on the meeting the photographer, the agency and the client agree on something and suddenly the client start to change the idea.

— Yes, that happens. Then the photographer and art director need to explain to the client why it shouldn't go in that direction. Sometimes the best thing is to take a couple of Polaroids to show the client why a certain idea will not work.

— So the dialogue is a pretty open discussion between the art director, the client and the photographer?

— Yes, it should be, although obviously it varies from shoot to shoot.

— Does it happen that an agency comes along with a corny idea and you will just say "Hey, I will not do that"?

— Yes of course. If it is a three-day shoot and you are going to be depressed as hell, why would you want to be involved? If they make me an offer I can't refuse I just have to be depressed for three days, but I'd rather not.

— Sometimes I feel that a lot of the young photographers, they can be more primadonnas compared to the people that have been in the business for a long time. Do you feel the same way?

— Yes. When you are young you are fearless, not just in photography but in life, you don't have any fears. I took chances in the early days and sometimes really stuck my neck out. This magazine doesn't want what I do, then I'll try another magazine. You live or die on that. That fearless attitude you have when you are young. But as you get older you get more fearful. We worry a bit more. You really want the pictures to be good for the client. You start taking on a more responsible attitude.

— If you are good and you have done a lot of good work, you are respected as a good photographer then you can choose more between jobs. You have that authority. Do you feel that?

— I find that people listen more to me now then they did before.

— I tnink that it comes with age. I can be bolder in my work now than I was before. First you were young and fear-less and then you were in the middle of your career and you didn't dare to do things and when you get older you try new things. I was thinking about the picture you had in your exhibition the New Castle Brown Poster. Was that a clear brief?

— One of the teachers at the University of Malmö is taking a doctor's degree and she is doing a thesis on that specific picture. A discussion about how one thing leads to another within culture. How commercial images are becoming art and how one ad turns into another ad.

— You work a lot with advertising, a lot of portraits, a lot of celebrities. So you are all over the spectrum. Is it the same thing working with exhibitions?

— So you only worked for a period of time on the book?

— I have never done a book for myself. I have done maybe 20 book for other people. Do you find it hard to work for yourself?

— Will you do a book on your advertising work as well? Would that be as big challenge as doing a nude book or a landscape book?

— Yes. You only do the job if you believe in it.

— I agree with you. When you go to a meeting now you feel that you've got a few years of experience behind you. You can sit down and say, "This is right for the idea and this is completely wrong", and they are quite happy to listen because all we are doing is talking at the moment. We haven't shot the pictures. They are just happy to hear what I nave to say even if they would disagree with you.

— Yes, it was pretty clear what they wanted. I know the art director well, he is very good and together we made the idea work. Sometimes young creatives are not disciplined enough. There are a lot of advertising campaigns that need discipline.

In this case we needed to keep pretty close to the original picture, but still make it inter-esting. People who drove along the road and saw the picture needed to think it was the Opium ad, then remember it was banned and think "Hang on, why is it up there? " Then when they get closer they are going to see this guy with his boots on and see it is actually for Newcastle Brown. It makes people smile.

— The first one is obviously original but it doesn't make the second one any less. It still stands on its own as a piece of art. We did a similar shoot a few years ago for Glenfiddich, which I really love as well. It was meant to be the moment that Mary Quant had the inspira-tion for the mini skirt. A model was getting out of an E-type Jaguar and ripped the bottom of the dress on the door as she is getting out. That was another discipline job. We created a 21st century image based on a 60's idea.

— More or less. But there are some things you love more than the others. It depends what you are doing at the time. When I was shooting my portrait book, "I'm Still Standing", the most important thing for me was the portrait. I was concentrated; I didn't want to be dis-tracted from that.

— Yes, it had to be done in 18 months – two years. It's better not to be too distracted with lots of other things.

— No, I think that is the easiest part. There is no democracy, it is fantastic. You make all the decisions. I don't compromise with anybody. When you do a book you a have a vision of how the book will be when finished.

— I think all the books on peoples advertising are done after they are dead. My advertising pictures are all over the place. To call all the agencies and get all the pictures back is a big job. There is enough material to do a book and a quite nice one.

— Is there any particular job you like?

— Yes, do you know Smirnoff? We went up to Scotland with horses, dancers and a large crew. We couldn't go to Canada so we made Scotland look like Canada, the mountains and rivers looked pretty similar. I was only about 25 years old, it was one of my earlier jobs and the production was enormous. We stuck this stake in the ground and tied a model to it, then we had 24 couples dancing around the girl like Red Indians. It was wonderful, just like a movie set. We had Indian smoke signals in the background. It was 3 miles from the nearest road. It was shot in the late 70's. The final image was on posters all over London. I don't know where the picture is now; I don't have the transparency.

— Do you do jobs like that now?

— No. I haven't done jobs like that for ages. Some of the commercials I have shot were big sets. We haven't done any massive things for stills in a long time. Agencies don't have the money anymore.

— Are there some jobs you wish you had done?

— I dream about the books I make. The portrait, the nudes, the landscape and the fashion book. I just like to keep working. It is very important to keep doing that. There was an auction recently with a lot of pictures where some of my 20-year-old pictures went for £2000-£3000. I had forgotten about half of them. They came from some old book that I have done. So they do become fashionable over the years. So what I'm doing now will be great in 20 years time from now, I hope.

— It's really nice to feel that photography that once was craft is now becoming art. Do you feel the same way?

— I think it has always been art, people just hadn't realized it until more recently. I think it happens gradually, work you did years ago starts to sell. You always think the work that you do today is so much better, but people are not so interested in it because it's too fresh, it's too new. Things have to date a bit. For example, Freud's paintings were always great but years ago they sold for almost nothing in comparison to today's figures, which are astronomical. People don't understand how to collect photography. You can buy from a signed edition of 25 or 10 prints, but people don't know the difference between a vintage print by Bill Brandt that can go for £15.000 - £20.000 to a print that they copied in the 70's because he was too old to reprint them. You can buy those for £2.000-£3.000. If you were not a collector you wouldn't know these little things.

JOHN SWANNELL

CLIENT: NEWCASTLE BROWN ALE
AGENCY: CIRCUS
ART DIRECTOR: TIM ASHTON
COPYWRITER: ANDY BRYANT
DATE: MAY 2001
GENERAL USAGE: PRESS & POSTER,
POSTCARDS, UK

JOHN CLARIDGE

CLIENT: INDIA TOURIST BOARD
AGENCY: KMP
ART DIRECTOR: JONATHAN HALL
COPYWRITER: ANDREW CRACKNELL
DATE: 1973
GENERAL USAGE: PRESS & POSTER, UK

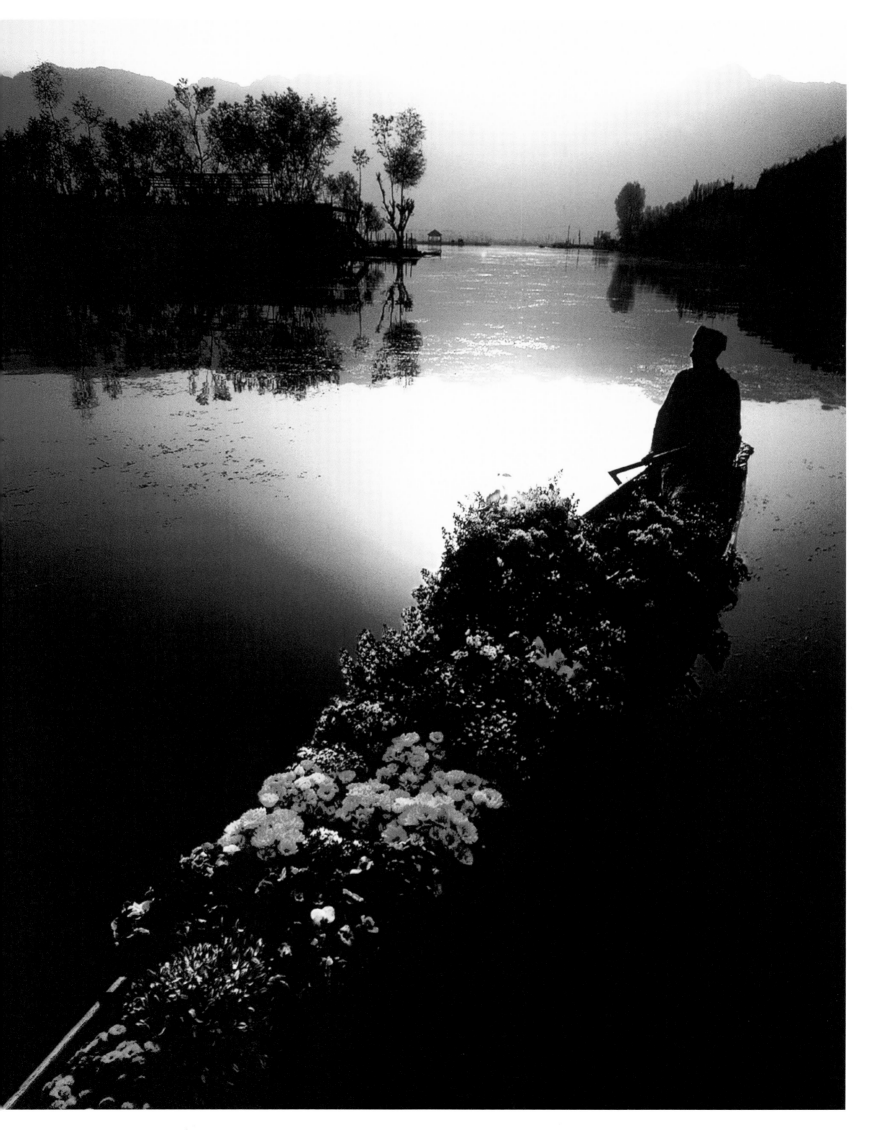

JULIA FULLERTON-BATTEN

CLIENT: GALAXY
AGENCY: GREY WORLDWIDE
ART DIRECTOR: DAWN HEUSTON
COPYWRITER: KAREN HAGEMANN
DATE: MAY 2003
GENERAL USAGE: NATIONAL PRESS, UK

MARCUSSENKIENBERG

PEER

MARCUS

— As a model, you are the last one to
be involved in the creative process of
a shoot. The AD has already spent
a couple of months thinking about
what the picture should look like. And
his Creative Manager has had lots of
opinions about it. They have been in
touch with the production company
and the agents. They have decided
on a suitable date to be somewhere
in the world and there, suddenly, the
model will play the main part, with
usually very little preparation time.
What do you do?

— As a model you are always more or less prepared. We just have to stay in shape!
Sometimes we get bookings with just a few days notice, which means you never know.
But it's not always the model who comes last, especially not if you've succeeded in build-
ing up a reputation. We have just done a shoot in India, where they wanted me as a model
and organized the shoot around my schedule. But normally the model is the last puzzle
piece to be out in place.

— So the model is the one who has to
make something come true in very
short time and with very little prepara-
tion. But can you be mentally trained
to grasp the director's instructions
quickly?

— It's a question of experience. When you've worked in this field for a couple of years, most
of the photographers I work with know what they want and what they think is good. The
first time you work with a photographer you have to listen and understand what they are
looking for. A good photographer knows this. There are, however, photographers who
don't know and they try out different things. "Ok, now we're going to try with this jumper,
or maybe this one..." and so on. And you have take five to ten different pictures to get just
one good one. A good photographer knows exactly what he sees, and he's got an eye for
what will work. So no time is wasted focusing on the wrong things.

— I suppose the chemistry between
the photographer and the model is
important.

— Yes it helps of course. Remember at the beginning of my career, I worked a couple of
times with photographers who were so unpleasant they shouted at me. It doesn't happen
very often, but when it happens, it doesn't give anyone a good feeling. All you want is to
finish the job and leave. A good photographer is one who makes the model feel good.

— There are so many people involved
in a photo shoot – everyone from
the customer to the photographer.
Sometimes the crew amounts to
twenty people. The team feeing must
be quite important.

— Of course! I'm going to the Virgin Islands in ten days. We'll be working for four or five days.
If you're away on a trip like the one I was on in India, we were with a team for the whole
week, and it's especially important that the atmosphere is good. If you start on the first day,
and nothing works and the people don't get along then it can be really hard work. What
matters on the set is a good atmosphere regardless of the number of people involved. And
that everybody has a good time, and then you get a good job done. I can understand that
customers get involved in a shoot, since it sometimes costs hundreds of thousands of dol-
lars. But the most important thing is to have a clear view of what you want to show when
you first start shooting.

— I've understood that customers some-
times are on the set, and even art
directors. Does it bother you?

— Photographers and models prefer it when the customer is not present because it means
yet another person with ideas and opinions. It can be difficult when the photographer has
one idea, the stylist another, the customer another ... and everybody throws in his own
idea. Then you have to test loads of different things. But most of the time, even if the cus-
tomer is at the shoot, they have decided what to do in advance and under normal circum-
stances everybody agrees, but not always.

— I often think about the difference
between a film shoot where you
always a have a manuscript and a
scenographer and an action plan
so everyone knows exactly what is
meant to happen. By contrast, at an
advertising shoot, or even more in the

— No I think it's better to let the feelings talk. In a film you have to stick to the script.
Somebody has maybe worked on the script for years so it's important to follow it. That's
not the case in a photo shoot. Nobody knows what's going to happen before the model
goes into the studio. How the model will look, on that day – if they've been partying and
are tired or hangover or in a bad mood. You don't know what to expect. So, it's better to
let feelings steer it. The model or the photographer might be having a bad day, or maybe
the clothes don't fit the model. Me for example, I've never been much into suits and so on,
I'm much better in jeans and T-shirts and underwear. It's important to get the right model
for the right product.

case of a fashion shoot, it's more the feeling of the occasion that makes the picture. Do you think it's better to have a clear brief?

— How long have you been a model?

— I started in 1990, about 13 years ago, doing a Calvin Klein campaign with Bruce Weber – a 116-page catalogue was my big break. After that, my career went up quickly. When I first started, there were very few well-known male models. Boys were mainly used as props to female models. They were the celebrities, who got lots of work and made a lot of money. After the Calvin Klein campaign, we succeeded in taking advantage of the big campaign and my agent asked for higher fees than usual. That was during the peak for super girl models. It left something for the boys too, though to a lesser extent. That was definitely a change for us boys. Male models started making money, newspapers wrote about us, we got TV interview etc etc.

— Is business a bit up and down these days?

— Yes actually. But I've been studying for two years, then I was in Italy for one year which means I've spent three or four years away from modeling. But now it looks as if things are picking up. I don't know if it's good or bad, since I've been working with film but you have to make hay while the sun shines. I want to concentrate on filming. I succeeded in becoming number one in modeling - something I never imagined could happen.

— Did it mean you could make more demands on the photographers or on the production itself?

— Yes, as soon as you get a name. Lots of things change. You get more respect, and not only in the business. You can say 'no' if you don't want to do a job. Earlier on in my career I had to accept all the jobs I was offered in order to make a living. A lot changes when you can turn work down.

— The model's integrity is an important matter. To be able to choose what you want to do. Then the customer or the agency should get in touch with the model right at the idea stage in order to be sure to carry out the project.

— Of course. It's just like some customers I've been working with that want to use me year after year for the same campaigns. They change the photographer instead. I've been working for several years in a row doing a campaign for XXX in Italy. They changed photographer. Before they would have changed the model. I'm happy that I've been retained during the switch over, because it opened the door for other male models. Lately very few top models have been discovered compared with before.

— Why do you think that is?

— They started using film stars on magazine covers instead of models. I think it has a lot to do with that. Maybe it's something to do with the grunge look. They use twelve-year-old models, who are so tiny and skinny, for adverts. Normal people don't really look up to it. It's not like with Cindy Crawford or Linda Evangelista who were more curvy. Girls today flat chests and thin legs. Normal peole are not attracted to that. Male models are also really skinny, without muscles. Not healthy looking.

— Do you think it's a trend; just the way supermodels were a trend?

— Yes, that's typical in fashion – it's cyclical. The 70s were hopelessly out in the 80s and now they're back again. Now it's grunge and they use young models that are just fourteen or fifteen years old. Supermodels became kind of celebrities I think. But it was not only because of their looks, but also because of who they were as private people.

— If you think about the Calvin Klein campaign, which was your break-through, and many campaigns of today, there's a lot of sex in advertising. Do you think it's a sign of the times?

— Yes it is. Sex always sells. Calvin Klein is a typical example of a company that uses sex to sell. Shock tactics. I remember when he had young girls and boys in such daring shots, that they had to be removed. They were on the news. That gave him publicity even if he had to redesign the campaign. Everybody talked about it.

— Have you got a dream project?

— I think I've done almost everything; I was lucky in my career. I've worked with all the top models – Cindy, Linda, Naomi. Etc. all the photographers, Herb Ritts, Richard Avedon, Albert Watson etc etc.

— It's probably because clever people search for each other, just like in a football team.

— It's the same with movies. The best directors want the best actors and so on. And they know they've got a greater chance of achieving good results. It's hard to go wrong when you've got the best ingredients. Now I'm mainly focusing on films. I've been working at the William Esper Studios in New York. I finished studying a year ago, and I've done soap

operas in New York such as "One life to live" and "As the world turns". And I've been involved in independent film productions like "Prince Valliant" which was shown on HBO the other day. I played the bad guy. That was my first film. A small part but it was fun to fight with swords. I worked on these films before I started school and when I was through with school a year ago, I was offered a chance to work in on Italian TV programmes. I've done that for a year now. But now I've moved back to Sweden and I'm going to start filming again. It feels like a natural step to start with film after my career as a model.

— What do you find in film that you can't find in modeling?

— It's completely different – a much bigger challenge. As a model you go to a studio, you strike a pose and hopefully make good pictures. Much simpler than to work as an actor, where you have to be really well prepared and work hard. I like the challenge.

— If you look forward a couple of years, is it movies you want to do most?

— Film and family are the things I'm looking forward to. I've studied for two years, plus I've been in Italy for a year. So I've been out of modeling for three to four years. Now it looks as if things are moving again. I don't know if it's good or bad since I'm going to start working with film, and maybe I should carry on modeling as long as I can. But I would like to concentrate on film. Now I'm going to Los Angeles to find a house, and I'm going to commute between New York and LA. I'm going to carry on modeling for a while – I can do several good jobs now. The last few months I've done a cover for Calvin Klein, eight pages for Numero Hommes Magazine and I been to the Virgin Islands and India for a fashion. They are going to be published in September and October and will probably lead to other good modeling jobs.

KELVIN MURRAY

CLIENT: ALPEN
AGENCY: BANKS HOGGINS O'SHEA
ART DIRECTOR: ANDY LENNARD
DATE: JUNE 2002
GENERAL USAGE: PRESS & POSTER

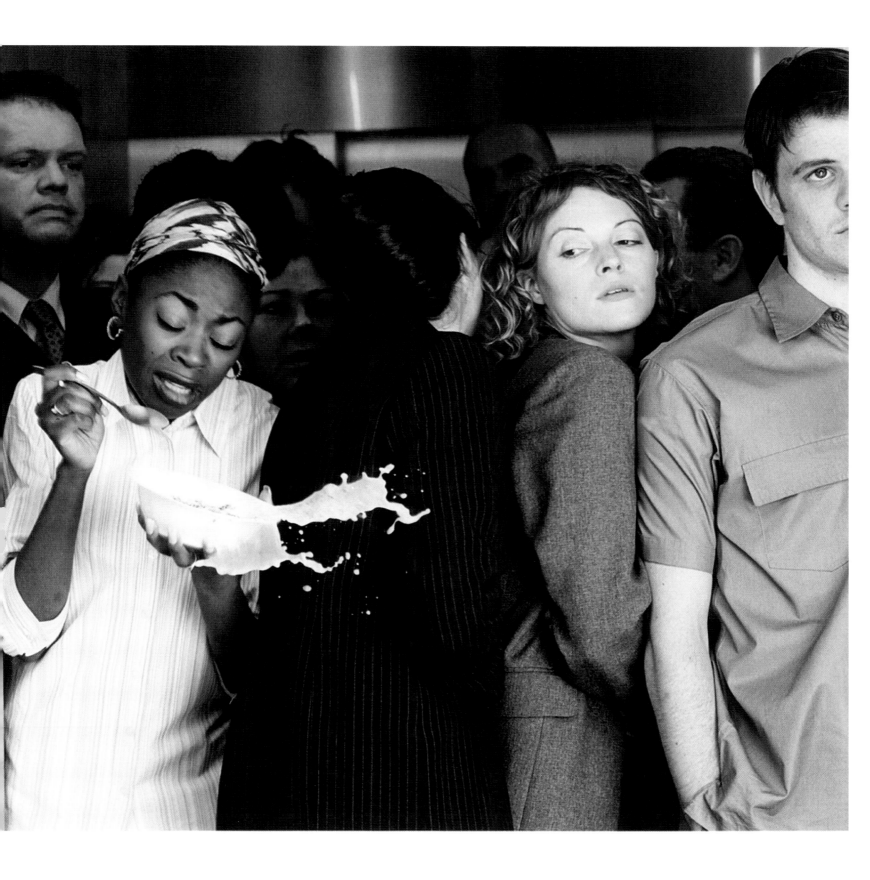

LORENTZ GULLACHSEN

CLIENT: JP MORGAN
AGENCY: MC CANN ERICKSON, LONDON
ART DIRECTOR: DAN BAILEY
COPYWRITER: BRADLEY WOOLF
DATE: NOVEMBER 2002
GENERAL USAGE:

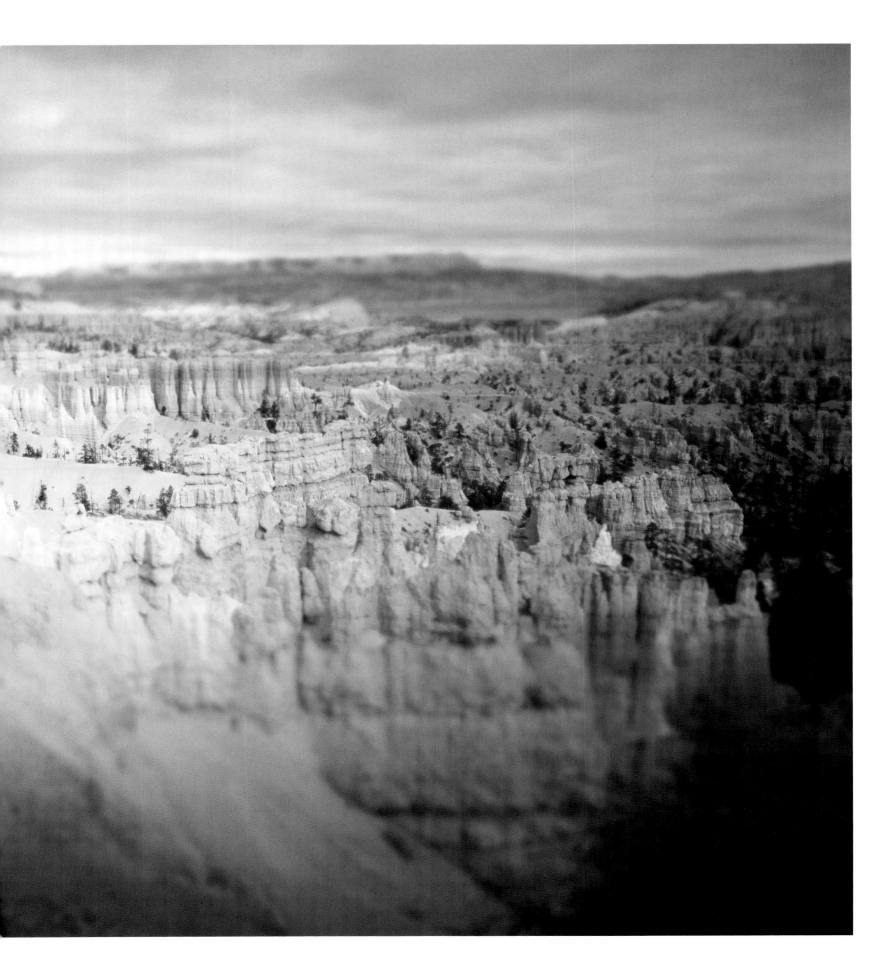

MARK POLYBLANK

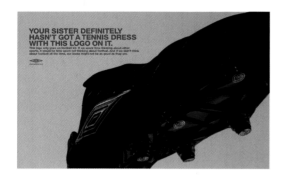

CLIENT: ADIDAS
AGENCY: FALLON
ART DIRECTOR: RICHARD FLINTHAM
COPYWRITER: ANDY MCLEOD
DATE: 2001
GENERAL USAGE: PRESS/POSTERS
WORLDWIDE

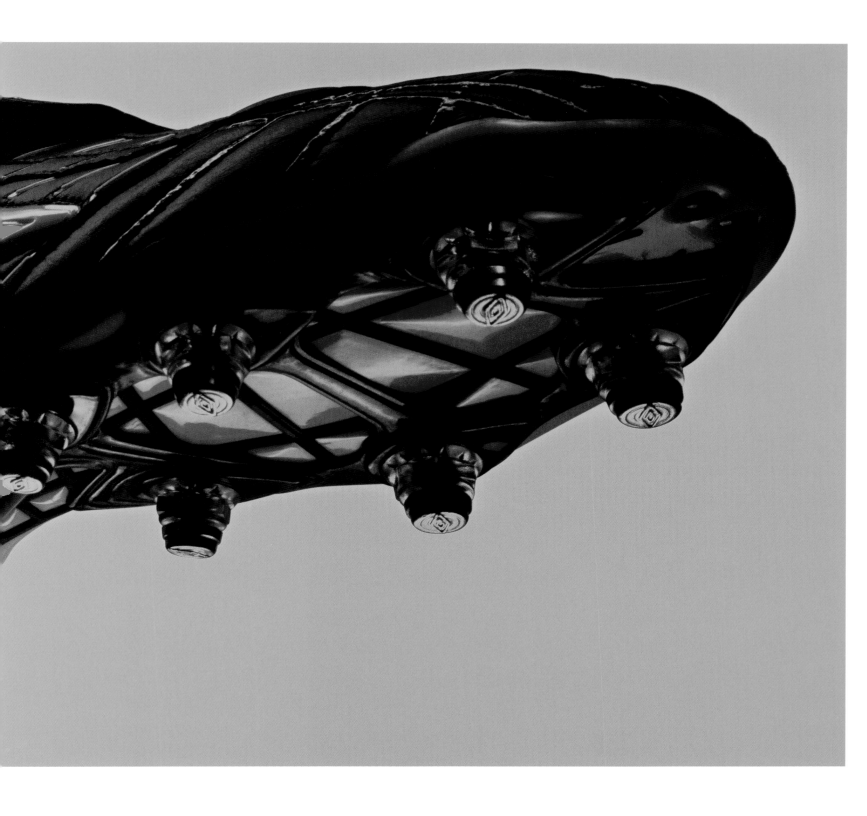

MAX FORSYTHE

PHOTOGRAPHER

PEER

MAX

— We were talking about the advantage of not being an educated photographer, to see things from another angle.

— The particular drum that I've been beating for a long time is that photography was prejudiced against color photography. The history of photography was black and white; art photography was black and white. If you went to a shop and bought books they were always black and white. You went to exhibitions they were always black and white. Color photography was the poor relation of photography. It's what you took when you went on holidays. From that point of view I think that this attitude, this prejudice, was perpetuated by colleges. You went into the darkroom where you created this art.

Because I did a graphics course and I then became an art director for a period of four, five years, I didn't have the same prejudice. Color was a much more natural thing for me and when I started taking photographs I took color photographs. They went down very well in advertising agencies and with clients but went down very badly with galleries and people like that. It took until 1984, I persuaded a Andrew Cowan at Hamilton Gallery to give me an exhibition. It was the first color photography exhibition he was involved with. It went extraordinary well and we sold more pictures than he had sold before. Suddenly it seemed possible that the public was far more ready for color photography than the photographic world was. The public saw things in color so it was not strange for them. So since then I suppose I've been pushing that particular barrel uphill. And I think that it has only really changed in the last five – ten years. You would have had difficulty getting a book by Eggleston in the UK ten years ago, books of color pictures were difficult to find. Suddenly it has become acceptable. I suspect it has a certain amount to do with the digital age the demystification of photography. Perhaps some maturity as well, photography has started to regard itself as something in its on right rather than a poor relation of art.

— I think that is a good idea what you are saying that the main thing is not photography itself, but the main thing is what's on the print. So the photographers are more like imagemakers.

— Yes. Although I think there are a lot of artists now using photography. And I think that their motivation is different. I think they are imagemakers where as I have no other means of making an image but photography. But now with digital imaging I have all the freedom and control with a color photograph that you could only achieve previously with black and white. You could take a neg into the darkroom and make a very different thing, whereas color didn't have that advantage. Now you have that control. That is a massive step forward.

— How long have you been working as a photographer?

— 31 years.

— If you look at advertising in the middle of the 70's there was a lot of black and white, who is changing the scene? Is it the advertising agency or the photographers or the art world?

— There was a demand from clients for color photography. Magazines became more colorful, Sunday times produced a color supplement and I think it was that side of things. There were also people like David Hockney who started using color pictures that he got from... just snapshots. While photographers did their personal work in black and white, the stuff they got paid for tended to be in color. Photography has always tried to ape art. And has always felt inferior which is perhaps why they clung to the automatic abstraction of black and white and why they did limited editions perhaps to try to instill a preciousness to the work that they didn't feel was inherited anyway. I think it was both sides closing in. Clients and the art world moving together with photographers in the middle desperately trying to hang on to the darkroom.

— So what changed that? I had a feeling that before the photographers did what they were asked to do but now it seems like it is changing that the photographer becomes more involved in the creative process at an early stage.

— Yes, I think that is because clients and particularly advertising agencies are demanding that you bring more to the party. That is a great thing, it is good for photographers. I think that the dividing lines between art directors and copywriters have become more blurred, people are stepping into other people's roles and amateurism has become valuable. That in fact is because I believe craft skills are dying, like the darkrooms. With the death of craft skills the image becomes more and more important.

— How did the craft skill change?

— Well you see my uncle was an amateur photographer and a very keen amateur photographer, he used to shoot on a quarter plate camera and the great skill amongst those amateur photographers was getting the exposure light and getting it in focus. If you could get those two right you had a good picture.

The moment the camera became auto exposure and auto focus, that great skill had gone. How do you now have a good picture? You have to rely on the quality of the image rather than the quality of the focus. It is that sort of craft, which I think, has died off and has made the image far more important. And that is fantastic.

I remember going to a Cartier Bresson exhibition some years ago, and being astonished of how many images weren't fully sharp. And also being astonished that it really didn't matter because the image was fantastic. And the craft and the quality of it was far less important.

— So the photographer is becoming more a creative person that creates images that are part of the creative process. Do you find yourself being useful to the younger generation of creative people?

— I hope so but I honestly find them more useful to me. I find it very stimulating to talk to students and also very scary because some of them are not afraid of going out on a limb and I have a lot respect for that. Unfortunately I suspect during the 80's and maybe the early 90's, people like me and art directors went to colleges and we tried to persuade them to gear their courses more towards the industry that they were serving and they did. And the problem now I think is that so much of the work is simply a repeat of what is currently winning awards. In many respects, it would be better to say, "Ok, no cameras for the first two years, you are going to be an artist. You are going to put images together. You are going to learn how to use your eyes. And once you have done that then we will give you a camera". But what we have is our own fault because I think that in the 80's we became too professional in a way.

— I'm thinking about musicians where you also have a craft machine. As soon as you can forget the techniques and your instrument and your notes then you can start to live the music rather than playing the music. Is it the same thing with photography?

— Absolutely and I think... I remember, I play a bit of classical guitar and I remember hearing an interview with Andres Segovia, he was a very old man and the interview started off with a crass question saying, "Obviously Mr Segovia you played the guitar very well" there was a long gap and he said "I forgot about playing the guitar years and years ago now I make music". And I think that is perhaps what a professional has over an amateur in that he hopefully has mastery over his instrument and he is concentrating on making the image. Amateurs are still obsessed with the equipment and that is far more important than the images.

— One of the photographers that I interviewed he said that on every shot he went he got loads of lights because he never know what he will do so he brought a lot of equipment but in the end he only used one or two flashes because he forgot about all the light he had with him. I think that is very positive. Then you concentrate on the image rather than the techniques. Talking about technique, the computer has slowly becoming part of the imagemaking. Do you use computers as well?

— Yes. I scan my own images I do prints for my own exhibitions. You have a greater level of control. I remember 5 or 6 years ago when everybody thought that computers would drive everyone out of business. They have changed the industry beyond recognition and I believe it has reduced the amount of commissioned work. But the advantages far outweigh the disadvantages Massive change has happened and it won't go back, it will just keep getting more. There is a distinct possibility that film will be gone in a decade. If that is good or bad I don't know. If that is something we can stop or affect I'm not sure.

— I was thinking about technique and that computer is becoming a part of the imagemaking. Maybe it has been like that all the time. I was thinking just like when black and white photography in the 60's changed. What will be the next step do you think?

— I don't know but it could be digital, it could be the death of film that could be the next step. I mean everyone says "But the quality...", but the quality is changing every day. The great thing is accessibility. When I started in the business you had type and if you wanted to see a setting in three different faces, you had to get it set in three. Now at a click of a button you can try any type face you want. It is the same with photography you can change the contrast of an image instantly and make a judgement rather than it taking several hours. It's all very exiting and one should look forward to it.

— And it's also pushing us to make better images. You reach new areas where you haven't been before. You have your commission work, you have your exhibition, and you have your private project as I understand. How do you divide your time between them? What is the driving force?

— There is actually a very blurred line between the three, because my folio is very much personal work, probably 60% of the portfolio is personal. I tend to get commissioned because people want that sort of thing, a large personal element in it. I suppose the main driving element is I really enjoy pushing a button and thinking I might have got one there. The more instantaneous that process is the better. I mean that's why I think that if you are going to be a photographer you have to carry a camera. I have had so many rewards from always having a camera and all the sweeter for being instantaneous.

— That is the base for photography. If you would explain to a Mars man that comes to earth what photography is, it's like you say.

— The skill there is hopefully is showing other people something that they probably wouldn't have seen themselves. The eyes are like our most muscles, you train them over a period of time they become a little bit sharper and perhaps increasingly you are able to see things that people would walk past. And if you can capture those in an instant and then show them that's very gratifying.

— There are a lot of art photographers that are doing that. Taking snapshots that you see with your eyes with the camera.

— I think it is the base ethic of photography. I was asked once "What is a good photograph?" and I think that if you show something to someone that they haven't seen before that is about 90% of it. I think that the great danger in photography is that we have an ego where we try to produce a 'good photograph' which means that within the context of that frame we have to display our skill. And that sort of ego thing is worth getting rid of if you can. I think a great example of that is Egglestons picture of the lightbulb in the middle of the room. There is no ego in that. No one is going to look at that and go "That is a really skillfull picture!". He is hanging himself out to dry taking a picture like that. He is taking a big risk. And that sort of lack of ego in a picture is very refreshing.

— That is true. You are documenting something and at the same time you are telling a story. Looking at your website, I do agree that they are very personal and I also think they are very graphical. Is that something that interests you or is that you?

— It is probably me, it's probably why I went to Art College and studied graphic design. I find shapes very visually satisfying. I think that the brief that you have for taking a picture somewhere in the back of your head that turns on the green light when something is in front of you that might be right for you.

— I find that when you look at the car works that you did, I mean they are taken on location, in very strange locations and sometimes they almost like a still life.

— I suppose they are. The car photography that I have done is hugely enjoyable, the Landrover which is like the big boys toy, so it's a hugely enjoyable experience. The major personal input I've had with those is saying, "We can go to that place, we can actually get a photograph there but we don't know how it will be until we get there". I remember I think it was Joel Meyerowitz who said a long time ago, " what's out there can do more for me than I can do for it." I think it is a lot of truth in that. If you prepare a photograph too well there are no surprises.

— And that is very true with life itself. You never know what is going to happen when you wake up. You don't know who you are going to meet, it's all very exciting. And as a photographer you can suddenly capture that image you've been looking for.

— That picture of a Spanish playground that was when we were on a shoot. We parked the cars and we were walking across a footbridge to this bar where we were getting some food and I had a camera with me, I always try to, so that was the reward of walking across that bridge and looking.

— It's very true to capture that moment that will never happen again. I think it is a fantastic photo. Do you have anything else you want to say?

— One thing that I think is worth saying is that clients and agencies are becoming more and nervous they now want several pre-production meetings each going over the same ground, they really want to see the picture before you take it. Which is why libraries are getting so much work you can see the picture before you buy it. This lack of courage

means that clients are spending vast amounts of media money on images that are 'off the shelf' rather than 'made to measure' they may be cheaper but they are often bad value for money and the saving is tiny compared with the overall budget.

The best brief is "This is what the picture should say not this is what it should look like" then you measure what you are doing against what it should be saying.

MAX FORSYTHE

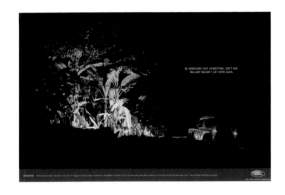

CLIENT: LAND ROVER
AGENCY: RAINEY KELLY CAMPBELL.
ROALFE Y&R
ART DIRECTOR: RICHARD DENNISON
DATE: JULY 2001
GENERAL USAGE: PRESS WORLDWIDE

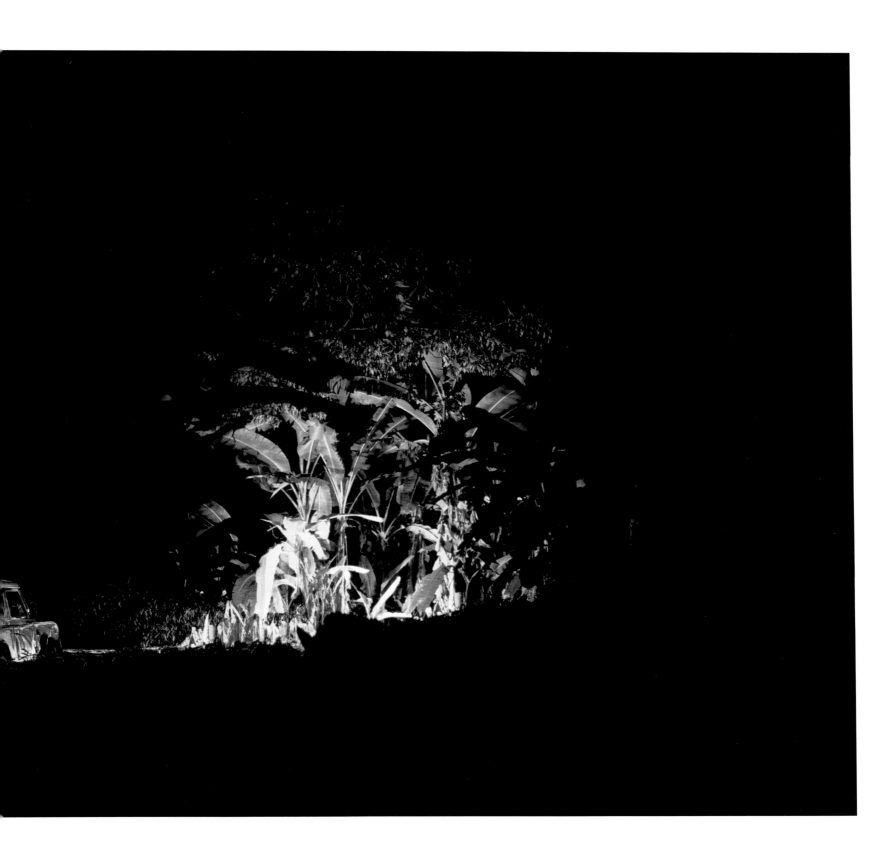

MIKAEL JANSSON

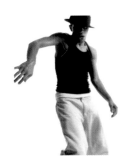

khakis shaped GAP

CLIENT: GAP
AGENCY: TROY LAIRD
CREATIVE DIRECTOR: TROY LAIRD
DATE: 2002
GENERAL USAGE: WORLDWIDE

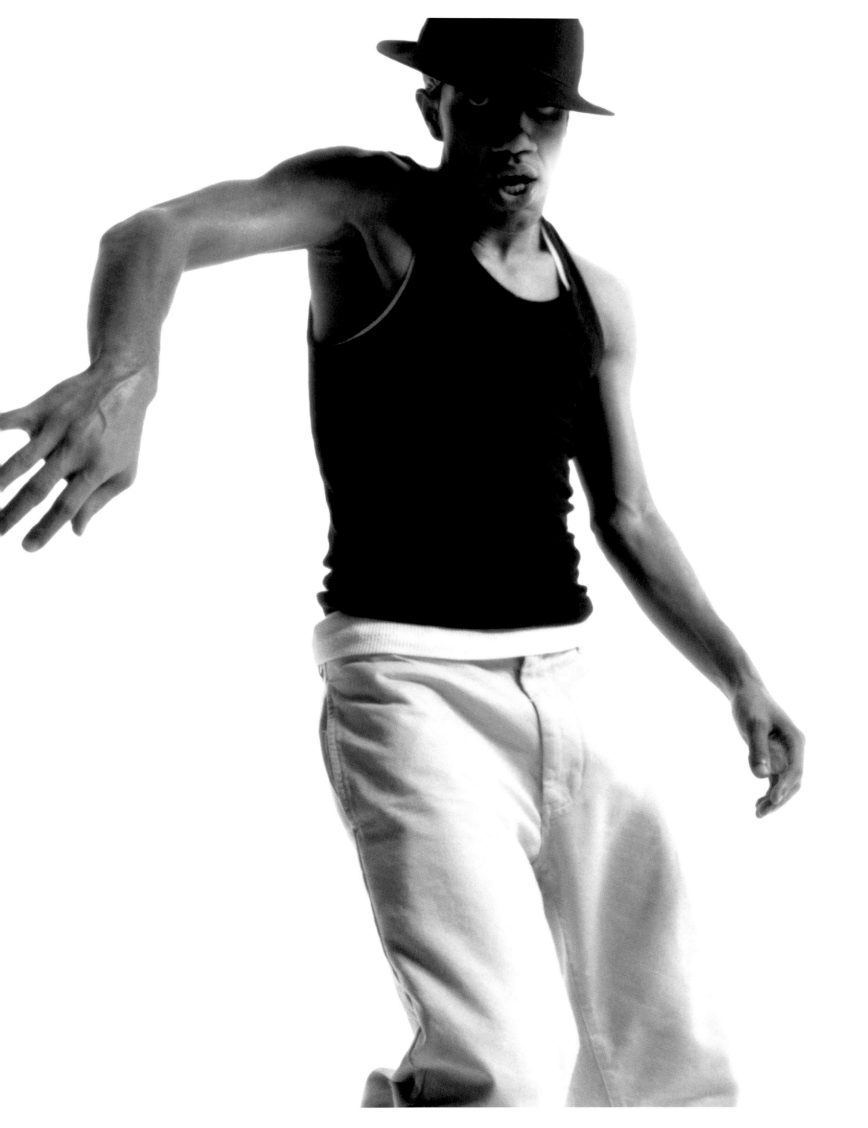

MIKE DIVER

CLIENT: ALGIDA/SOLERO
AGENCY: MCCANN ERICKSON, MILAN,
ITALY
ART DIRECTOR: STEFANO COLOMBO
DATE: MAY 2000
GENERAL USAGE: PRESS & POSTER,
EUROPE

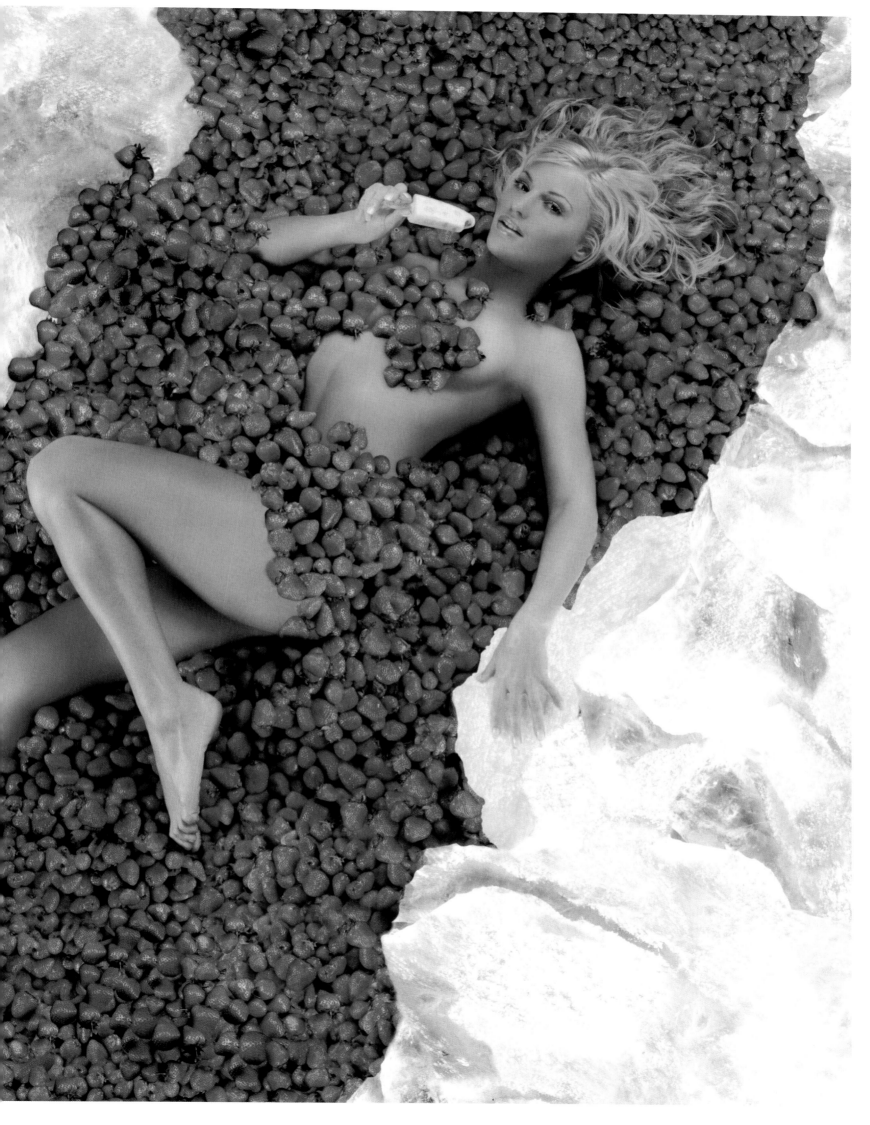

NADA KANDER

PHOTOGRAPHER

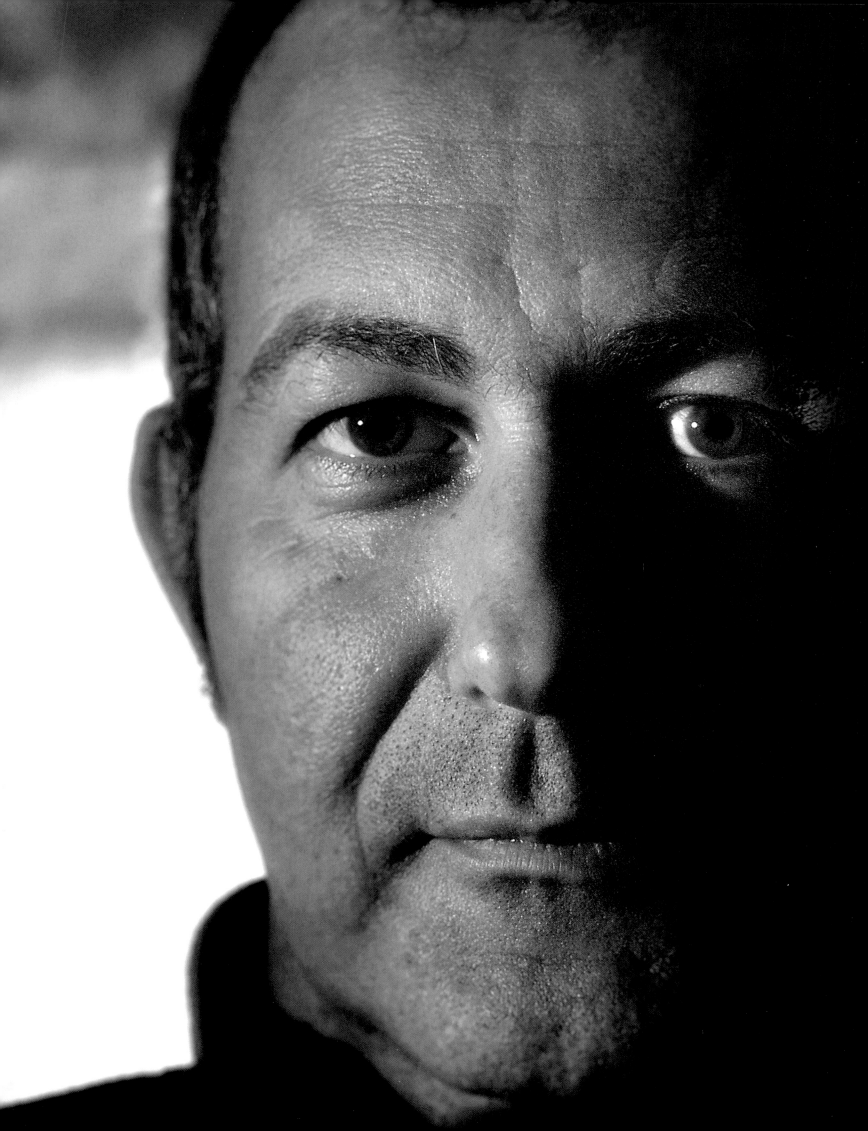

PEER

NADAV

— Today I see commercial work and photographer's own projects going into one. Do you think that's a trend in photography today?

— No I don't. I think commercial work is not as free as it used to be. There are many more constraints in commercial work and I think that personal work has separated much more. My approach to commercial work is still the same but the work is quite different now.

— Is it because of the economy and because the clients are more aware of what they are buying?

— Yes and no, I'm not sure if the economy has ever been the cause but I really think that agencies have a different relationship with their clients than they used to.
I think it was seen as magic what the agencies and the photographer did together, and they were left in peace to make that magic come true. The clients are very well educated in how things work and what changes or demands they can make and they have been allowed to do so.

— The client it taking a bigger part in the work today. Does it mean that when they come to the set, they are more involved into the shoot?

— The way that I work, they are not always involved with me but speak through the agency.

— Sometimes it can be very hard to have a committee to work with, instead of only one art director. Do you think that the role of the AD has changed in the works that you have done?

— I think that it has changed from a photographer's point of view, even if it does not really concernt me as I have to make sure that my AD is working in the way I need him to, to take part. I don't really allow clients on set. You know I'm well protected; I'm protected by my agent. I try not to be involved wirh relationships and committees.

— I think it's very good that you keep your integrity, because everytning might come down tc that at the end. Integrity improves the work. Do you agree?

— If they don't respect your integrity they are going to force you to change. But that really depends on the terms upon which you've got into the job.

— What about photography has it also changed over the years?

— Yes. It's changed a lot and it keeps changing, every 10 or 12 years or so. The nineties were very different from the eighties and now we are coming into a new time as well.

— Could you define what characterizes this "new time"?

— I think that the main thing is that the craftsmanship has left photography. Craftsmanship was the main thing in the seventies and in the eighties as well. In the nineties it was grunge nothing was polished. At the beginnning of the nineties thing had to be more natural, more floppy, and at the end of the nineties and where we are now it's getting more polished again. But with no effort to the craft: just more expensive.

— Does it have to do with the fact that people are working with computers today?

— I think it does. After a more natural period the computer came along again and the result was to really polish and retouch the photos to deal with the skin of the models in a totally superficial way, almost like using the air brush. There was a period of that but we are coming out of it now.

— Do you, yourself work a lot with computer?

— Yes, I use it a iot in a somehow basic way. I'm not terribly interested in completely manufacturing my own images on a computer. I scan from negative, for the obvious benefit of colour control or simple things like that. I'm not that intrested in totally creating from scratch on computer. I could do it but I'm not (at the moment) talk to me about it in two years time and it could be completely different.

— What about you own projects, your personal work? Are you working on a project right now?

— The things that distinguish me most from other people is that I tend to work on a few personal projects at the same time and what characterizes my work is diversity. There are really quite a few things that I'm working on at the moment. Voyeurism comes into my work quite a lot at the moment plus a landscape project that I might do in Russia.

— Are you still working on book projects?

— No, I would love to be again. But I don't think that struggling to make a book is the right thing for me right now. What I tend to do to get a body of work that can become an exhibition, and that could become a book as well. Right now I'm just aiming for the body of work.

— Are you exhibiting your work at the moment?

— I've actually been building a house and a lot of energy has gone into that over the last three years. I'm about to really kick off with my pictures again and I'm hoping that I'll soon have something that I'm ready to exhibit.

— Does your personal work influence your commercial work?

— Very much so! That's probably why I've separated them more now. My personal work has progressed in the normal way that all personal work would and should do. My personal and commmercial work? Well I think they are just more separated now.

— On your own terms I suppose... you want to separate them more!

— No. It's not even on my own will. It all comes back to your first question: commercial work is not as free as it used to be. But my approach is still the same. When I approach a commercial project I do it the same way as my personal work.

— If you look ahead, how will your work change?

— I'm an intuitive photographer. I don't really intellectualize my own work.
So how it goes along is, to be very honest, very natural. I think that each project I do when I look back on it I see that there's a slight progression from the project before and that I have gone deeper into myself. I'm quite happy with that because I think that's the true form of art – going deeper into oneself.

THE EXHIBITION

NADAV KANDER

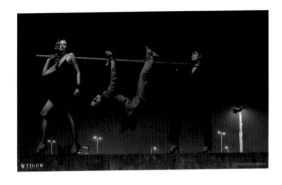

CLIENT: TIGER OF SWEDEN
AGENCY: LOWE PEOPLE, STOCKHOLM
CREATIVE DIRECTOR: WAYNE HANSON
COPYWRITER: BJÖRN STÅHL
DATE: SHOOT DECEMBER 2002/
FEBRUARY 2003
GENERAL USAGE: SWEDEN, DENMARK,
NORWAY, UK, BELGIUM, AND HOLLAND

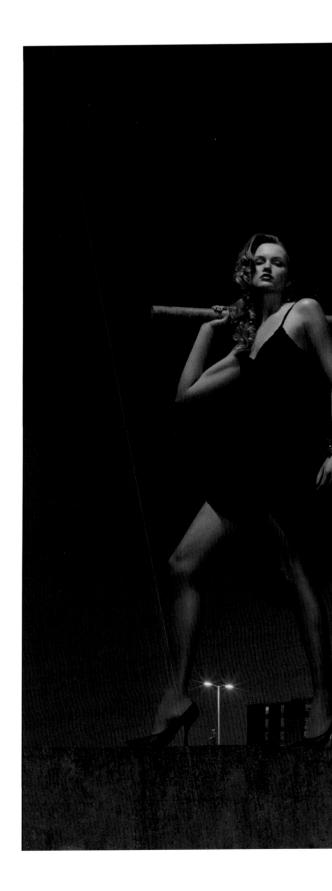

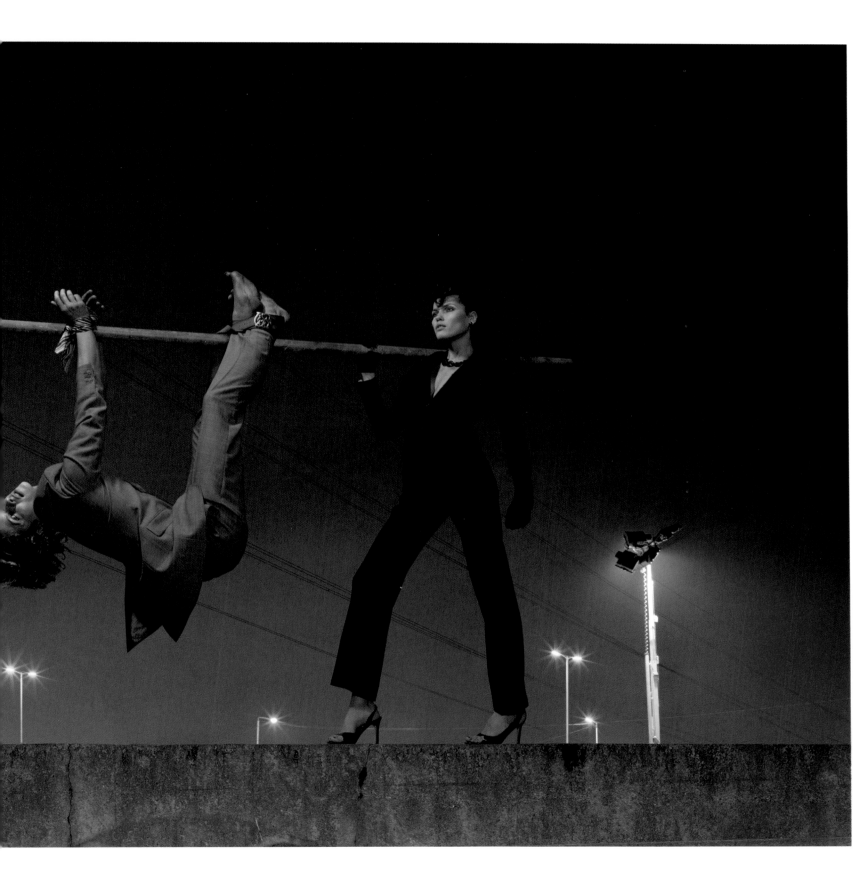

NICK CLEMENTS

CLIENT: CARLSBERG
AGENCY: STYLE COUNCIL/AD AGENCY:
DDB DENMARK
ART DIRECTOR: JABALI RAVN
DATE: APRIL 2002
GENERAL USAGE: ALL MEDIA, UK,
EUROPE & USA

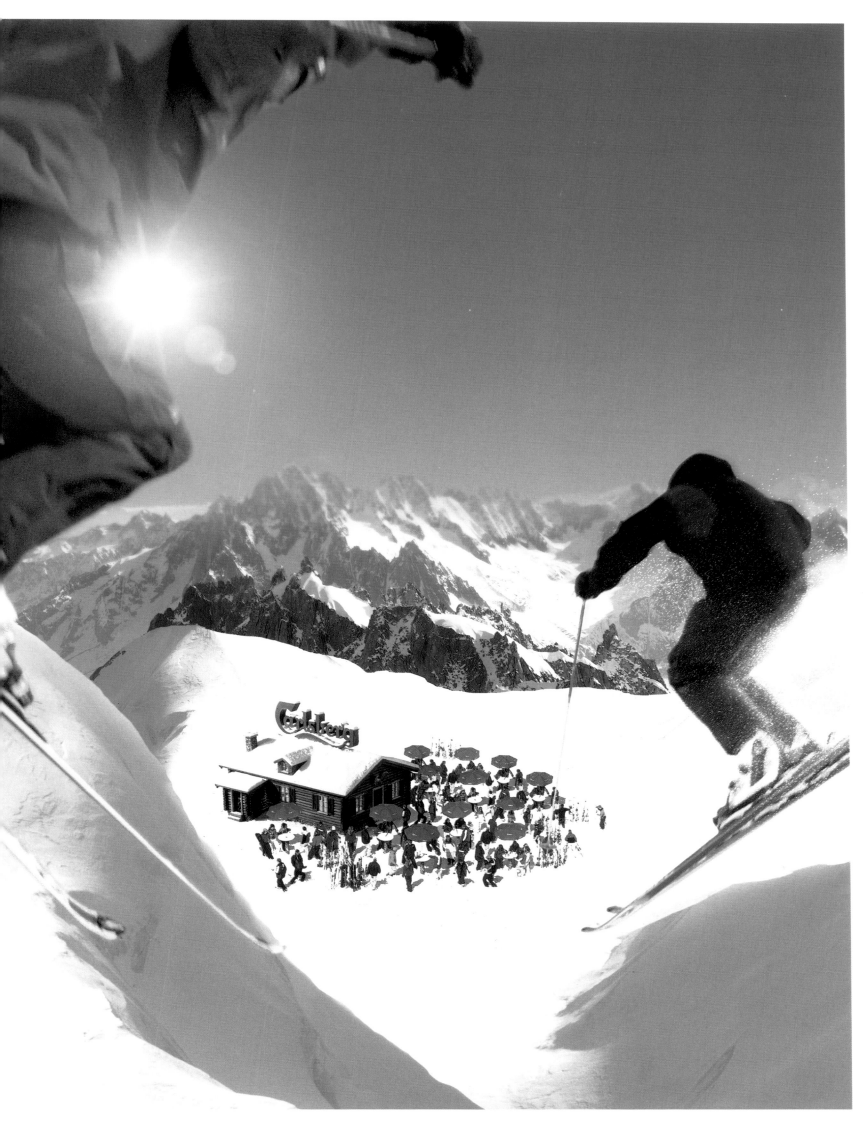

NICK GEORGHIOU

CLIENT: BARNARDO'S
AGENCY: BBH
ART DIRECTOR: ADRIAN ROSSI
COPYWRITER: ALEX GRIEVE
DATE: JULY/AUGUST 1999
GENERAL USAGE: PRESS & POSTER, UK
AND NEW ZEALAND

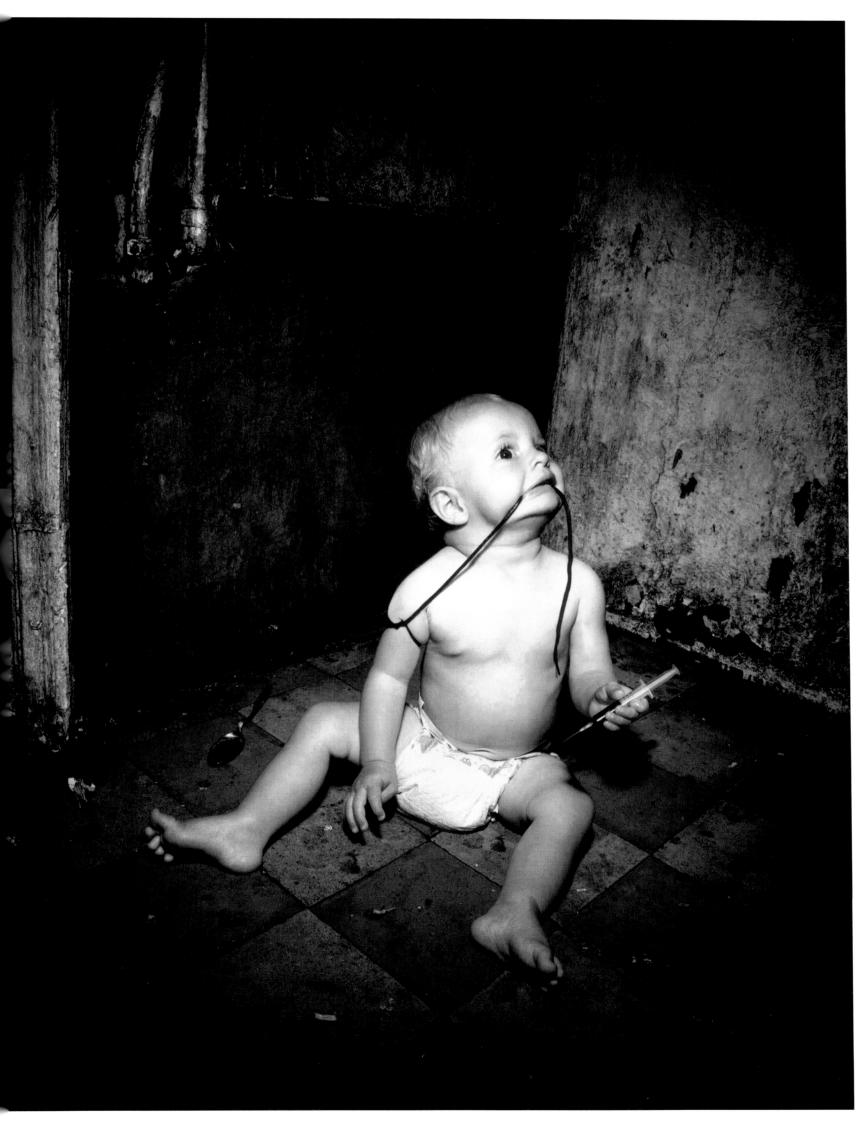

NO ON NOW WRIGHT

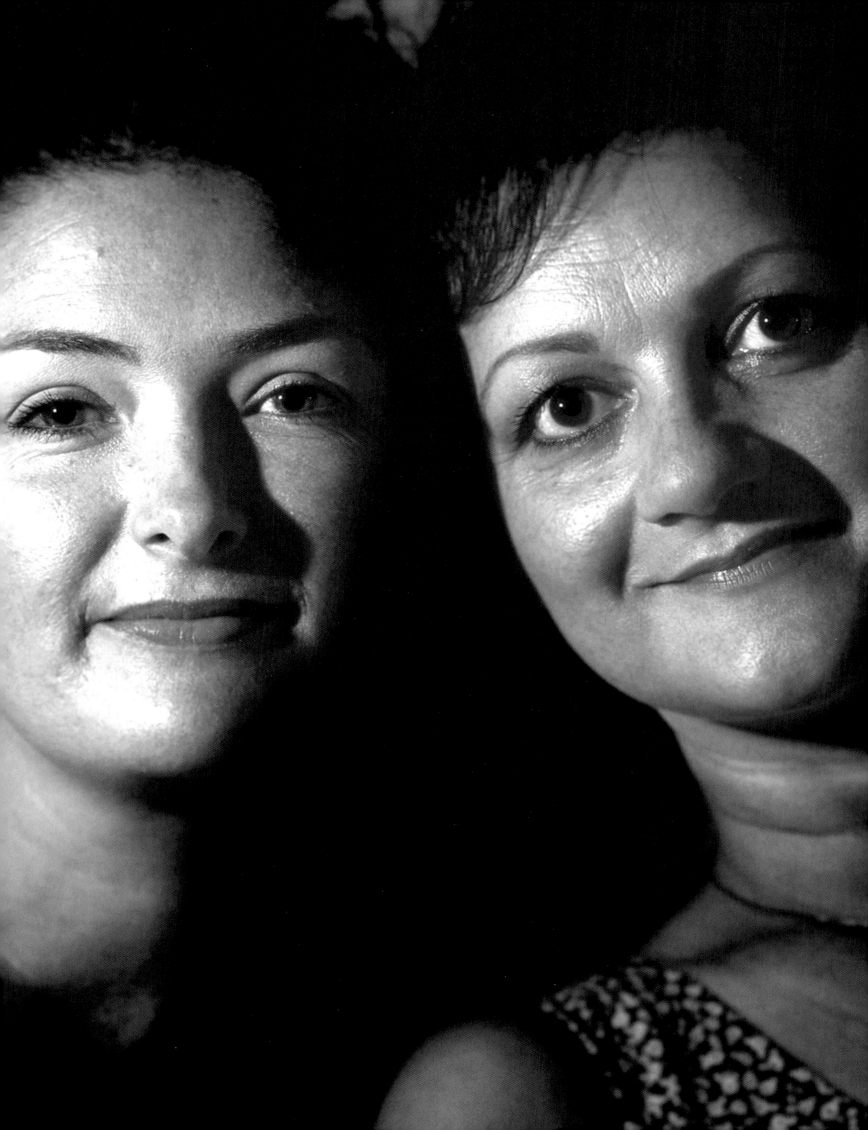

— How should you label different people in the industry? Some of them are photographers obviously, they are editing, they shoot commercials, and sometimes they are even art directors. How did you come up with the idea of Noonwright? How would you label that?

— We would label NOONWRIGHT as an independent creative resources company. It offers an expertise to creatives that cover all aspects from concept to completion to achieve their advertising campaigns for press, posters and direct marketing.

Our background of both working in top advertising agencies in the Art Buying area and also producing photographic shoots for high caliber photographers on global as well as domestic markets over twenty years, has given us a wealth of experience to enable us to offer this complete service to our clients.

As the industry was changing so much with large cutbacks in Advertising Agencies where a lot of the creative services departments most effected, we felt five years ago that it would be a perfect time to launch our Company. We were able to offer an alternative solution to clients to use our services per project so that we could still offer advertising agencies top Art Buying skills without the expense of staff on permanent salaries, office space etc...

It also gave opportunity to existing Art Buyers to hire us for global campaigns, which can take up vast amounts of their time on models, usages and all production, where they know it is in safe experienced hands. This allowed them to cope with their workload.

We wondered if people would understand what Noonwright could offer in the beginning. Initially agencies assumed that we would sit in an agency and cover for their Art Buying department for example, if they were away on holiday or sick.

We started from day one and we have continued that way – we are not freelance buyers, we are complete project managers to whatever level the client wants to take it. We will go in to an agency to get briefed on that project and then take it to our NOONWRIGHT office, but we will work with them on it to completion.

If it is per project, it is accessible to everyone. So you've got design groups, you've got hotshot advertising agencies that are up and coming. They are not going to spend seventy thousand pounds on a top art buyer on a permanent basis. They have the opportunity of using us as and when the project requires that experience and that expertise. That's what we always intended to do - we wanted to open this knowledge up to everyone. We have worked on so much international business that we love working in Europe, America, everywhere and our experience covers talent around the globe. We are very glad to say that our idea was right – just look at our website as proof of that!

— What about the... at one hand you have the agent and on the other hand you have the art buyer. And today the art buyers are more like producers rather than just buying art. Do you find yourself being an agent's worst nightmare, there is suddenly one step more before they reach the art buyer or do you get to be a part of the creative team as well?

The Art Buyers responsibility is vast so when their workload demands such production, we are there as right hand people to ensure that every project gets full attention and an Art Buyer can be sure that it will be handled with every detail being considered and that the best negotiated estimates will be done and presented to the Agency. Also bear in mind that a lot of Advertising Agencies do not have a specialist Art Buying resource, so we can fulfill this roll for them.

We think Agents should really consider it a joy because they have an opportunity to be introduced to creatives that they have not met or have not seen for a long time and yet we have come to them with a project. As we are completely independent we can approach anyone in the world that we feel is right for the campaign. We would have done all the initial meetings with the creatives, shown various examples and shortlisted the talent with the Art Director, so the real serious contenders can be approached. This saves everybody a lot of time and expense. We are certainly not a hindrance but an asset on both sides. We bring the team together.

— What backgrounds do you have?

— Jo: I come from a photographer agents' background. I'm very used to the close relationship with photographers. Also helping out on the producing.

What works here, when we look at a layout, I'm able to see the components that are in the layout, how they could be quoted, how they could work. We are not just checking the budget, we are also making sure that it is looked at it in the correct way so it would actually work photographically.

Sherry: My background is advertising agencies. I worked with several. The last agency that I worked for before we started this wonderful Company, was McCann-Erickson. I was Head of the Art Buying Department, and grew in the ranks there to Board Director.

The Art Buying roll was to be the right arm of the whole creative department. They look to you to interpret their work and suggest and put forward the talent for consideration and for you to get the best deals. Not only working with the stars but finding new ones.

My attitude, and I know it is Jo's as well, we never believe that 'that will do'. It's got to be thoroughly researched to get the very best. We don't go to somebody just because we know them or they'll be ok. We want to get the right person for each roll – every time.

— That's when you normally use freelancing but you are not. It's a new way of working.

— It's just a terminology used in London that freelance Art Buyers for example, could be x amount of money per day to sit in the office and take the calls and do whatever is necessary in that department. We are not freelancing in that way. We are an actual company where we will take the whole project on and give one itemized invoice showing a breakdown of each section having been checked against all estimates from everyone involved to achieve the finished result. This can be very time consuming on massive production jobs and is very beneficial for the clients that they know it is all taken care of for them.

— As I can understand your 'hat' can differ from time to time depending on what the project is

— Yes, we are flexible as our experience of having worked on the inside in an advertising agency, understanding everybody's rolls, the account people, the relationships with the clients etc. With Jo's experience in producing for very high quality photographers, we have on several occasions been asked to produce a shoot for photographers abroad or who wish to shoot in the UK. We have also been asked to investigate various manufactures for merchandising and also to get involved on a TV commercial. Our main area of business is on the stills mainstream print advertising, but our motto is to always do the best all-round, complete project for a client.

I guess it's very much a different hat for different occasions, but we do have these skills to offer.

— Do you have lot of hats in the office?

— Yes we do, we have a vast array of contacts; photographers, illustrators, storyboard artists, web designers, printers, retouchers, set-design, TV Producers etc...... virtually any connection in the creative field. Bear in mind we are totally independent so we research for the right talent anywhere in the world!

— So it differs from time to time who hires you, everyone from a creative director to an art buyer. Is that true?

— Yes it is. We have been briefed by Creative Directors, Art Director and Copywriting Teams, Designers, Art Buyers and Marketing Companies. We tend to get most of our work from the Creatives in advertising agencies. They find what we offer very beneficial for them. On their projects, we are really wanted for our input on the talent recommendation and of course the control/support throughout the project and working also with the account teams to ensure that all costs and usages are adhered too.

— So what about the size of the companies? There are big companies to small, small agencies.

— Yes, the spectrum is that wide. We work for very large advertising agencies who are responsible for clients on a worldwide basis. They find having an independent service with such vast experience, strong project management skills and heavy negotiations on these types of campaigns, very important. When you see how thick a project file can be on conclusion, with the amount of correspondence and the job reconciliation required, you would appreciate what we are talking about! Buying for different markets around the globe – we put the whole package together for our clients and we feel very much a part of their team. It works very well.

On the other hand we work for smaller companies like the design groups. They tend to come to us because they have international clients and they want a global service. We have also worked for smaller agencies who require a one off ad for the UK market only, but is looking for great talent to achieve the very best. We have also done the production on a shoot for photographers only. We hope to think we are very approachable in all aspects.

— All the clients that you have, are most of them in London?

— They are all over the globe, but we do a lot of business for clients who are based in London.

— There are no special teams that you prefer working with? Like projects with food, or cars or fashion?

— We have worked in all areas and as we work per project we have found them all exciting. It's wonderful to have been so privileged with such variety!

— And it seems like the advertising scene is changing. It's putting harder pressure on the agencies in the advertising world to be on their toes. If you try to look a couple of years ahead, what are you finding yourself doing then?

— We personally think that our business idea is looked upon as the future. We are already so cost effective. We feel individual talent will be hired as and when required and this is going to be the direction advertising agencies will be going. Some are already working this way. Not over staffing. Advertising agencies will be leaner and they will buy, as they require and our company will be there for them when they do!

— So in the end you are pioneers? You will be the tool for a leaner advertising agency to be on the same creative level.

— We feel we are an excellent reliable tool for agencies to still be able to offer their clients great expertise without the constant internal overheads. We are not just Art Buyers. We are not just a Production House. We are not just Project Managers. We are most importantly thinkers working on behalf of our clients. We are not just saying these words, we really do have the experience and knowledge to offer the full service. As we say in London ' The proof of the pudding is in the eating!'

OLIVIA BEASLEY

CLIENT: HEALS
AGENCY: BMP DDB
ART DIRECTOR: GRANT PARKER
COPYWRITER: PATRICK MC LELLAND
DATE: FEBRUARY 2002 PUBLISHED
SUMMER/AUTUMN 2002
GENERAL USAGE: UK POSTER

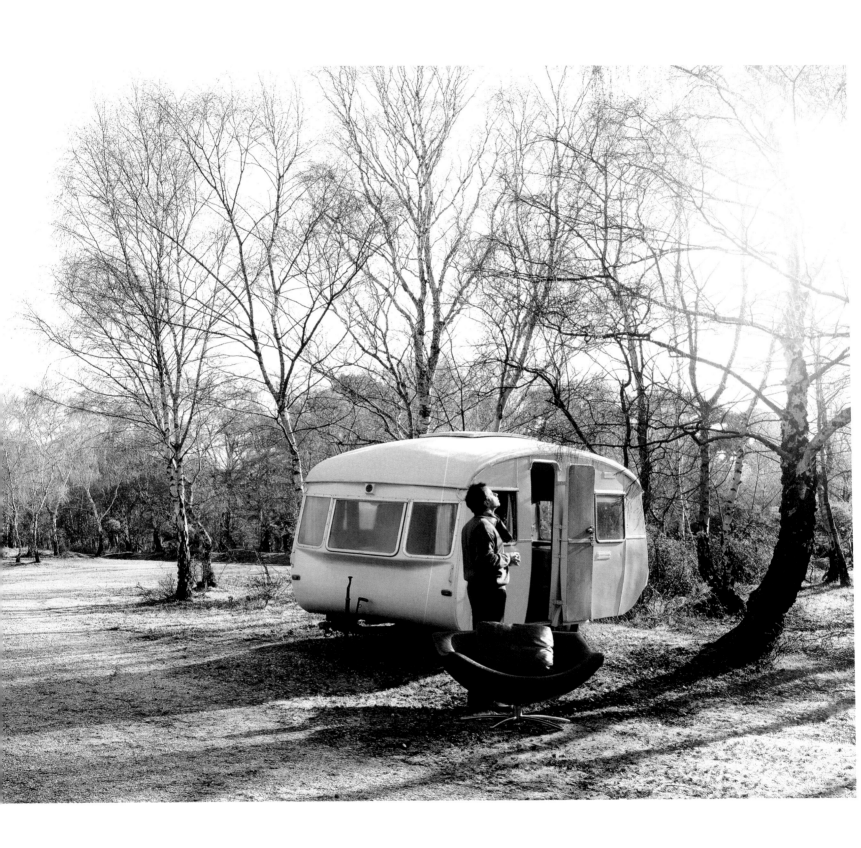

PAOLO ROVERSI

CLIENT: YOHJI YAMAMOTO
AGENCY: LES M&M
ART DIRECTOR: LES M&M
DATE: SPRING/SUMMER 1997
GENERAL USAGE: PRESS & CATALOGUE
WORLDWIDE 6 MONTHS

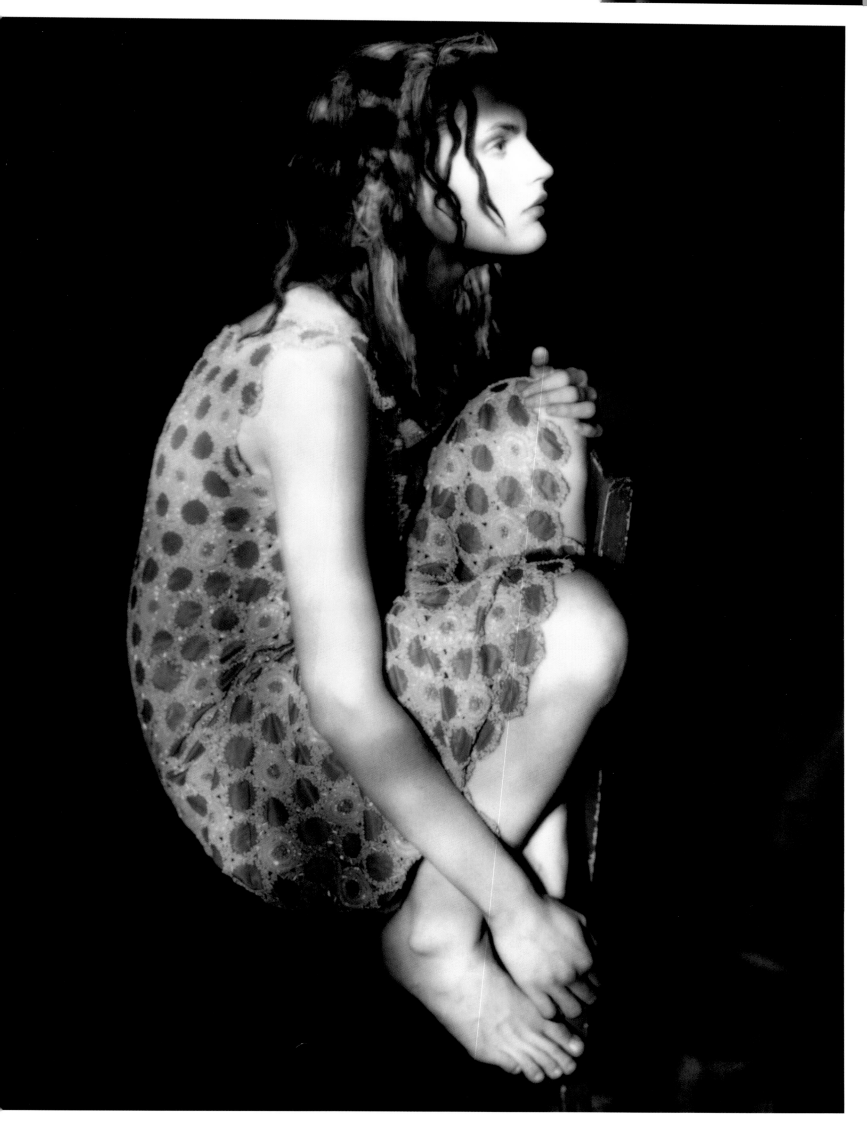

PAUL REAS

CLIENT: VW
AGENCY: BMP
CREATIVE TEAM: NEIL DAWSON & CLIVE PICKERING
DATE: 2000
GENERAL USAGE: PRESS & POSTER, UK

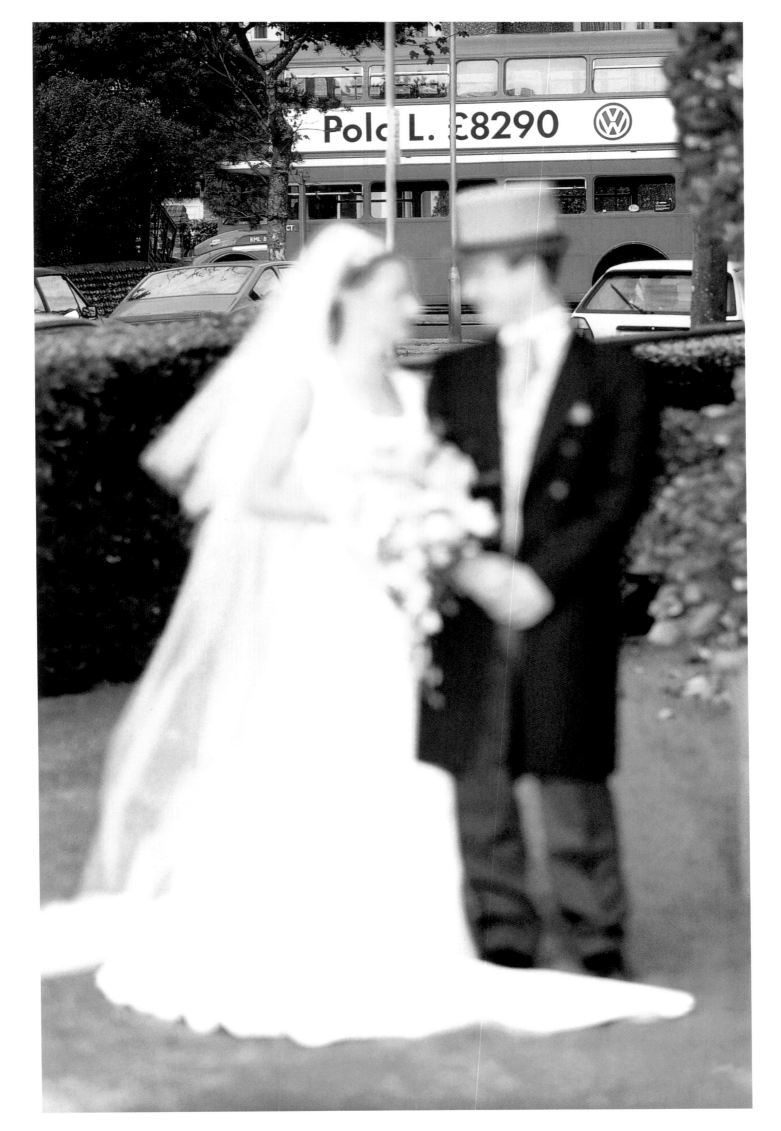

PETER GEHRKE

CLIENT: DIESEL JEANS ITALY
AGENCY: PARADISET DDB NEEDHAM
ART DIRECTOR: JOAKIM JONASSON

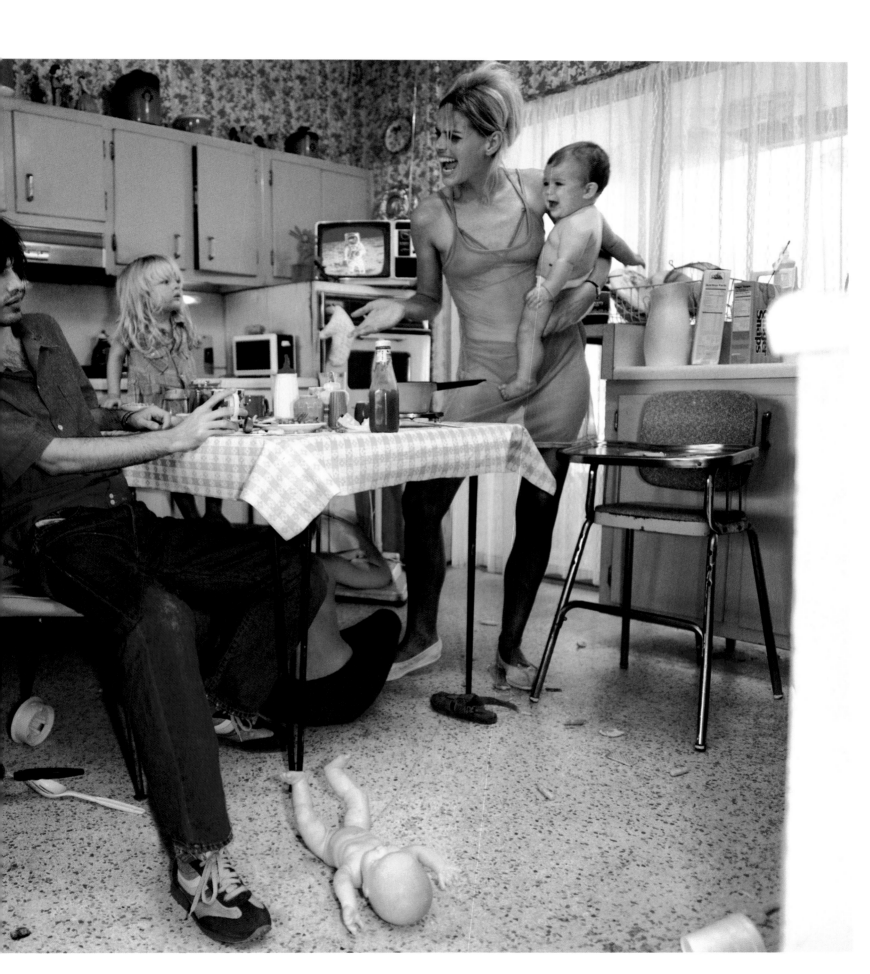

RAINER STRATMANN

CLIENT: COMMERCIAL VEHICLES/
MERCEDES/DAIMLER CHRYSLER
AGENCY: H2E, GERMANY
ART DIRECTOR: TOMAS ELSER
COPYWRITER: ARMIN JOCHUM
DATE: MILLENNIUM PROJECT
GENERAL USAGE: WORLDWIDE
CALENDAR

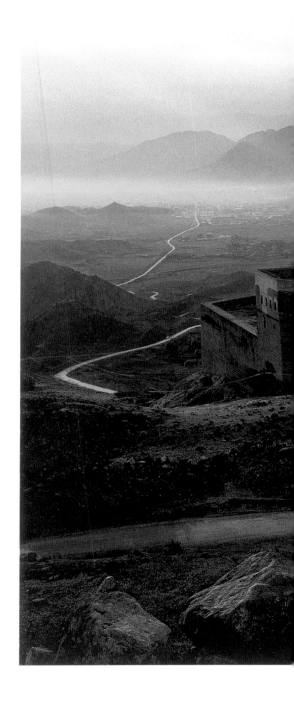

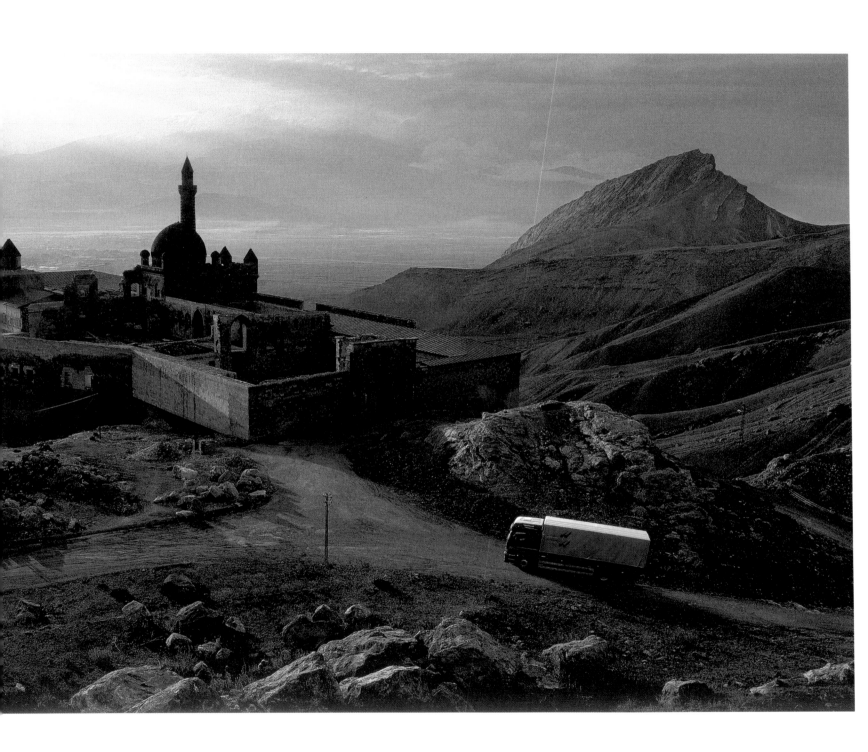

RANKIN

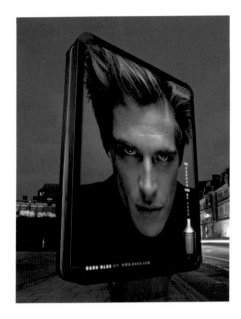

CLIENT: HUGO BOSS
AGENCY: GREY ADVERTISING LONDON

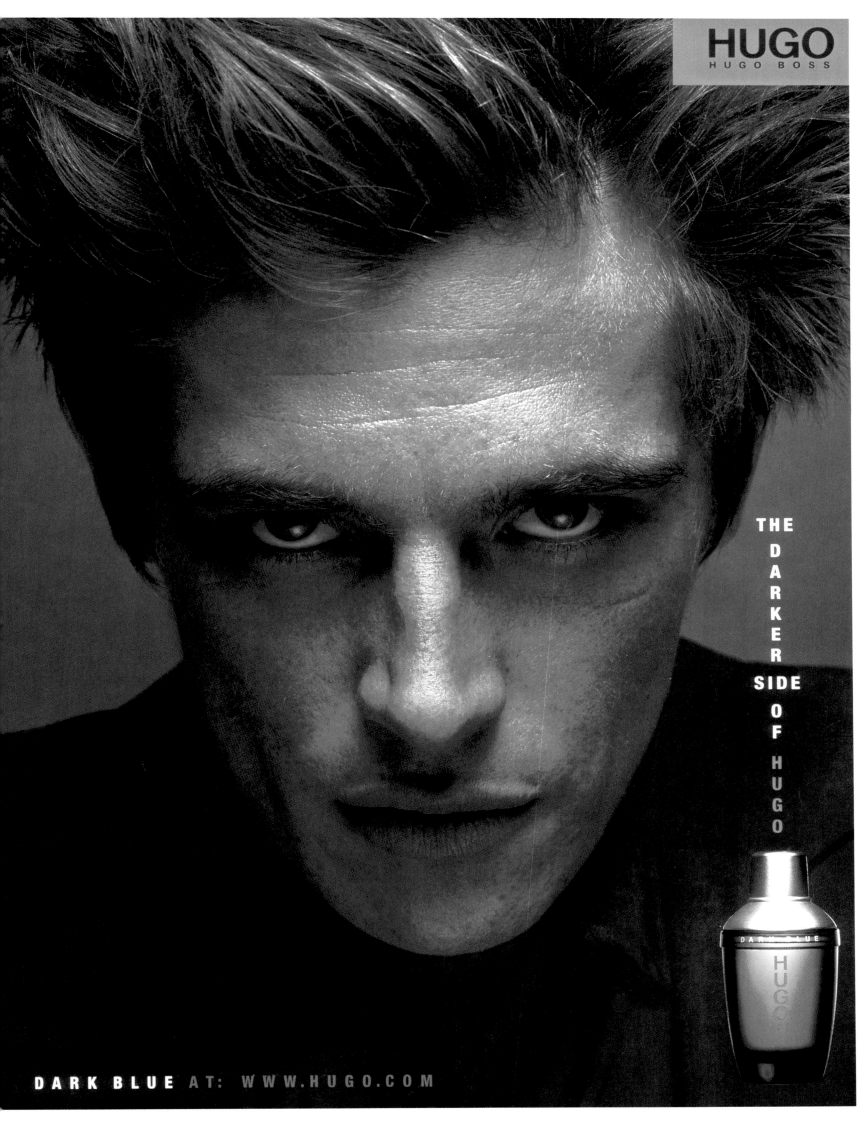

ROBERT DOWLING

CLIENT: FULLER'S LONDON PRIDE
"WORTH TRAVELLING FOR" CAMPAIGN
AGENCY: DONER CARDWELL HAWKINS
CREATIVE DIRECTOR: NICK SCOTT
ART DIRECTOR: PAT THOMAS
COPYWRITER: JOHN LONG
DATE: SEPTEMBER/OCTOBER 2002
GENERAL USAGE: POSTER, TUBE
CARDS, P.O.S-UK

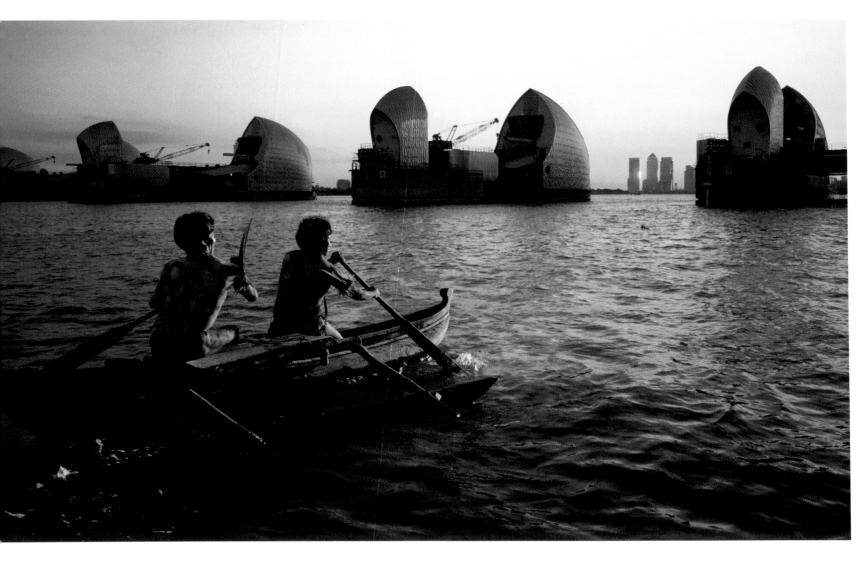
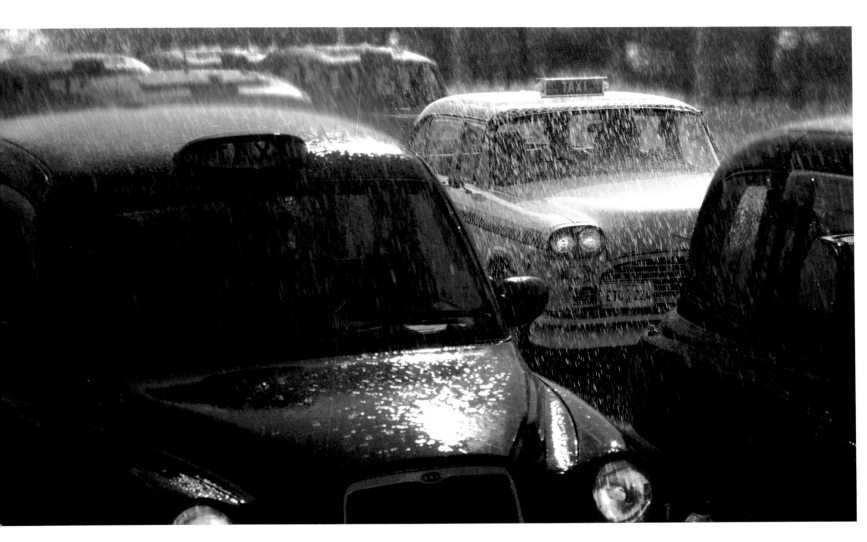

RUSSEL PORCAS

CLIENT: MERCEDES, "SKIDMARKS"
AGENCY: LEO BURNETT
ART DIRECTOR: MARK TUTTSELL
COPYWRITER: NICK BELL
DATE: NOVEMBER 1996
GENERAL USAGE: PRESS & POSTER,
WORLDWIDE

STEVEN MEISEL

CLIENT: VERSACE FALL/WINTER 2000
AGENCY: A/R MEDIA
ART DIRECTOR: RAUL MARTINEZ
DATE: FALL/WINTER 2000
GENERAL USAGE: WORLDWIDE PRINT

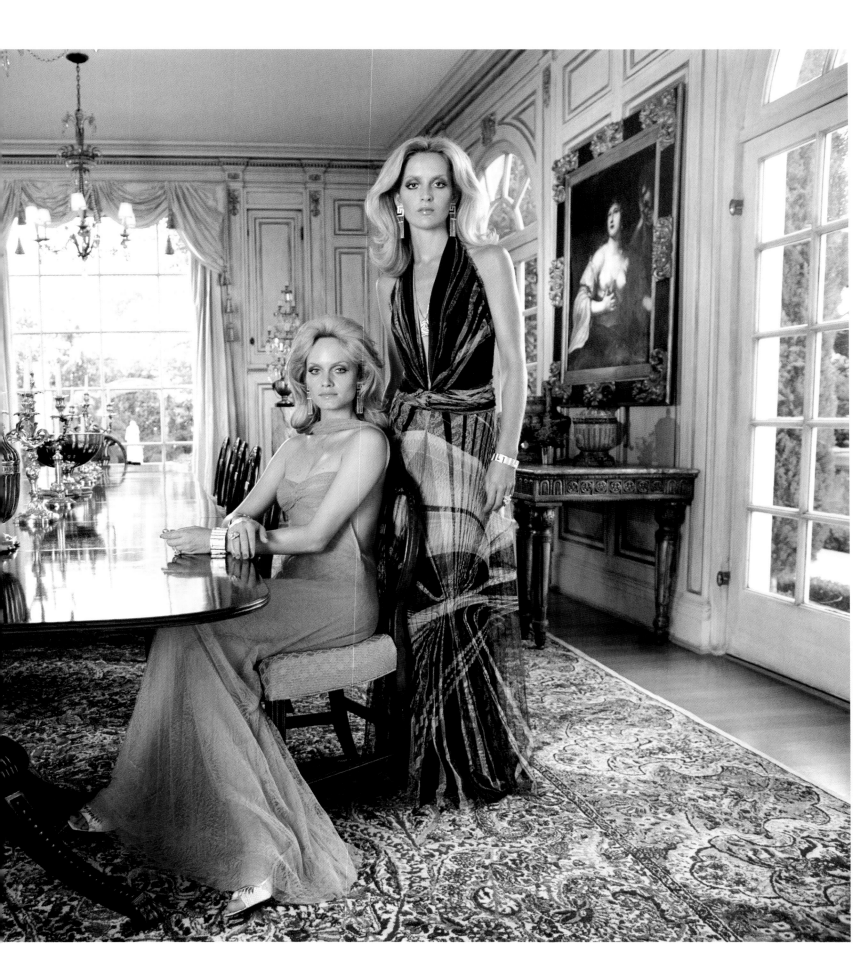

TERRY RICHARDSON

PHOTOGRAPHER

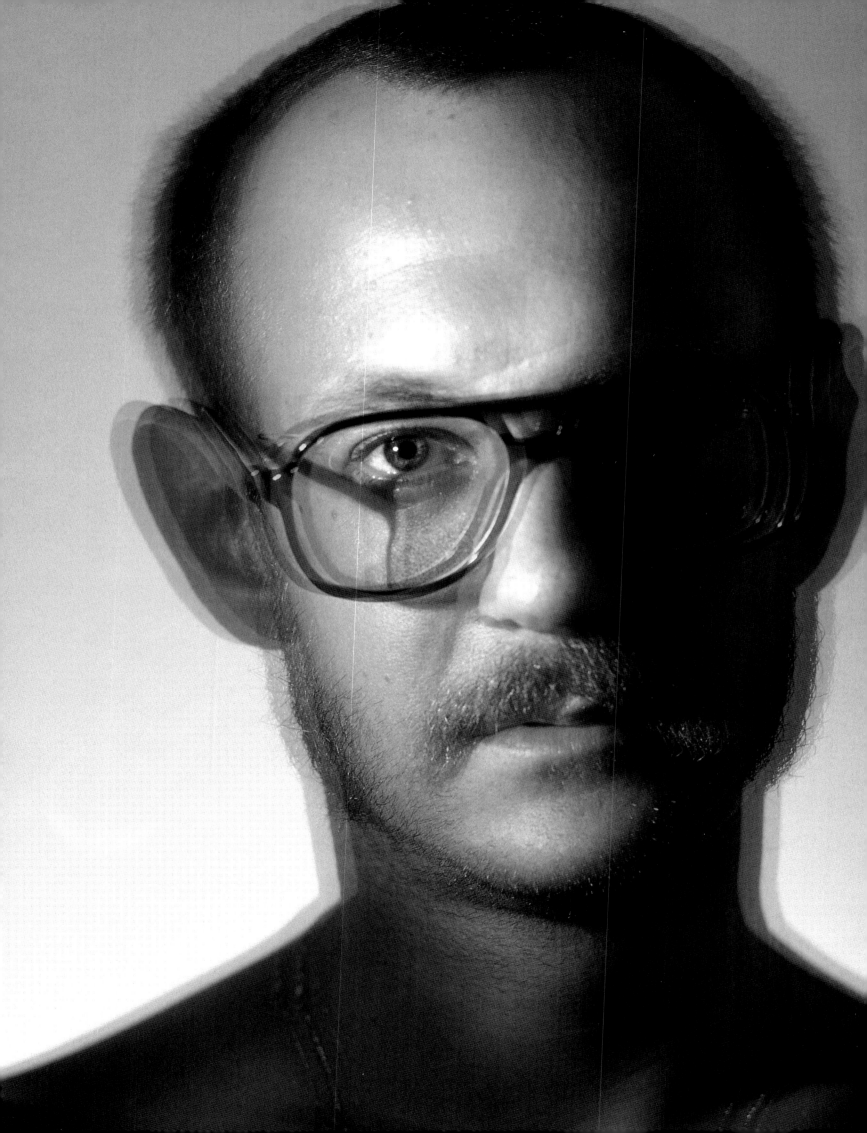

PEER

TERRY

— A lot has changed in advertising since I started. The business has changed to be more in the center of today's culture. It seems like advertising and photography are becoming a center of what is going on, what is the driving force among people. Do you feel the same? Has photography or image-making changed?

— Hopefully it changes and involves a bit. I think small parts of it do. Styles and what people are inspired by in trends, in music and in fashion keep changing so that effects what people see. I think that now everything is a mix from the past, it's a mix of a whole life. I think it's parts of it that differs each year. A lot of it stays the same and then there is small bits that come through.

— If you look back to the painters working on the Sistine Chapel like Michelangelo. They were asked to do portraits and to do paintings in churches, a sort of advertising of that time. Do you find that photography has the same roll today?

— I don't know if I want to compare anything to the Sistine Chapel.

— That was commission work as well.

— Yes, I know. I think the key for me anyway, is to do things that inspires people whether it will be in advertising or documentary books or art shows or whatever. That is really the key to create things that inspires. For me I like to provoke a little bit. If you look at most images, everything looks the same, it's so lame and it's really boring. Conservative and mediocre, mediocrity that's the norm basically. I think the key issue in advertising is that you want people to stop and look at an image. Remembering the brand or the label or whatever it is. For me I think there is good days and bad days and not everything works. When you look back on images I think they are more powerful when you look back on them than how they come across when you first see them. You can see something and then in a year you can say, "Wow, I'm still thinking about it. I really haven't seen anything else like that." I think that's when they last for a long time.

— The task the religious paintings had in the church was to inspire, to inspire people to have more faith in God. Do you think that fashion magazines or MTV has the same role today?

— No, it's all about money, selling products and making money. I like to make people laugh and smile. There is so much bad stuff and people take them so seriously. I take my work seriously but not necessary myself. So it is great to make people laugh. I think humor is an important aspect. And also just to inspire and make people stop and think a bit. People, they don't do that. Too many people make so much money creating such bad work. And that's the way it has always been. The rewards for me is if I am walking down the street and some kid comes up to me and says like "You know your thing has inspired me to do my thing and really try to do something". To inspire is such a wonderful gift. Many images and people through the past have inspired me. That's why Sisley is so great because we have this really good relationship where we are able to make kind of interesting images. We can just dance on that fine line of what we can get away with.

— The Sisley work is a revolutionary work to me. It is different and stands out. It makes people think I believe. Your pict-ures are "art" to me because they are more communication than just nice picture of some girl or boy in clothes.

— Communicating is part of inspiring. It is so nice to be able to communicate with people because that's what communication is all about. A language between two people.

— It is a conversation you are trying to achieve?

— Yes, and put smiles on peoples faces. I have had a really fortunate career, I have been able to be in the art world and also do the fashion glossy thing. That is great because I wouldn't just wanted to be all in one. It is so nice to have different things and then you start to communicate and put work out.

— So the most important thing is not to be this or that photographer it's more of your way of talking to an audience?

— Yes, I mean that it is such an amazing thing I just love doing certain sort of images. What will people think when they see this? I'm speaking to them a bit or communicating in whatever country they might be in. I know that they are going to have some sort of a reaction and think about it and that is such an amazing thing. There is so much stuff that doesn't speak to people and I think that is so important.

— You take a magazine and you flip through and it is very little there that really speaks to you. There is no communication what so ever. So you never stop, you keep on flipping. That is maybe why your clients are turning to you because you have that skill. Being able to talk to people with your images. Have you used any other media than the camera?

— I have done a few music videos and I film. I'm working on a film now too. I have a script that is almost finished. I'm writing with someone. So I would like to make films too. And be able to do that. To me I have such a short attention span it is just a nice variety for me. One day I will be doing a fashion shoot for a magazine and the next day I will be shooting a porn thing or something, I must be able to mix all of these things. I wouldn't like to work for a porn magazine because it is the same as the fashion magazine, the whole magazine looks the same, it's all the same thing.

— Maybe you should have fashion shoots in the porn magazine instead?

— Yes, that's the way to do it. Or just put images in more conservative magazines then they will be more provocative. Vogue – that's a conservative magazine. It's like dancing on that thin line, too much or it gets pass censor. Even with Sisley we have had pictures where they won't run them. And it is such a shame because there are these images that will be so great to run. Because you had never really seen them in advertising, it's like totally new images.

We had one last season, I was naked running down the beach with a girl and they said I had a hard on but I didn't. And the woman at Sisley had this conversation with the people in England and she was saying, "I was on the shoot and he didn't have a boner" and they were like No no no his dick is hard". So they couldn't run the image. For an ad I thought that was such a funny image. They are just human and real these images.

— If you look back to Michelangelo and when they painted naked ladies, the panters were told that there was too much nudity you have to cover it up. Maybe they had the same censorship then as we have now?

— When you look back at things and what has been going on since then it is nice to create images that hopefully in a hundred years people will still look at.

— Sex is a very positive thing for everybody. Everybody does it and everybody loves it.

— If there were no sex, creation would stop.

— It is like food. You have to have it or in other case you will die. I know that you are doing art projects and a lot of exhibitions as well. Is it necessary to do those art projects?

— It is another way of communication having people have access to buy prints and have them in their homes. And it is nice, because when you have an art show no one is paying you. I can't call a magazine or an ad agency and say, "You have to run this or fuck you!", I mean I can do that and I can fight in what I believe in but in the end of the day they commission me and they have the final say. And that's why it is important to work with people that understand.

— It seems like the clients are interfering too much in your work and they don't give you the freedom that you want to have.

— I have much more restraints on the editorial. Like you use to look at magazines in the 70's the editorial would be incredible and the ads will all be really boring. Today the ads are the most interesting thing. When you open up a magazine today the most interesting thing is to see what the new Calvin Klein ad looks like or whatever it might be. The editorial is just to please the people that spend money and buy the pages.

When I do editorial now, people get so scared because they don't want to offend the designer. That is the most frustrating thing. Unless if you work for magazines where there is no money and they just want to run the portfolio the way you want it. But like I said before, it is nice to be in a glossy pusher.

Even with ad jobs people would say, "Don't do this". With Sisley, Nikko will let me do whatever I want. He might not run it but he lets me push it as far as I want to go.

— Your collaboration seems to be a very tight one?

— It's like a trust, you know. In a healthy relationship there is a lot of trust.
It is like a great marriage. He does his thing and I do my thing. It's a respect for one another.

— So you won't have this image of you running on the beach in an exhibition?

— That one they can use. The nudes are fun. We have shot models that are fucking and sucking and peeing, animals whatever. We have done it all but you can't run those.

— Artists have always been trying to be close to the edge or explore all sorts of areas. Sometimes it is hard to talk about certain things so it is easier to communicate through images.

— Completely.

— Sex will always be there. Are there some other areas you would like to explore?

— I think that humor is very good. I like making people smile and laugh at different stuff. When I put myself in pictures, it makes people laugh for some reason. I never ask a model to do something that I wouldn't do myself. I'll get naked, I don't care. I like documenting all those things. I like photographing kids and I like photographing sunsets, I like all aspects of life. People get so upset about sex. They react to it and start talking about it. I mean it's not easy to create images but we all know how people are going to react. If people didn't care so much they wouldn't censor things.
 Why do people wear clothes? To look good and to attract partners. Why do they wear perfume? It is all the same. It all revolves around sex basically. You buy that outfit because you want to look good and you want people to respond. Which is all about communication too.

— It sounds very much like a message of love. That is one of the things that the church revolvs around, – love, it is one of the central messages in the faith of God. Do you believe in God?

— I pray to God. I believe in a higher power. Whatever you want to call him, Joey or God. But I do believe in a higher power. I believe in spirituality and I have a connection to it.

— When I see your images; the ones you're creating for Sisley there is a big love message. Like the apostles, they tried to spread the message of God or Jesus, and that was love. Do you think it sounds strange?

— I like that message. I don't think that in my head before but I'll go with that. For me I think I do things subconsciously. I just try to take honest pictures; I just do what I feel at the moment. To be spontaneous and just do what happens on that day. Each day you feel in a different way; you're upset, you're happy, I mean whatever you are going through. Subconsciously I probably do things that are a little premeditated but not consciously. I try to react more to the situation. For me it's very emotional. If I don't get along with people or I can't connect with them, it's very hard for me to work. That's why casting and subjects are so important. I am not a technical guy that just relies on hair and make-up and fancy light that can make anyone look good, I can't do that. I can if I really want to, but that is not what I choose to do, it's more about the person and myself.

— As I understand you try to create an atmosphere where outstanding creativity or communication can flourish. Does it ever happen that you get into a situation where you feel sort of pushed into a corner?

— At times I do things I don't want to do. Sometimes it is hard to say no and you just try to create something out of any situation. I'm trying to do not so much now. I try to be very exciting about things I do. For me the most important thing is that I like the image that I create. Sure it is great if people like it, but the most important thing is that I like it. So if you are working all the time as a commercial photographer that is pretty impossible to accomplish every time. I am trying to be a bit more careful now. I don't like to work all the time. Some people like to work every day. I always take pictures, but I don't want to shoot people in dresses every day.

— It seems you have a very clear idea about what you want to do. You have a strong integrity. Does it ever happen that clients come with a very specific layouts and say, "This way or the highway"?

— Oh yes, in order to do the things you want to do you need to keep money coming in. I do jobs all the time where I think anyone can do this but they say we want you to do your thing but you have to do exactly this. It's nothing wrong with that, you got to pay people and keep everything going. It is still fun to work and I try to do the best I can. It's nice to make a living doing something you like to do.

Not every day is going to be Sisley.

TERRY RICHARDSON

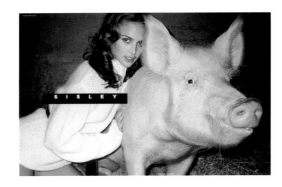

CLIENT: SISLEY
AGENCY: ENERGY PROJECT
CREATIVE DIRECTOR: NIKKO AMANDONICO
DATE: AUTUMN/WINTER 2001/2002
GENERAL USAGE: PRESS/POSTER WORLDWIDE

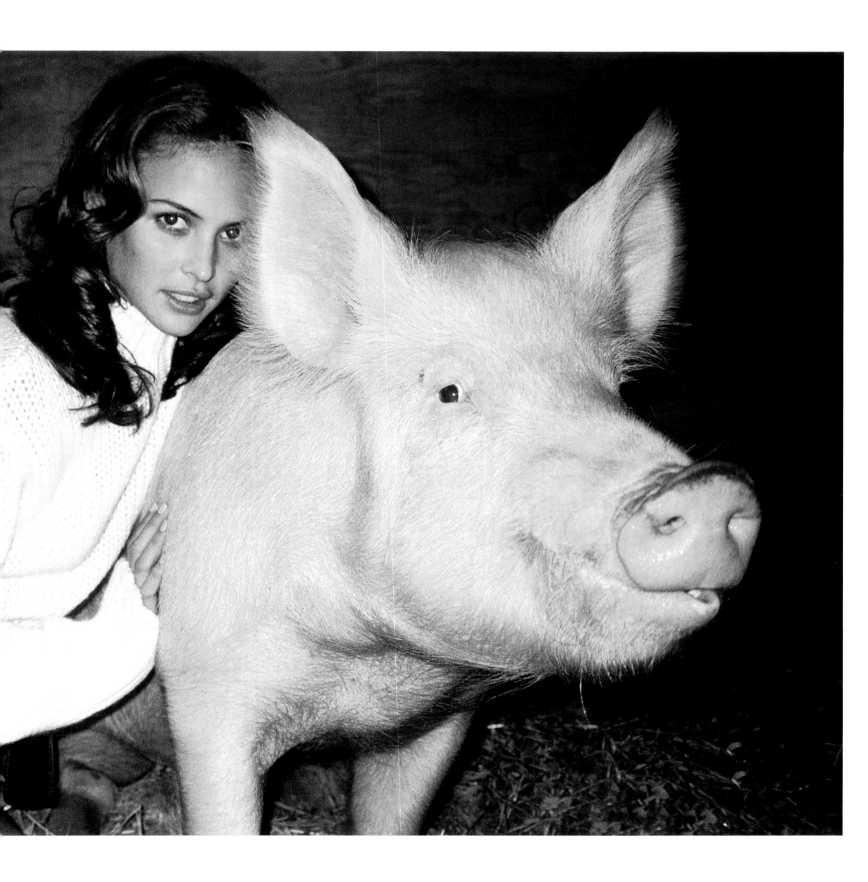

TESSA TRAEGER

HARVEY NICHOLS

CLIENT: JASPER CONRAN AT HARVEY NICHOLS
AGENCY: HARARI PAGE
ART DIRECTOR: RUAN MILBORROW
DATE: 1993
GENERAL USAGE: PRESS U.K.

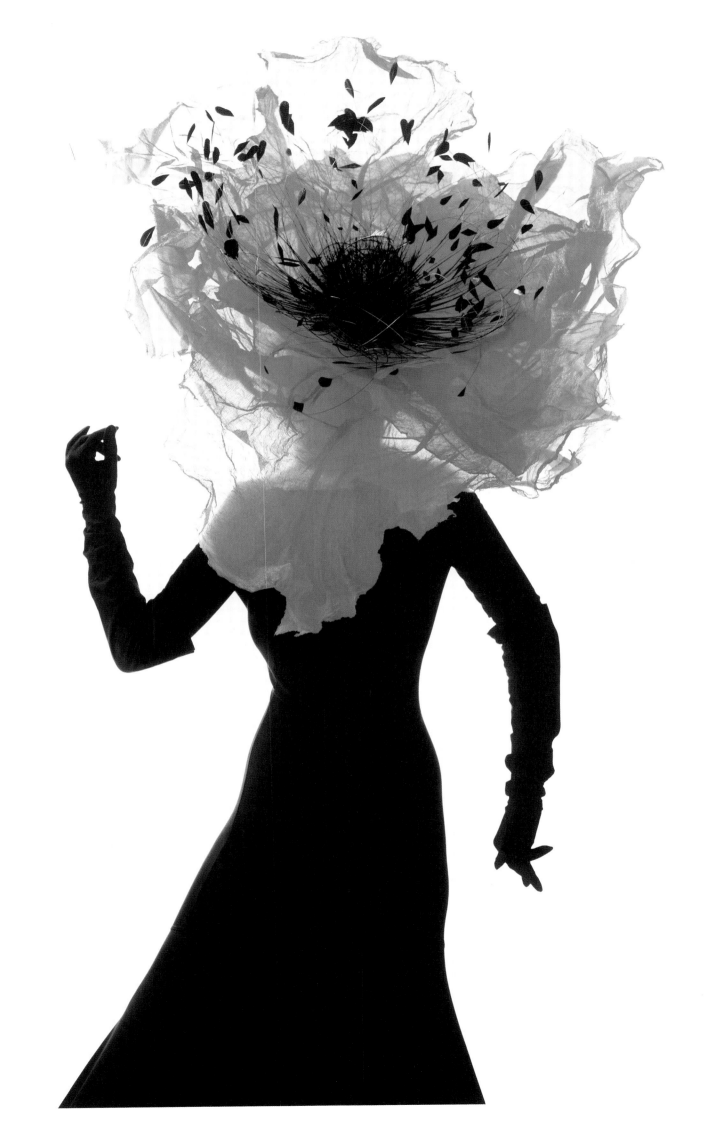

TIM FLACH

CLIENT: GETTY IMAGES
AGENCY: GETTY
ART DIRECTOR: PAUL FOSTER
COPYWRITER: CHRIS ASHWORTH/CHRIS MYERS
DATE: JANUARY 2002
GENERAL USAGE: GETTY WORLDWIDE PROMOTION. FASHION AND STYLE MAGAZINES.

GÖRAN BERNHOFF

FORMER CEO OF HASSELBLAD

PEER

— Every profession has its own tools. A
good tool is a prerequisite for a good
job. For a musician, it's his musical
instrument, for a web designer, his
computer, and for a photographer, his
camera. The camera represented a
breakthrough for humanity, enabling us
to freeze a piece of time and save it
forever. When you started to work for
Hasselblad, did you consider it as a
purely technical company or a devel-
opment company?

— If you look at Hasselblad, it's a brand
with fine old traditions, that has
been around for over fifty years. If I
remember correctly, Hasselblad was
launched a back in 1948. How did
you perceive the company, when you
first started working here?

— A strong brand is important in order
to succeed but of course the product
you sell is still what counts. Image
takes you a fair way, but must be
complemented by good products.
What is it exactly that made
Hasselblad so successful for more
than fifty years?

— I perceive Hasselblad system thinking
as a strength. The camera is a kind of
Lego product that can be made into
many different things. I think that was
its main strength. Is that the main rea-
son why people choose a Hasselblad
– that institution like NASA take it up
into space, or that the modern pho-
tographer chooses Hasselblad for its
fashion or advertising jobs.

GÖRAN

— I considered it as both a tool and a technical company. A company that had done so
much in the past, but that found itself in a situation where a new platform was required. I
perceived it to be more technical with all the challenges that might occur on its way up.

— I was asked to join the board in 1996 when UBS and Cinven acquired the company from
Incentive. I already knew Hasselblad since I had been on the board from 1986 to 1992. I
was asked to become the CEO in spring 1997, and started my job in July the same year.
When I came to Hasselblad I felt that confidence in the brand was extremely high. But I
started hearing comments about Hasselblad as a company of the past – a company that
was based on retro-style. The photographer didn't buy the camera to be at the cutting
edge, but for prestige reasons. A bit like Harley Davidson bikes, those are the feelings that
steer. Of course there are lots of feelings involved in buying a camera. But I felt that if we
wanted to develop while keeping confidence in the brand high, we had to show that we
could make modern, state-of-the-art products. If we could show the world that we could
create something new, that was also something the photographer needed, then we would
have renewed brand confidence, i.e. no longer a 19th century image, but an up-to-date one.
 It felt as though our most important task was one of renewal. That's why we took the
decision to go into the H-project, just two months after I had started my job. At that time,
1997, it was important to understand what our tradition meant, and to use the core values
as a basis for a renewed Hasselblad.

— Victor Hasselblad was a visionary, when he developed his first 1600 camera. It was a revo-
lutionary concept, system thinking. It was really well designed and it gave the photographer
lots of new possibilities since the system was so flexible. A photographer could adapt his
tool to the objects he was shooting. That's what was revolutionary.

— I think the system's versatility and adaptability is the key to its success. And it is very well
executed, with rigorous quality and mechanical precision in the camera's construction.
We collaborate with the lens manufacturer Zeiss, which like Hasselblad, continually strives
towards perfect quality.

— Can perfect quality be defined?

— The product itself that radiates quality. You can feel when a camera is well made, when it's robust and everything is genuine. You can notice when you look through the eyepiece and you see a fantastic picture. The feel of the product is really important. And of course the camera feels comfortable and gives the photographer a precise tool. And of course the photographer is pleased by the good result. Just this kind of system made it possible for the photographers to choose their optimal equipment for each specific occasion. But it's not only the end result that counts. It's also important that you feel a strong desire to own the camera. It must feel comfortable to hold in the hand and it should inspire pride. This has been our guiding star when we built the new H-system. When you take the camera in your hand, you must feel you want it.

— As with everything in life, there's both an emotional and a rational side of it. But as I understand it, the emotional side comes first and the technical side merely confirms the decision. But it must be first driven by emotion. Do you agree?

— Exactly. It's as obvious for a professional photographer as it is for a skilled amateur – the choice of equipment is loaded with emotion. The brand as well as the technical solution must feel right. Of course, there is a precise analysis based on performance criteria. But there's a feeling when you buy a tool which you are going to use everyday. The right feeling has to be there. The feeling of quality is of course a really important part of a Hasselblad. If you check the chrome edging on the V camera, you understand that an incredible degree of precision is involved in making it. When a photographer has used his camera a couple of times, it probably gets a bit worn out, but it's totally unacceptable for somebody to buy a camera if it seems to have the smallest cosmetic defect. You might assume people buy for functionality, but in fact the whole feeling is important.

— Yes, when you talk to photographers, that's what matters. How you can turn it one way or another. It's that about the product we are most interested in. A good camera becomes a kind of extension of the photographer himself. In the instant when the picture is created, you have to concentrate to take the picture and the tool must be perfect. Do you test this kind of emotional aspects? Can they be tested?

— When we designed the new system, the ergonomics were seriously tested. Grip, weight and balance are part of the final design of the system. We take pride in being as close to perfection as possible. An important aspect is the viewfinder – that it represents the whole picture as clearly and completely as possible. That's one of the things we spontaneously hear from photographers when they start to work with it. There we've got a construction that allows photographers to take pictures in a fantastic way.

— The technology is important in all contexts. The digital picture has become very important for all photographers and in fact for the whole advertising industry. How have you adapted to this?

— Hasselblad is quite a small company and we have to target our niche with greater precision. We want to make a perfect tool that lets photographers to take perfect pictures. But to create digital or analogue solutions it has been a challenge to develop a system that would endure over time. When we constructed the H-system we had in mind that it should work both digitally and analogically. There are plenty of suppliers of digital adapters and their product development is very fast. New sensors and new products are being developed continually. Our company hasn't taken part in this process so far. It would swallow our R&D budget many times over. And it wasn't possible since we were developing the H-system. So what we have done is to create a solution that gives photographers the chance to work both digitally and analogically, and for that we have third party suppliers developing of the digital adapter.

— So your core business is the photo taking equipment uniquely. Not so much what kind of media it gets used in?

— It is vital that we make a tool for both. We think that a photographer in the future will continue to shoot with film. In some sectors film is highly suitable. A photographer can go out to the countryside to take nature pictures, and he takes it with film. Maybe that's the simplest thing in that case. But while he's in the studio shooting a catalogue, it might make more sense to shoot digitally.

— You can see a Hasselblad camera is made of four parts: a lens, a camera, a viewfinder and the film cartridge adapter, roughly. Does this create opportunities to work in other formats than still pictures? Could Haselblad also be used to take movie pictures?

— Not really. We haven't regarded that as a priority. But in the future we could use digital adapters to take moving pictures. But for us it still pictures, that are the primary goal.

— Still pictures are very interesting, for me. They maybe fascinate more photographers and artists, just because the aim of photography is to freeze time. Is that where your core operation lies? Is it our job to freeze time?

— Well put, you're quite right. To do it in a way that represents reality with the highest quality. But also to give the photographer high flexibility and the chance to create pictures and capture the instant.

— The photographer as an artist, via the perfect tool with the highest quality and greatest versatility in the complete system. To be able to reach what really interests photographers, is exciting because there's a kind of relation to old Hasselblad tradition - of freezing time with modern technology and high quality. Is that what drives you?

— To give a professional photographer a perfect tool. That's our business idea. That's where our know-how lies, and that's the direction in which we strive to develop. Everybody who's worked with Hasselblad over the years has helped to create confidence in the brand in many people's hearts. We, who have been here for the last five years, we have succeeded in renewing this confidence through the H1 and the XPan II.

They are new systems that have been very well reviewed. We are very pleased, and have received one prize after the other. But the bottom line is, how many do we sell?

— To see that photographers actually use your system must be the most important thing for you? If you look forward into the future, what do you see coming?

— We have to figure out our next steps. Internally, we have lots of future projects. I see that Hasselblad, in five years will be working around the same values as today trying to create new solutions for very demanding photographers. But maybe in a few years, we'll develop products that are affordable for a broader audience. It's of course an investment to get into the H-System. The entry price is around 50,000 Crowns, just for the analogue side. But of course it'll be possible to achieve good photographical solutions for less money than that, and that even have the same ambition as ours – to try and create the ultimate tool. At the moment, we're going over to digital photography and we follow this development. However, we think this kind of view is going to be a bit more varied. Because of course there will be areas, even in the future, where film will be preferred to digital solutions. I hope that we can contribute in the future to digital as well as analogue solutions.

— The best of both worlds.

— We see lots of opportunities for Hasselblad in digital photography. But we are convinced that lots of photographers will carry on wanting to do better work both with film and digital pictures. Here Hasselblad offers its fantastic flexibility. We give photographers a degree of freedom in their profession that few other manufacturers can match. It's our greatest strength.

WERNER PAWLOK

CLIENT: SCHEUFELEN PAPER FACTORY
– GERMANY
AGENCY: ACOM WGS
DATE: END 2002
GENERAL USAGE: ADS & EXHIBITION
PIECES, FOLDERS & POSTER, EUROPE

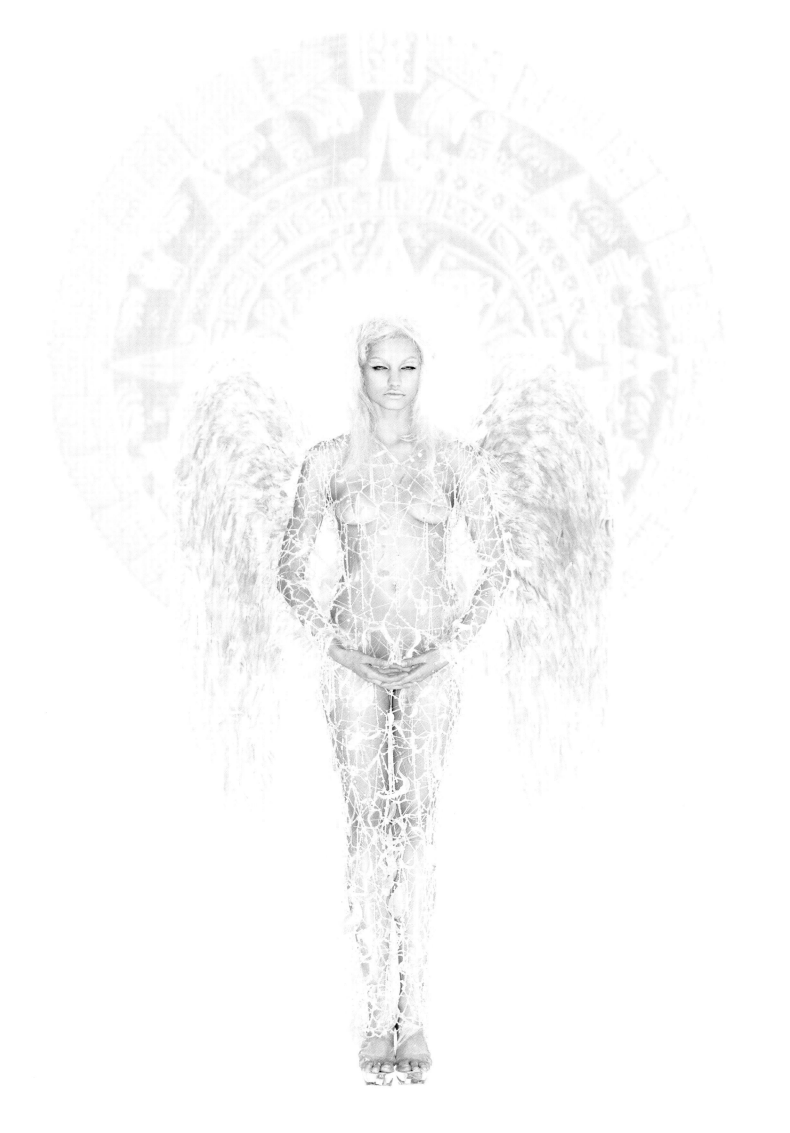

ZENA HOLLOWAY

CLIENT: O'NEILL
AGENCY: MARTIN TATE REDHEADS, UK
ART DIRECTOR: BERRY BURGESS
COPYWRITER: MICHELE HOULSBY
DATE: 2003 EUROPE CAMPAIGN
GENERAL USAGE: EUROPE PRESS &
POSTER

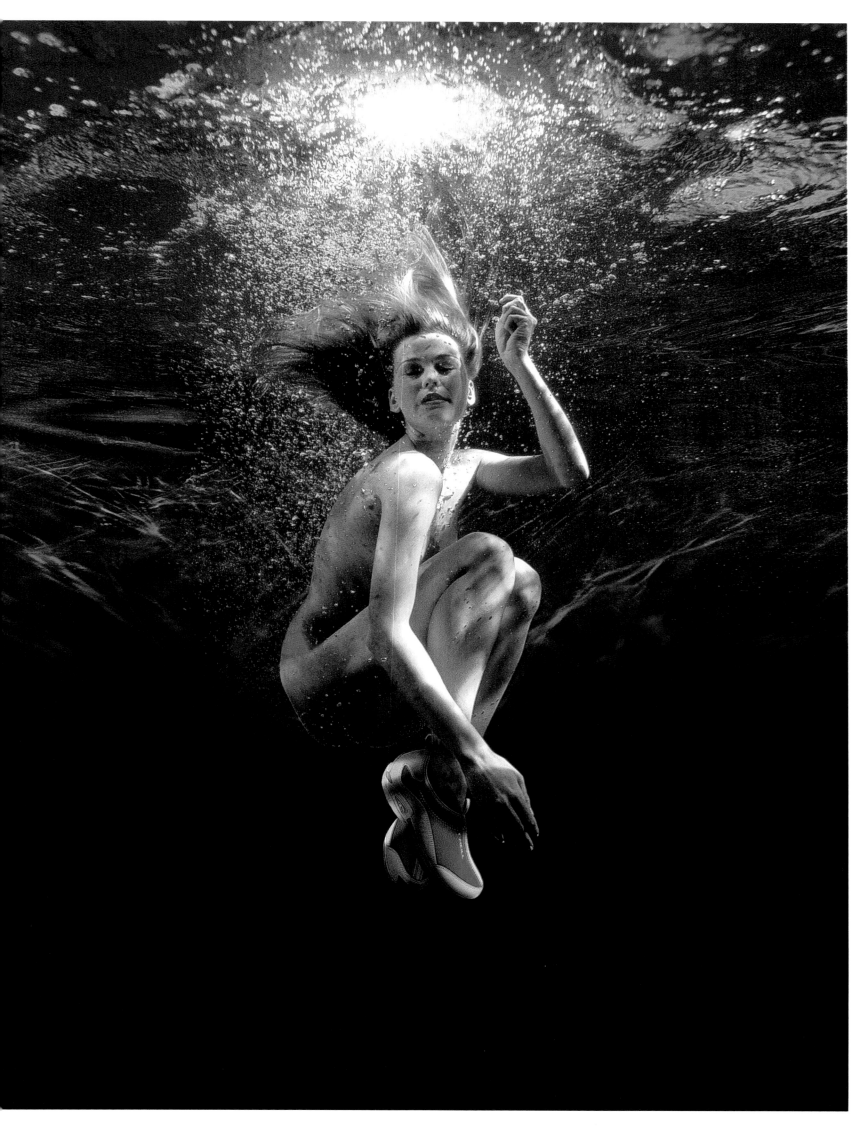

"A picture says more than a thousand words." This old saying is more relevant today than ever before. We live in a visual culture, delineated by images in the media. And in advertising.

In the information society, it is through the media that we become acquainted with lifestyles and patterns of behaviour. And in this system, advertising plays a not insignificant role: advertising creates trends, defines whole worlds of values, kindles vitality and stimulates acquisitiveness. As a globally operating company and an engine for advertising, AUDI AG is conscious of this role.

For this reason, we support dialogue by means of promotional communication. The art director, Peer Eriksson, has brought together in his exhibition "Photography in Advertising" a collection of first-class publicity photographs from renowned international photographers. It is with great pleasure that we, as sponsors, pledge our support to an exhibition that has likewise been introduced to an interested public in Audi forums in Stockholm, Berlin, Munich and London.

Michael Renz
Marketing Director
AUDI AG

CLIENT: AUDI
AGENCY: BBH
CREATIVE DIRECTOR: RUSSELL RAMSEY
CREATIVE TEAM: GEORGE PREST,
JOHNNY LEATHERS

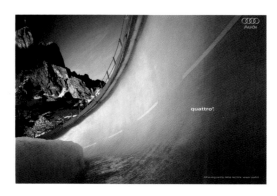

CLIENT: AUDI
PHOTOGRAPHER: BOUDEWIJN SMIT
AGENCY: VERBA ITALY
DATE: 03/2000

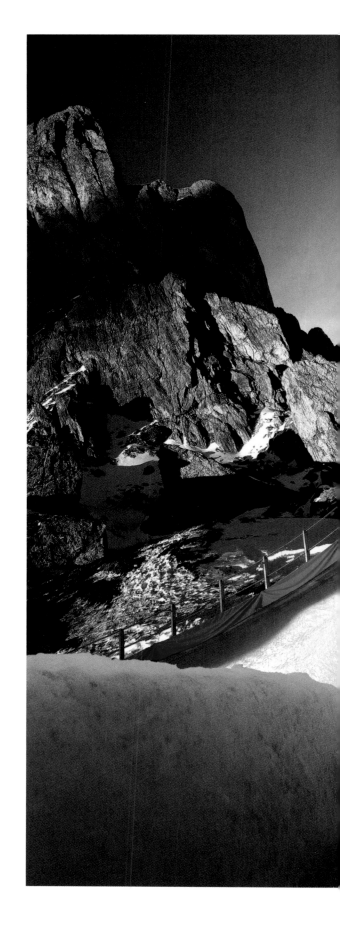

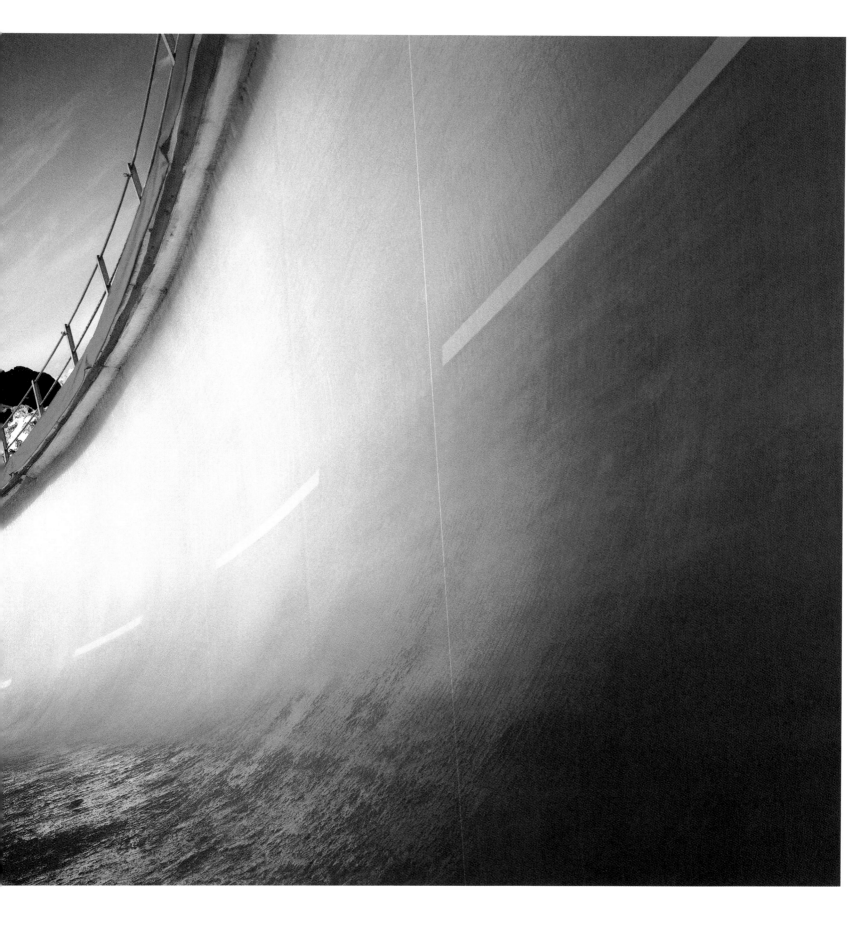

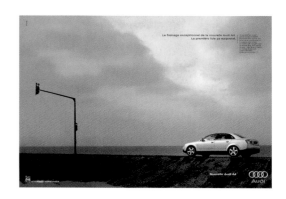

CLIENT: AUDI
PHOTOGRAPHER: HARRY GRUYAERT
AGENCY: LOUIS XIV FRANCE

CLIENT: AUDI
PHOTOGRAPHER: MAURIZIO CICNOCETTI
AGENCY: VERBA ITALY
DATE: 03/2003

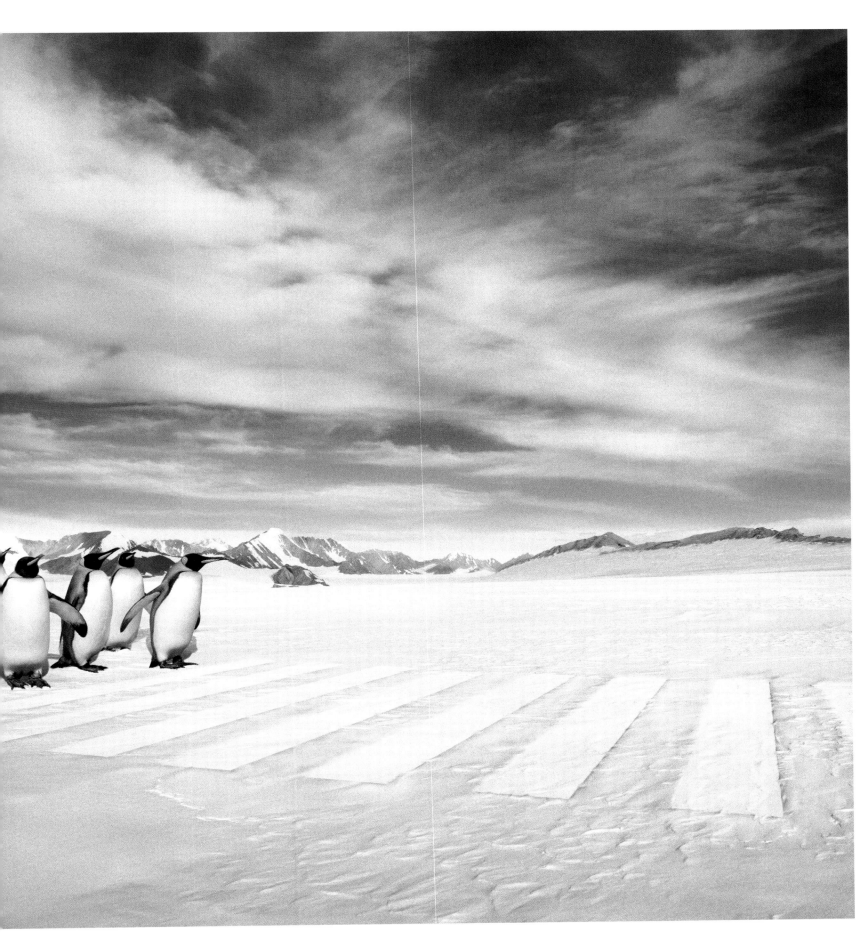

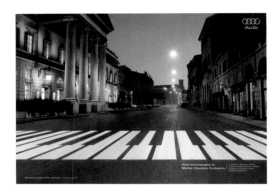

CLIENT: AUDI
PHOTOGRAPHER: MAURIZIO CICNOCETTI
AGENCY: VERBA ITALY
DATE: 03/2003

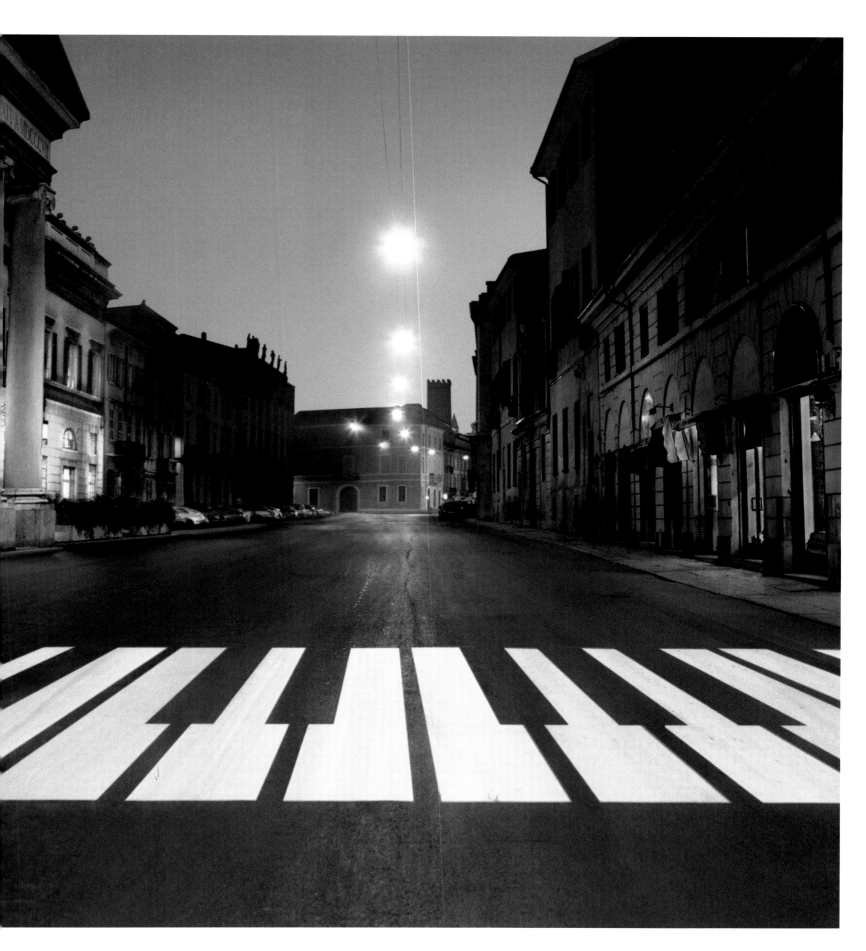

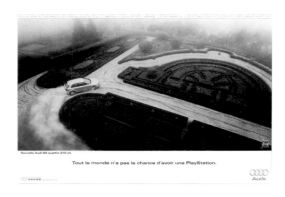

CLIENT: AUDI
PHOTOGRAPHER: BOB MILLER

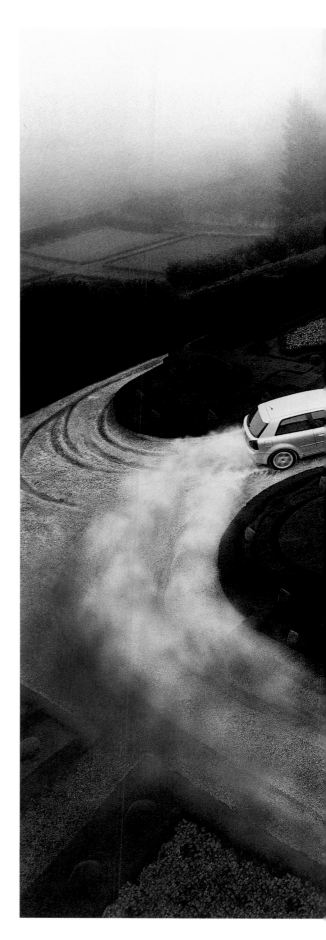

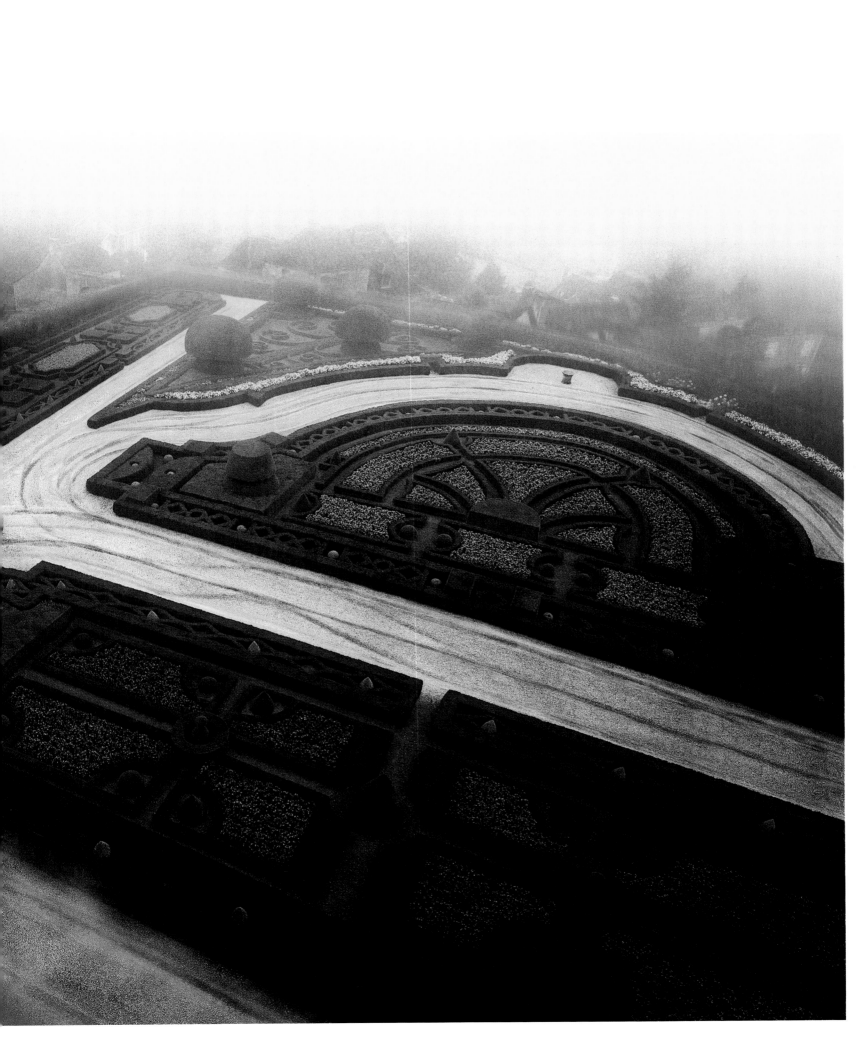

CLIENT: AUDI
PHOTOGRAPHER: HERVÉ PLUMET

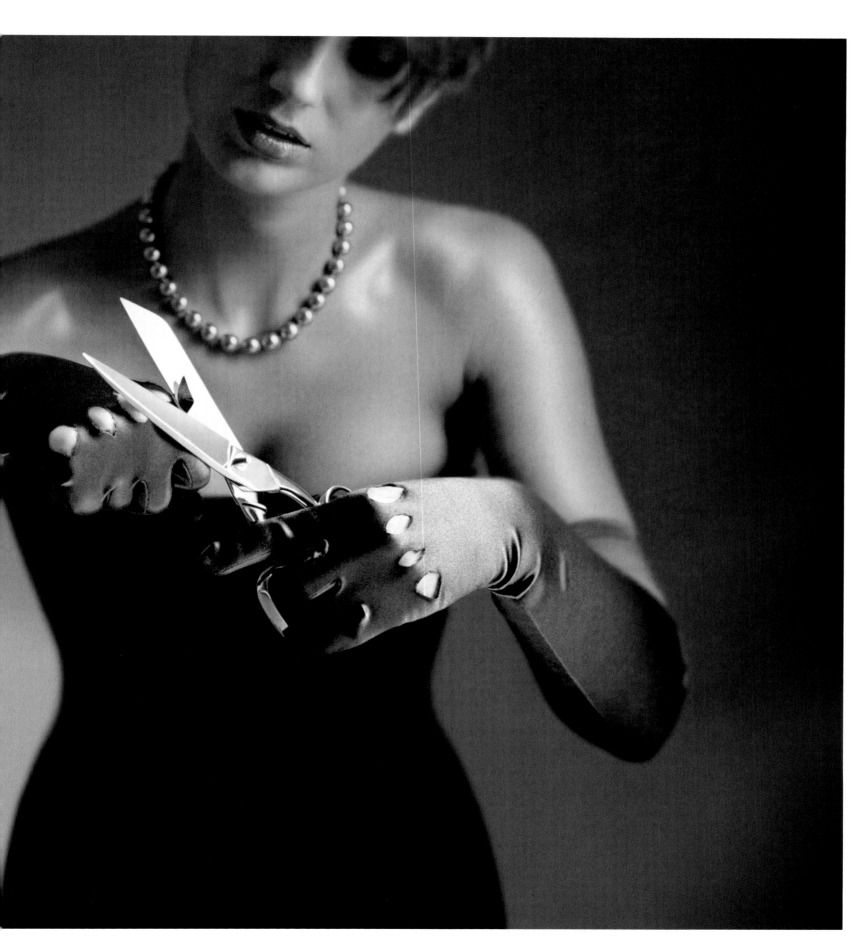

CLIENT: AUDI
PHOTOGRAPHER: STOCK PHOTO & 3D ILLUSTRATION

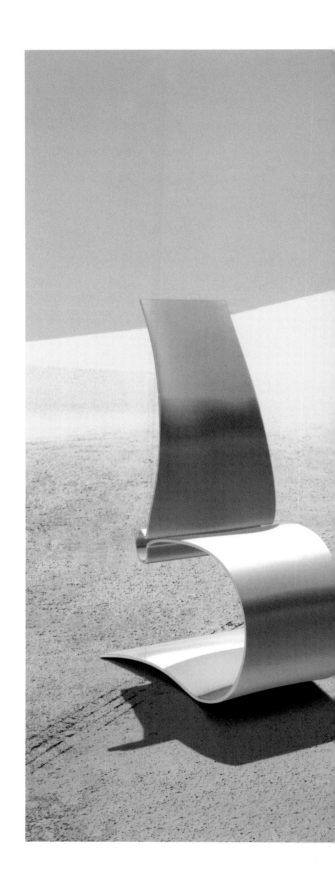

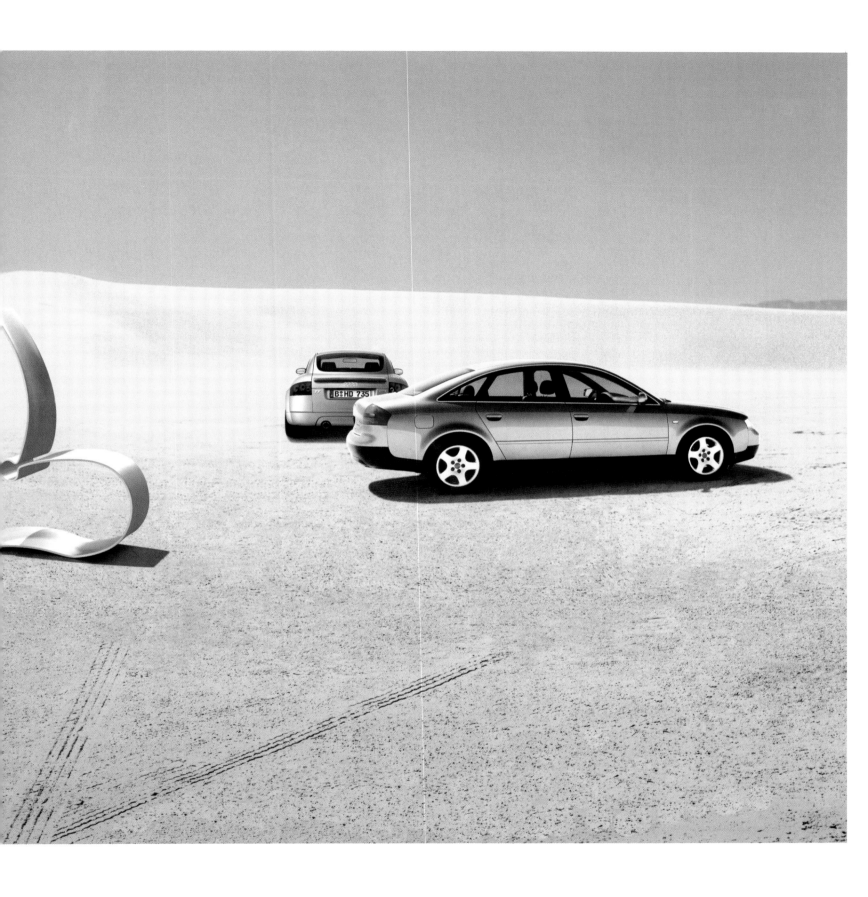

Two grip. But four grip much better.

CLIENT: AUDI
PHOTOGRAPHER: MAURICIO NAHAS

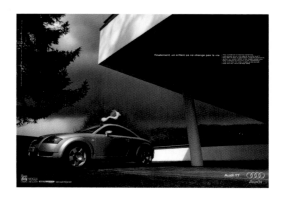

CLIENT: AUDI
PHOTOGRAPHER: MARC GOUBY

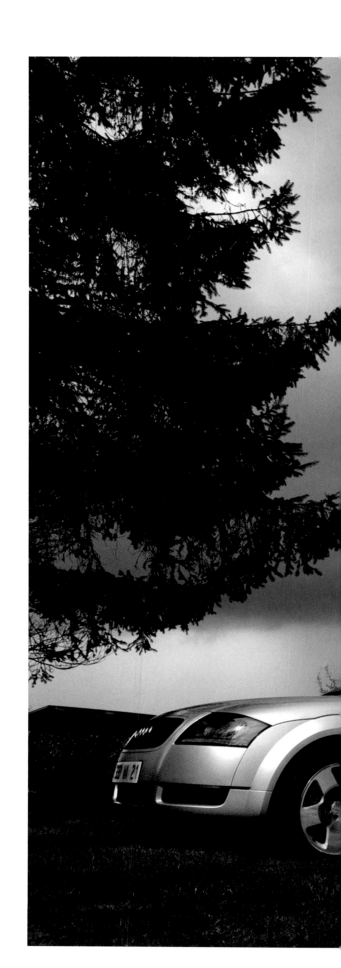

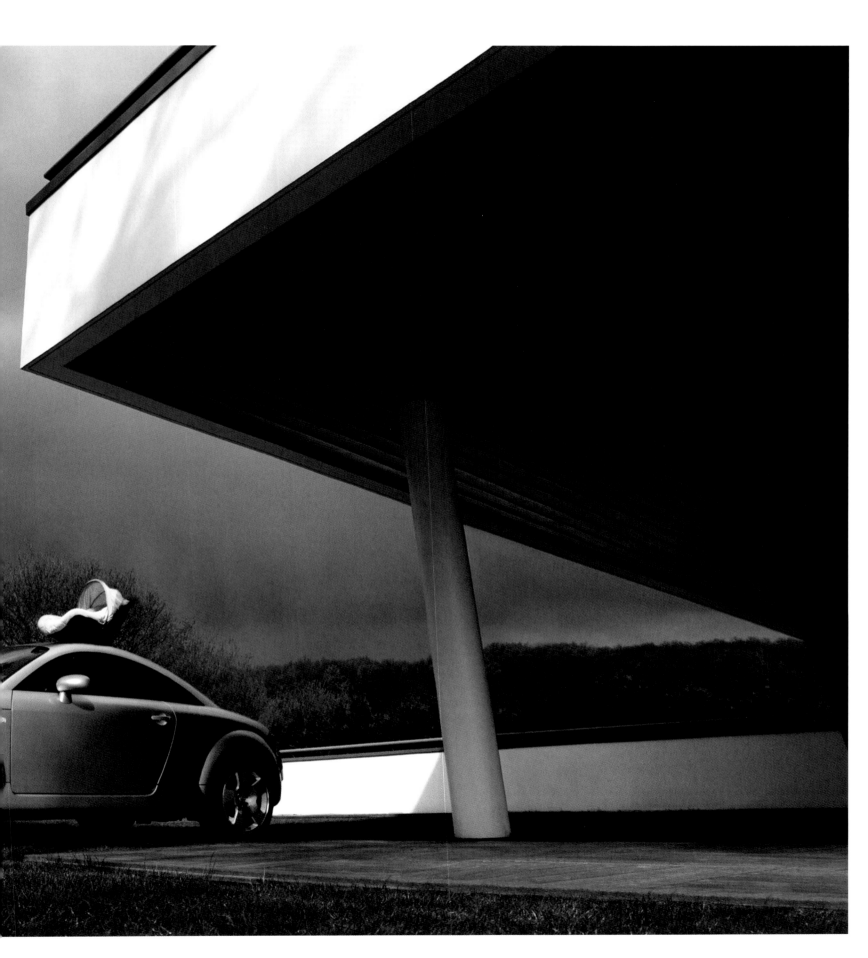

CLIENT: AUDI
AGENCY: BATES RED CELL
ART DIRECTOR: THORBJØRN NAUG
COPYWRITER: ØYSTEIN HALVORSEN
DATE: JAN 2003
GENERAL USAGE: MAGAZINES, NORWAY

CLIENT: AUDI
PHOTOGRAPHER: GREG MYHRA

CLIENT: AUDI
PHOTOGRAPHER: JOHN EARLY

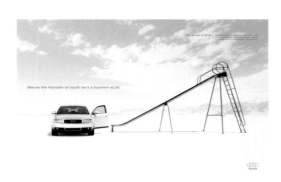

CLIENT: AUDI
PHOTOGRAPHER: OLAF VELTMAN

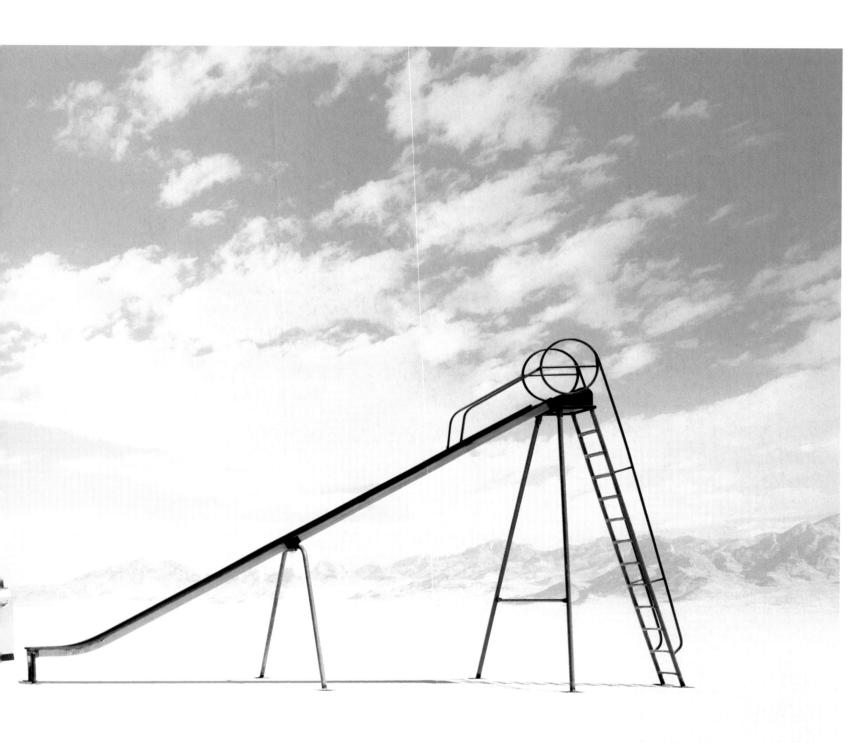

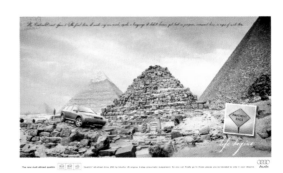

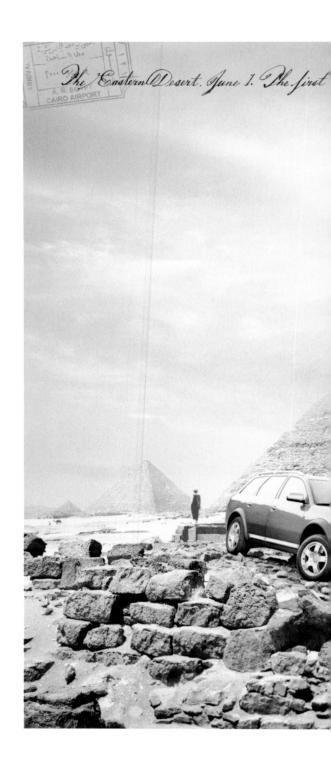

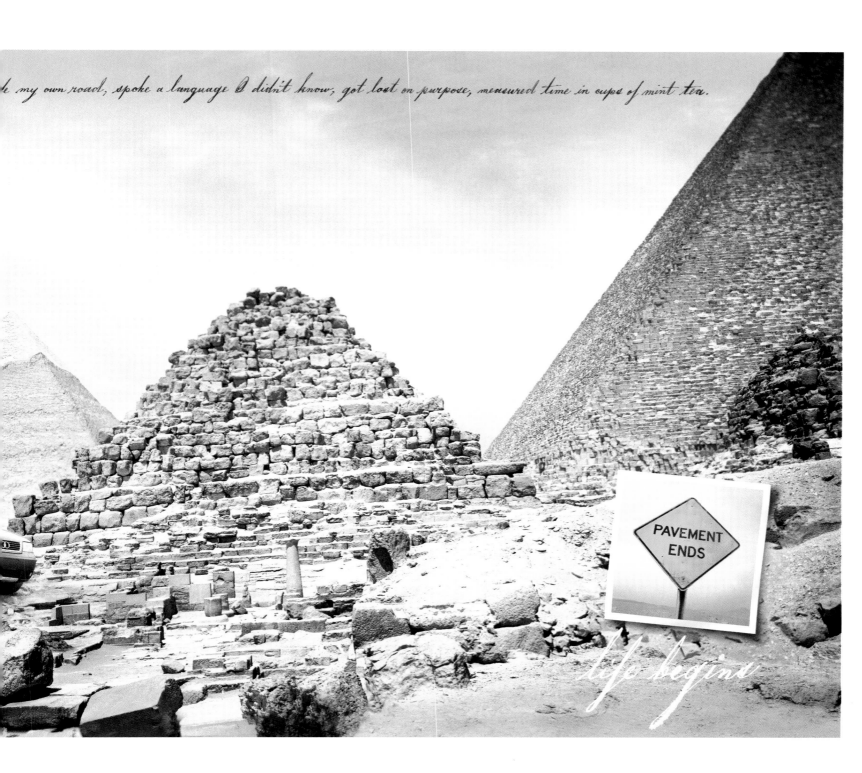

de my own road, spoke a language I didn't know, got lost on purpose, measured time in cups of mint tea.

life begins

CLIENT: AUDI
PHOTOGRAPHER: PAUL ZAK

CLIENT: AUDI
PHOTOGRAPHER: PAUL ZAK

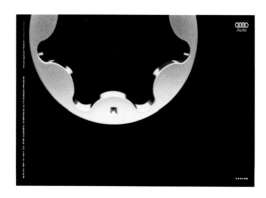

CLIENT: AUDI
PHOTOGRAPHER: PAUL ZAK

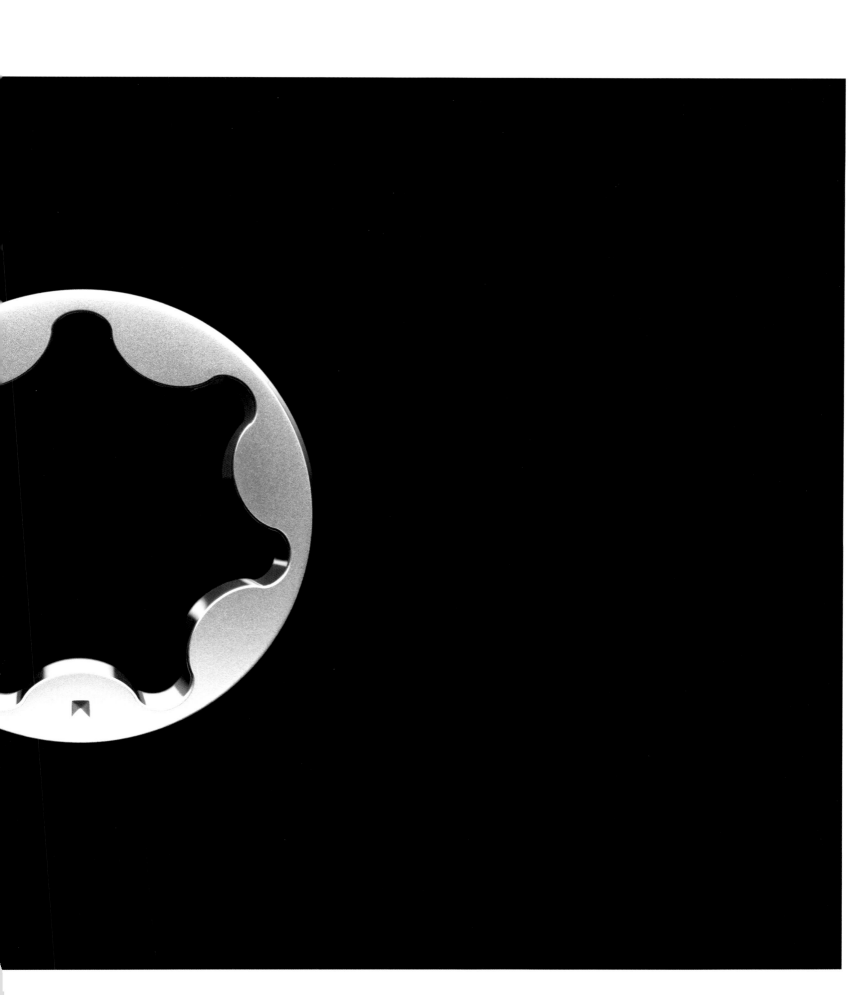

CLIENT: AUDI
PHOTOGRAPHER: KEVIN SOMERS

CLIENT: AUDI
PHOTOGRAPHER: KEVIN SOMERS

CLIENT: AUDI
PHOTOGRAPHER: KEVIN SOMERS

PRODUCTION: PEER Communication
PRINTING: Holmbergs i Malmö AB
BINDING: Förlagshuset Norden Grafiska AB
PAPER: Svenskt Papper AB
INSERT: Silverblade matt 150 g
COVER: Klot Spectra 317
JACKET: Silverblade matt 150 g
TEXT: Peer Eriksson
TYPOGRAPHY: Helvetica Neue
ART DIRECTION: Peer Eriksson

This publication is issued in conjunction
with the exhibition: PHOTOGRAPHY IN ADVERTISING
organized by PEER COMMUNICATION and
NOONWRIGHT.

THE EXHIBIT VENUES ARE:
Form/Design Center Malmö
April – June 2003

AUDI Forum Stockholm
September – November 2003

AUDI Forum Berlin
December 2003 – Februay 2004

AUDI Forum Munich
June – September 2004

First edition

First published in Sweden October 2004

ISBN 91-631-2021-6

Published by PEERBOOK
PEERBOOK is an inprint and trademark of BOKMOLLAN AB

Printed in Sweden

Master Johansgatan 6
211 21 Malmö, Sweden
+46 406995400, +46 705336631
info@peer-com.com, www.peer-com.com